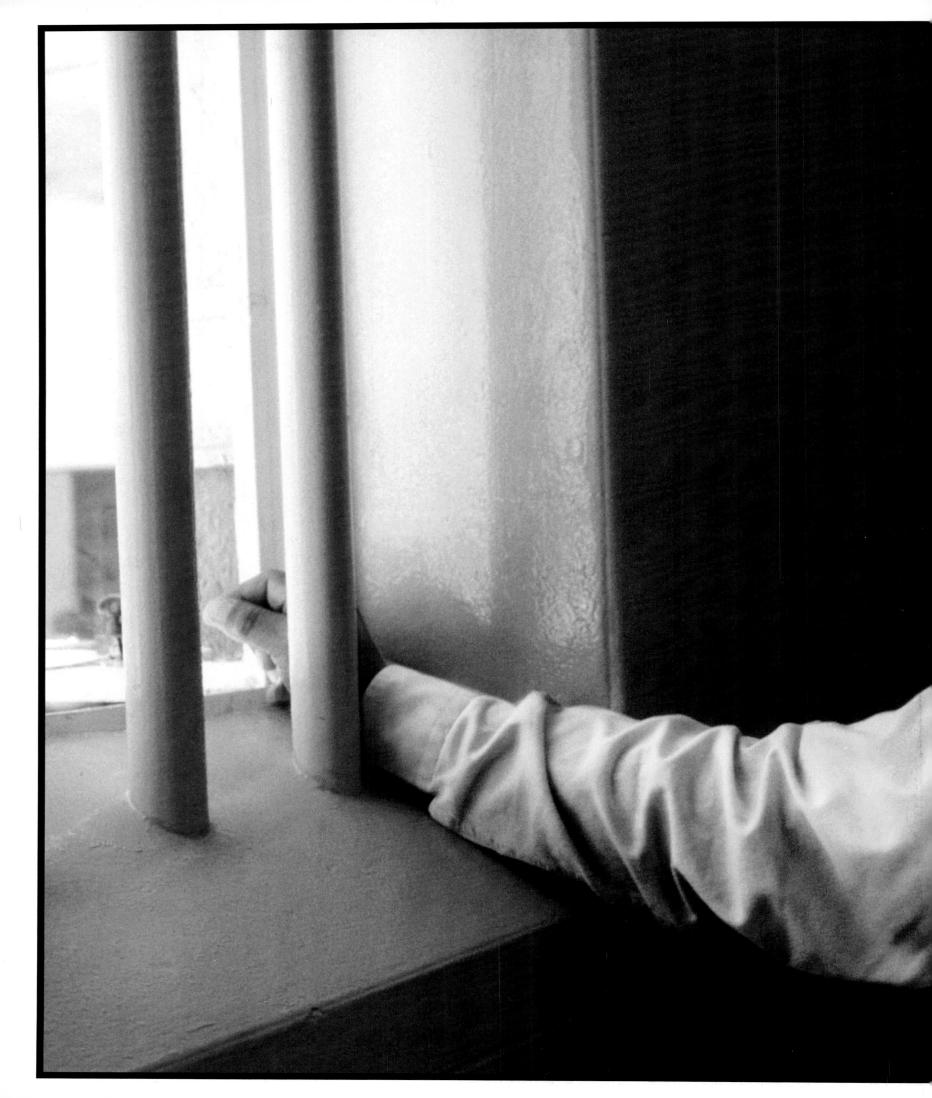

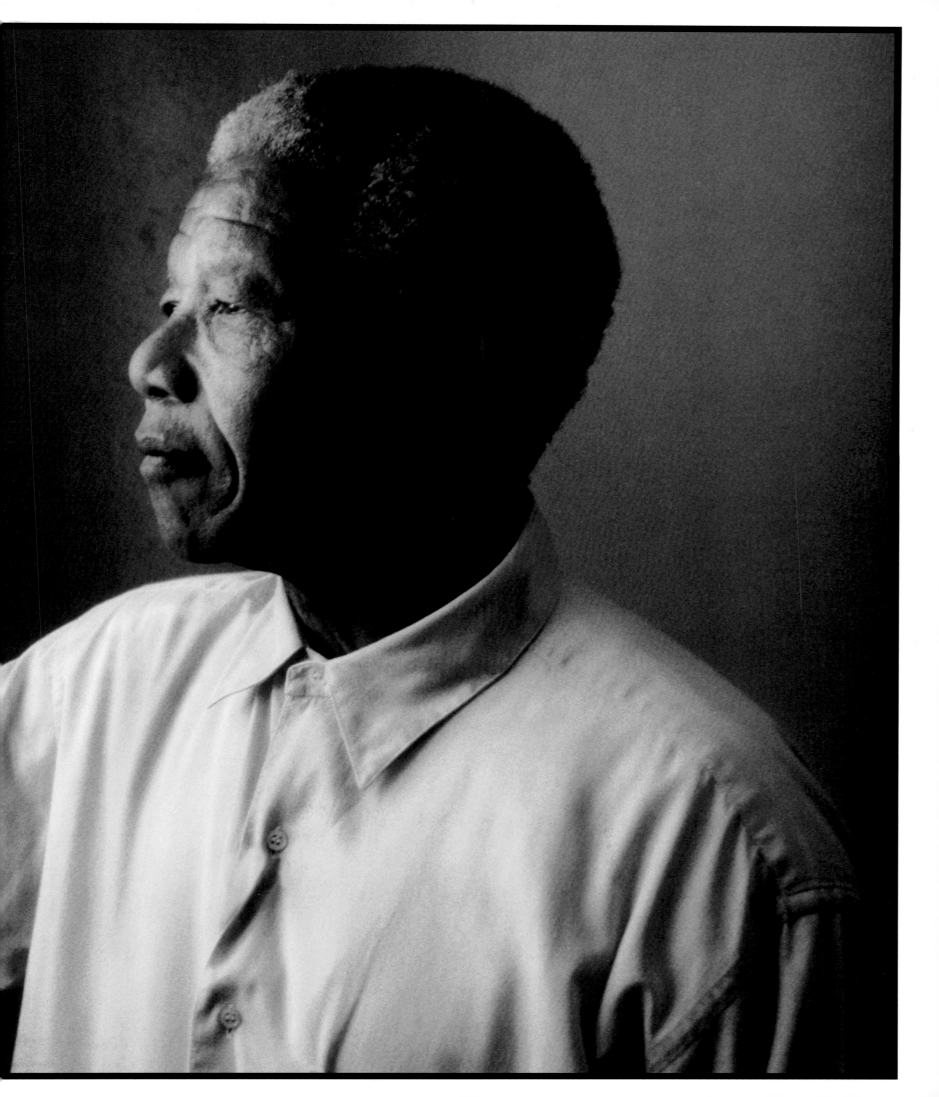

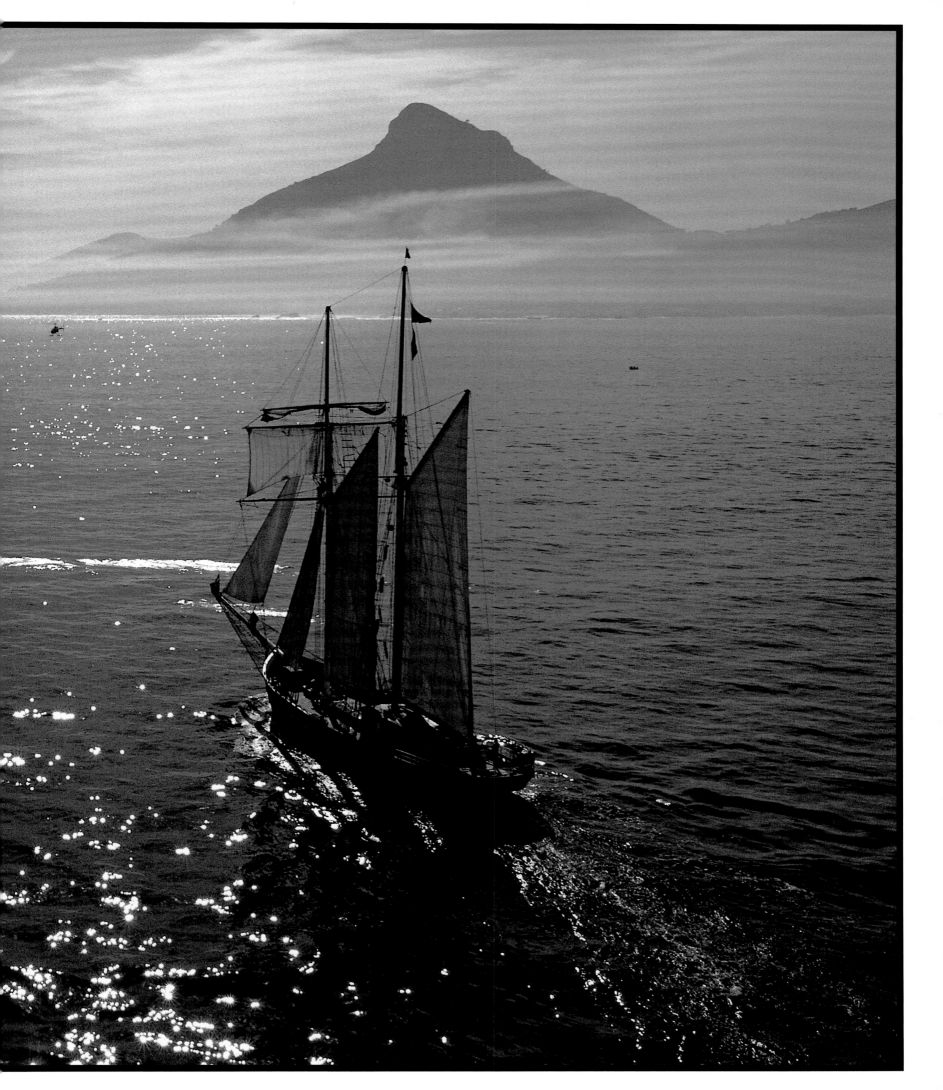

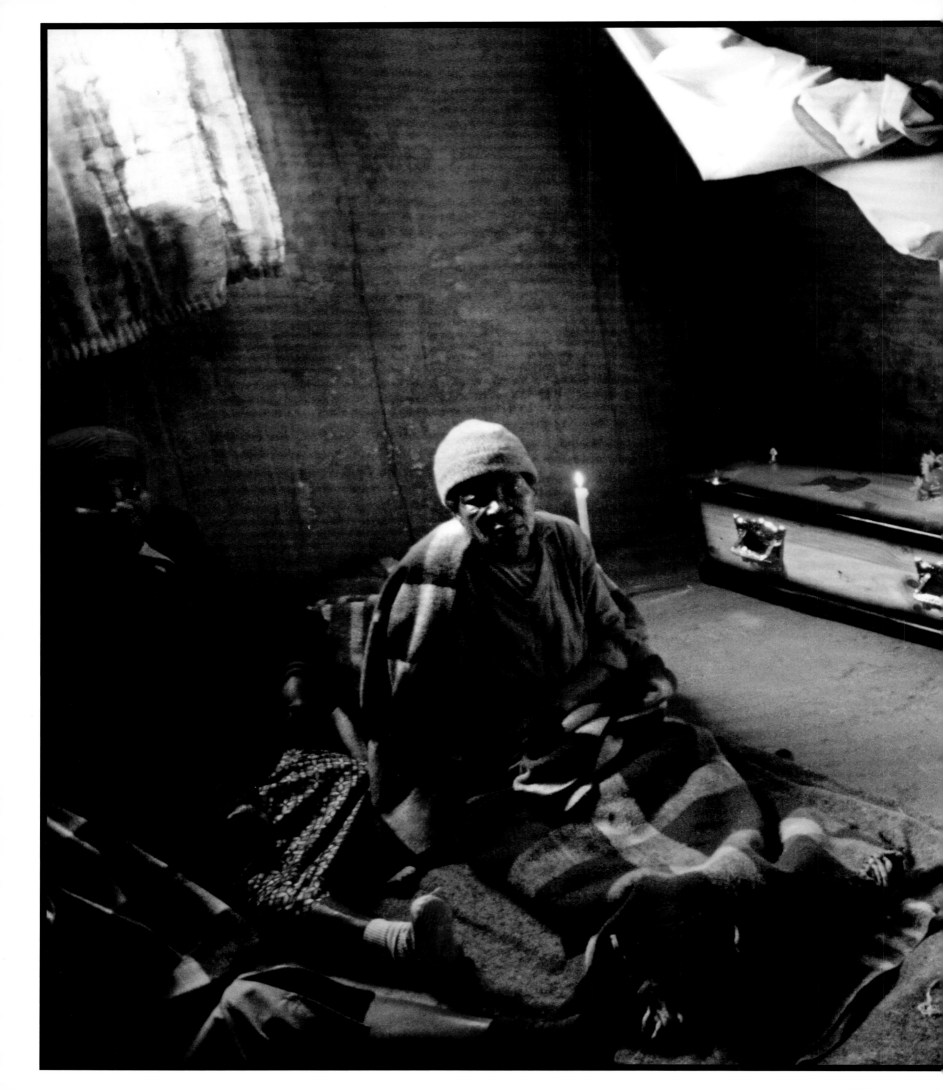

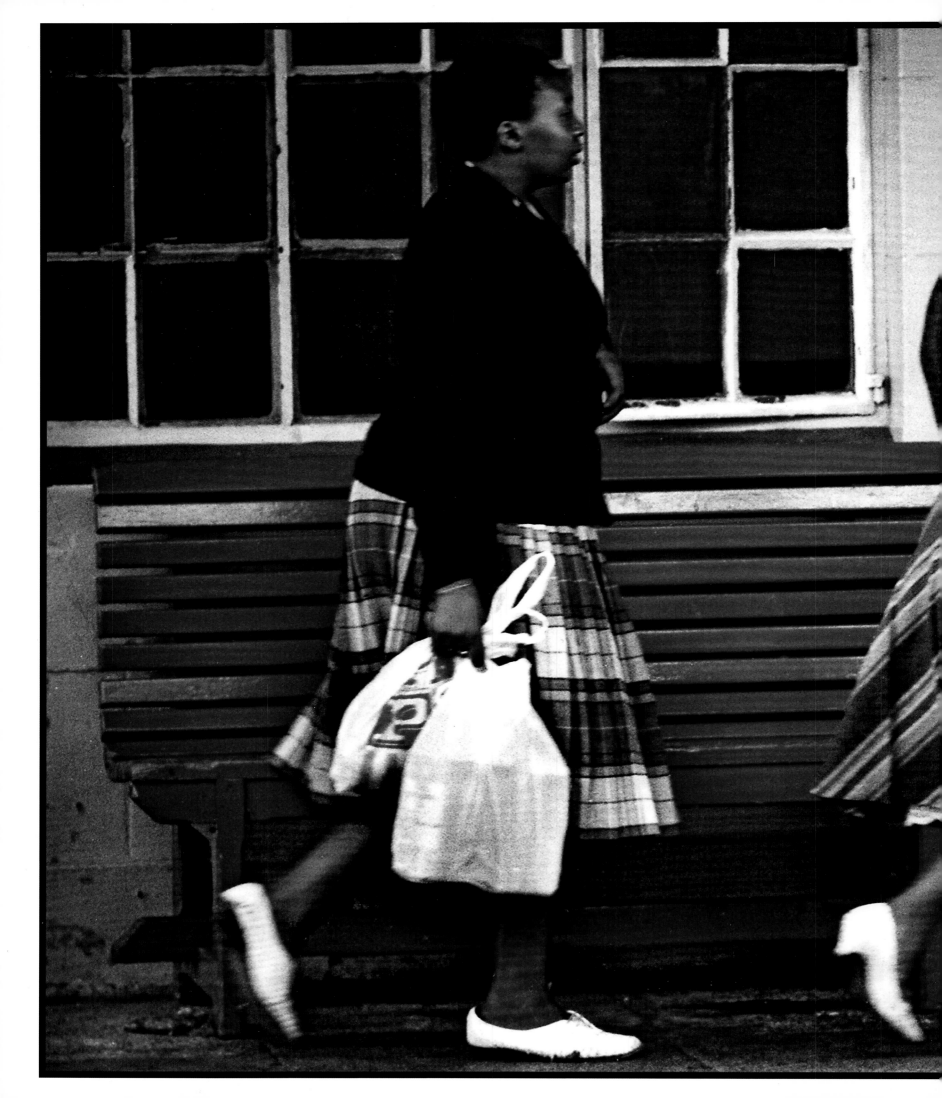

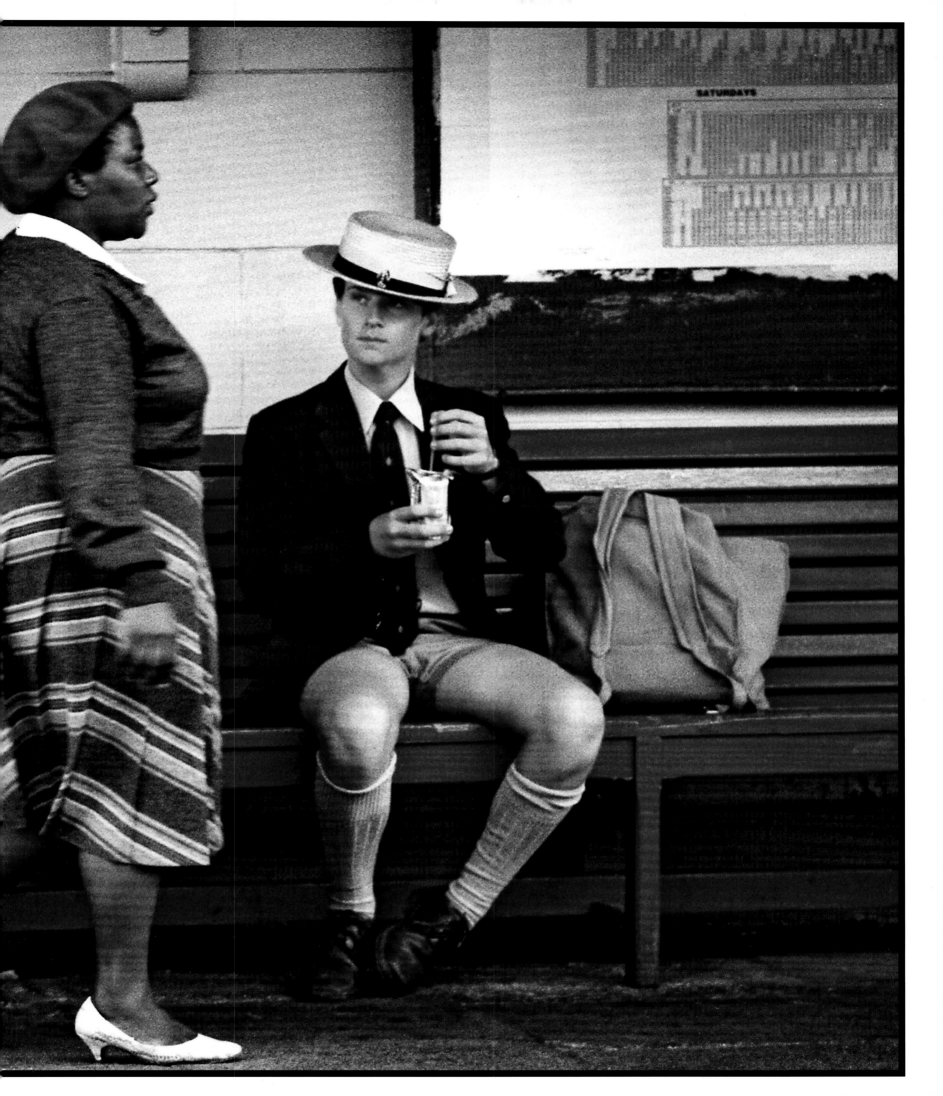

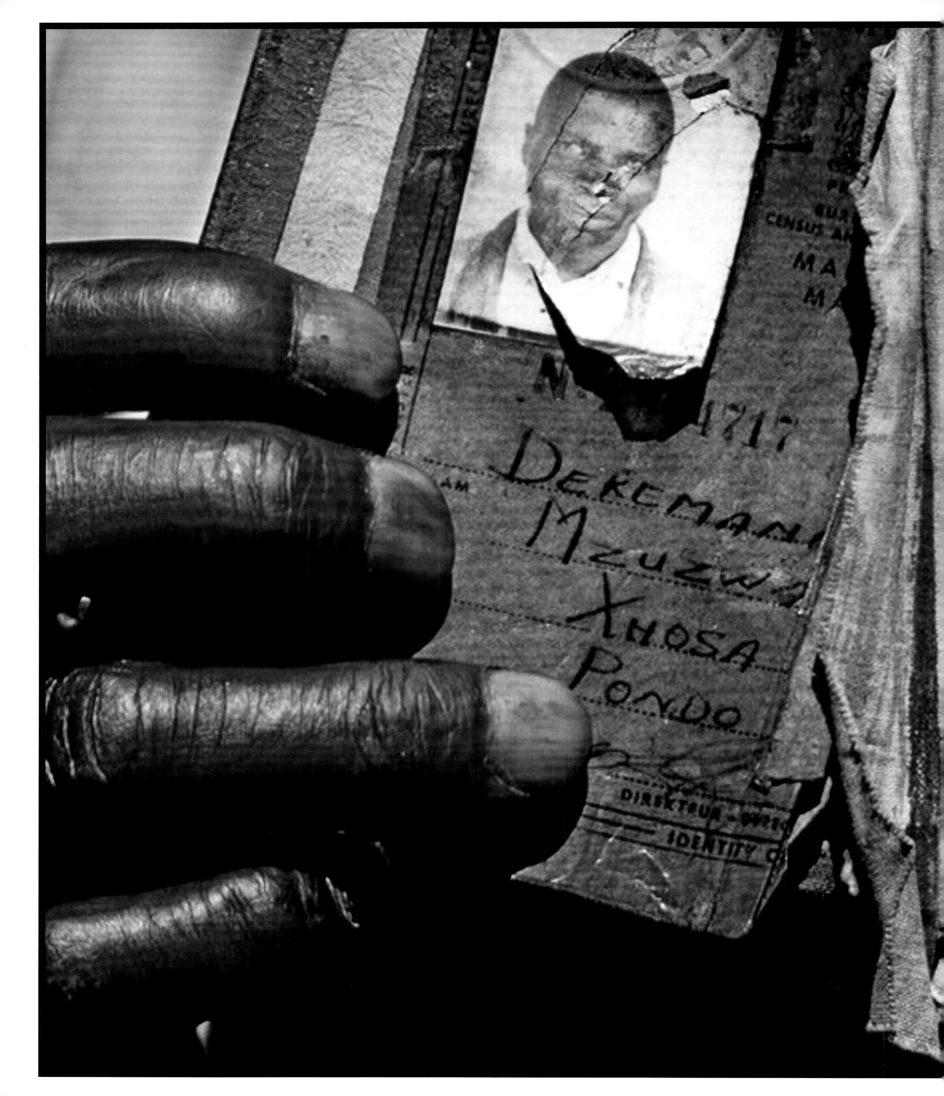

INDEX.—INDEKS.

A. Labour Bureau, Efflux and Influx Control and Registration.
Arbeidsburo, Uitstroom- en Instroom-beheer en Registrasie.
 (For official use only.)
 (Alleenlik vir amptelike gebruik.)

B. Employer's name, address and signature.
Werkgewer se naam, adres en hand-kening.

C. Union Tax.
Unie-belasting.
 (For official use only.)
 . (Alleenlik vir amptelike geb

D. Bantu Authorities Tax.
Bantoe-Owerhedebelasting
 (For official use only.
 (Alleenlik vir amptelik

E. Additional particular concessions in respect of law and custom, etc.)
Bykomende gegewe gunnings t.o.w. aa en gewoonte, en.
 (For official us
 (Alleenlik vir

G.P.-S.6464—1952-3—3,000,0

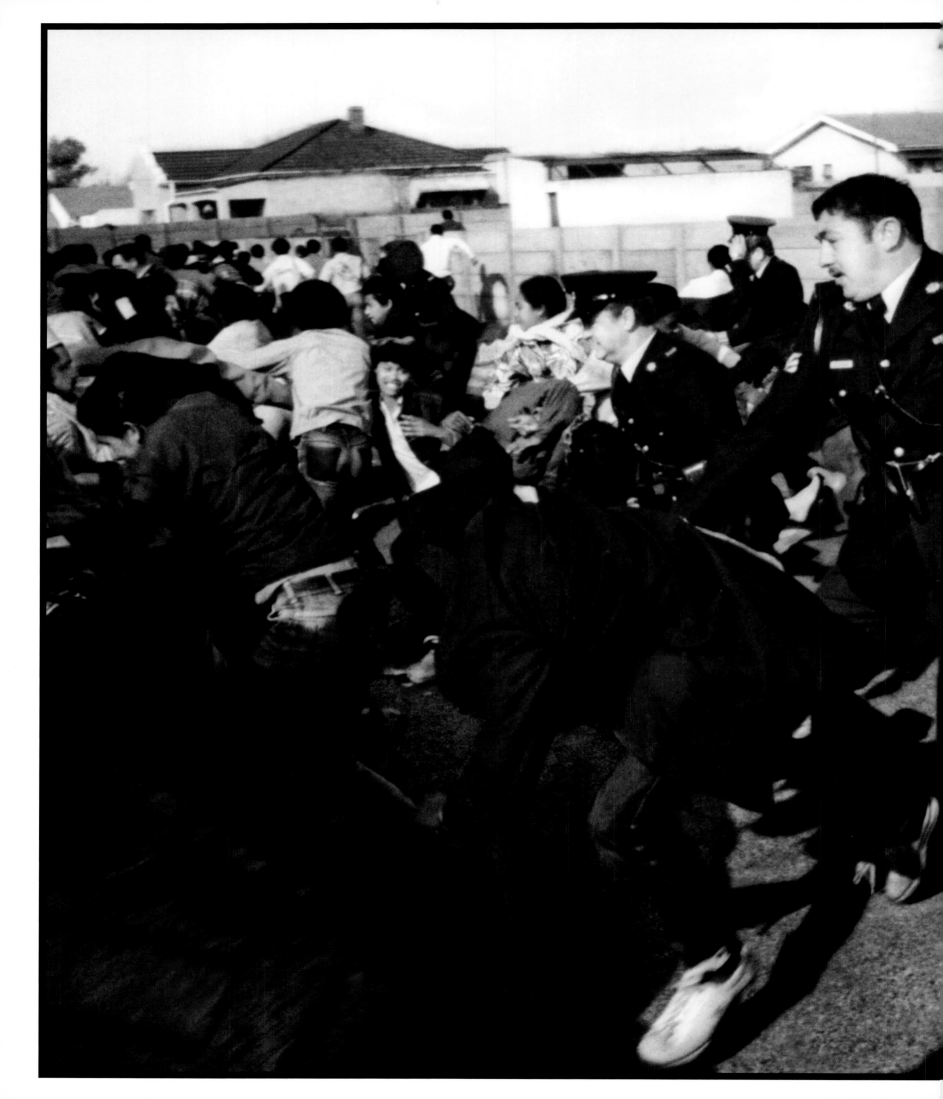

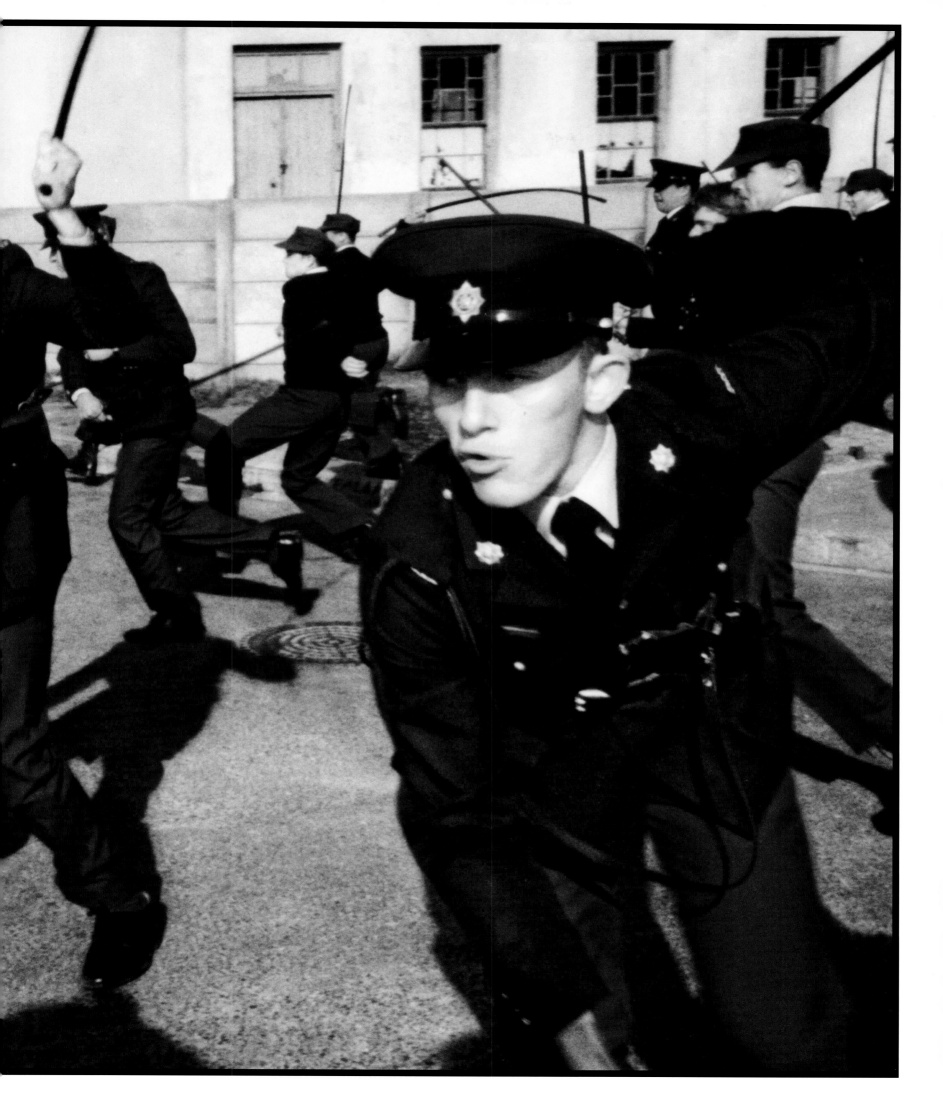

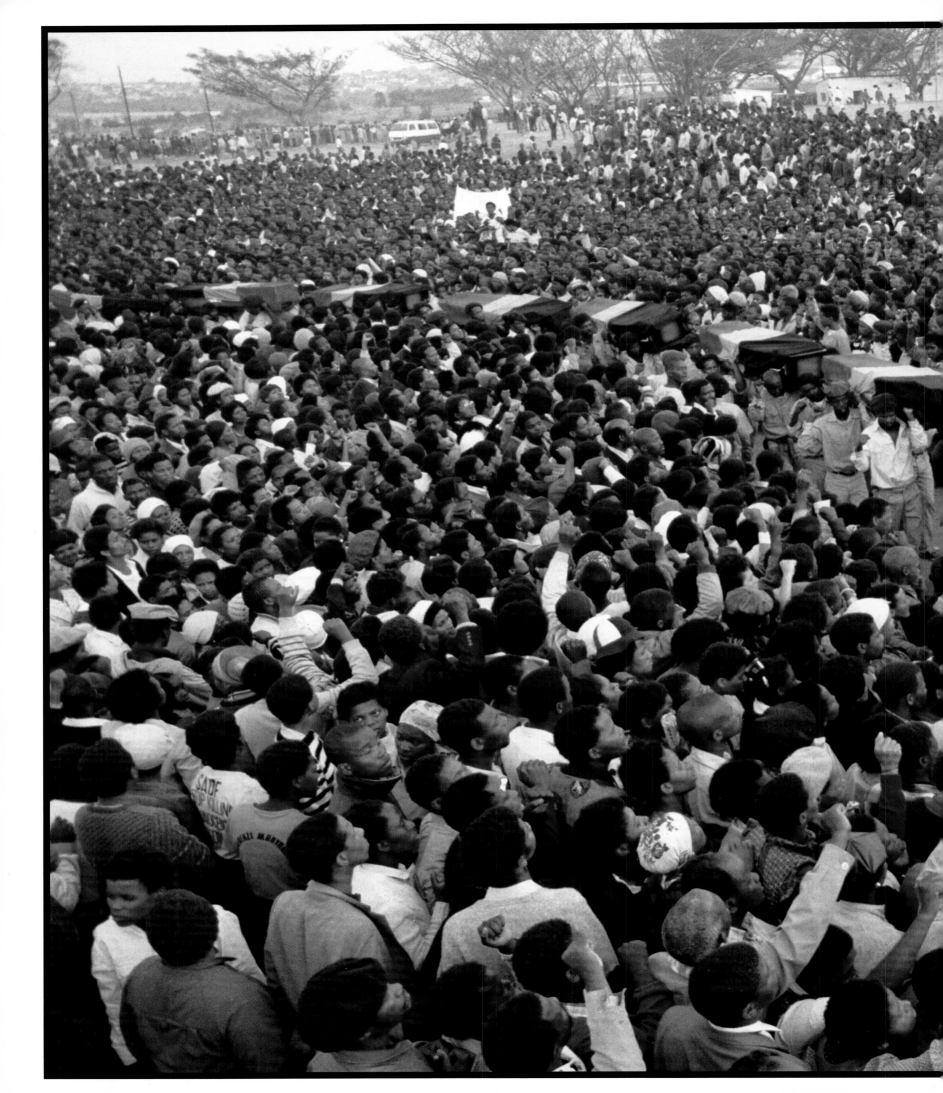

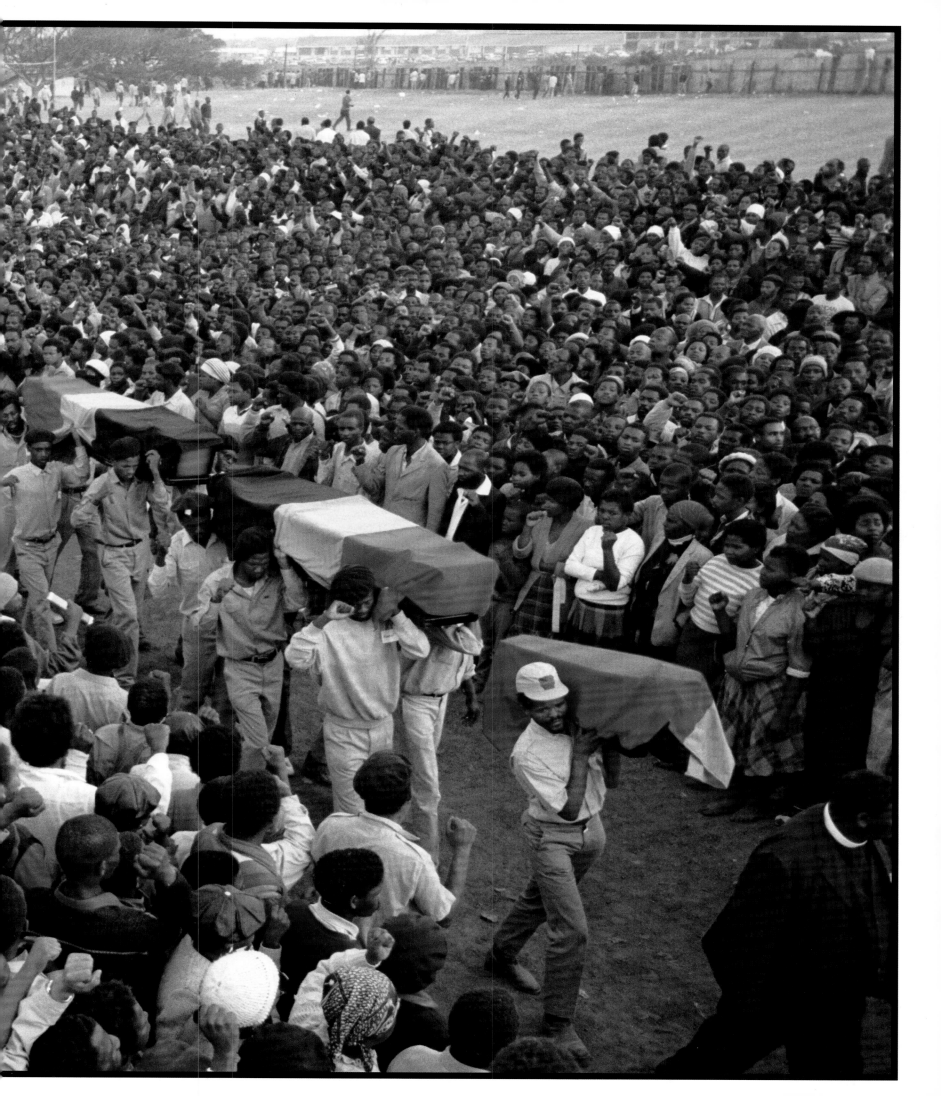

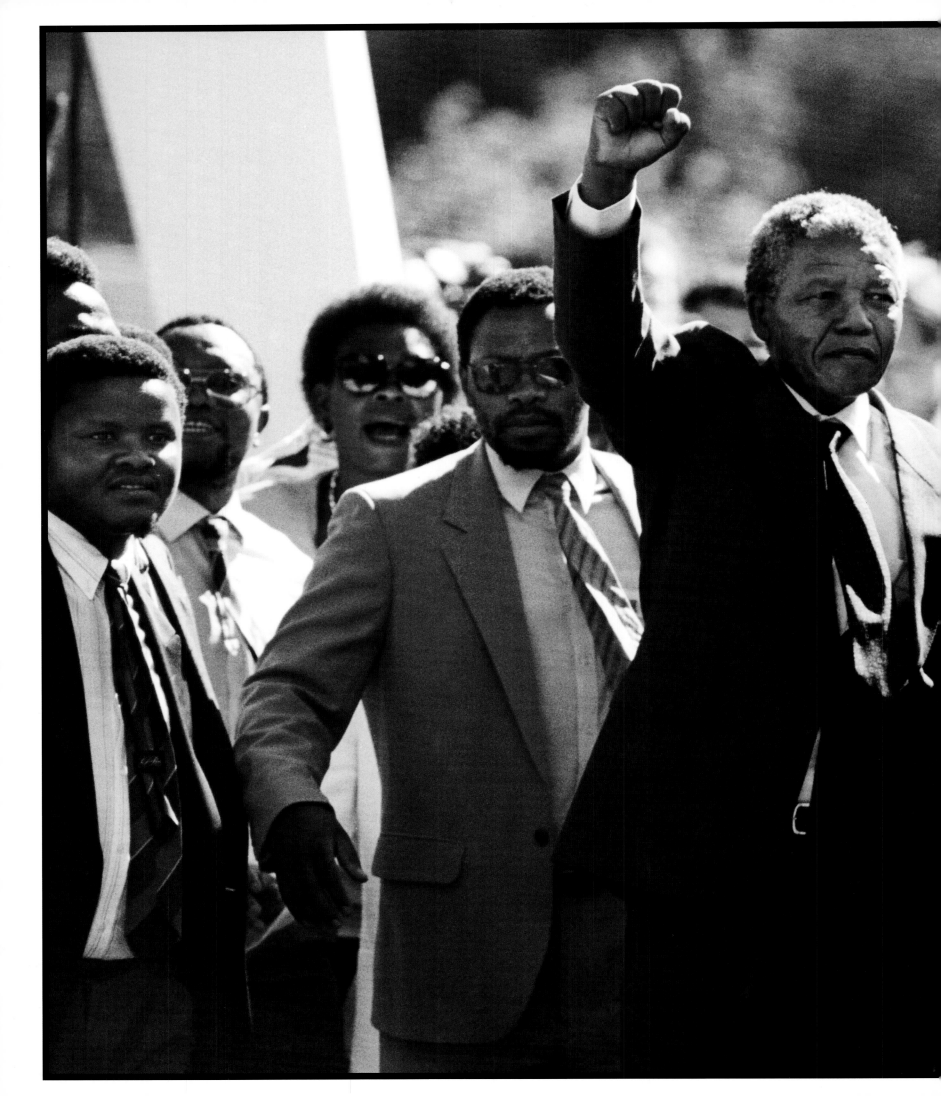

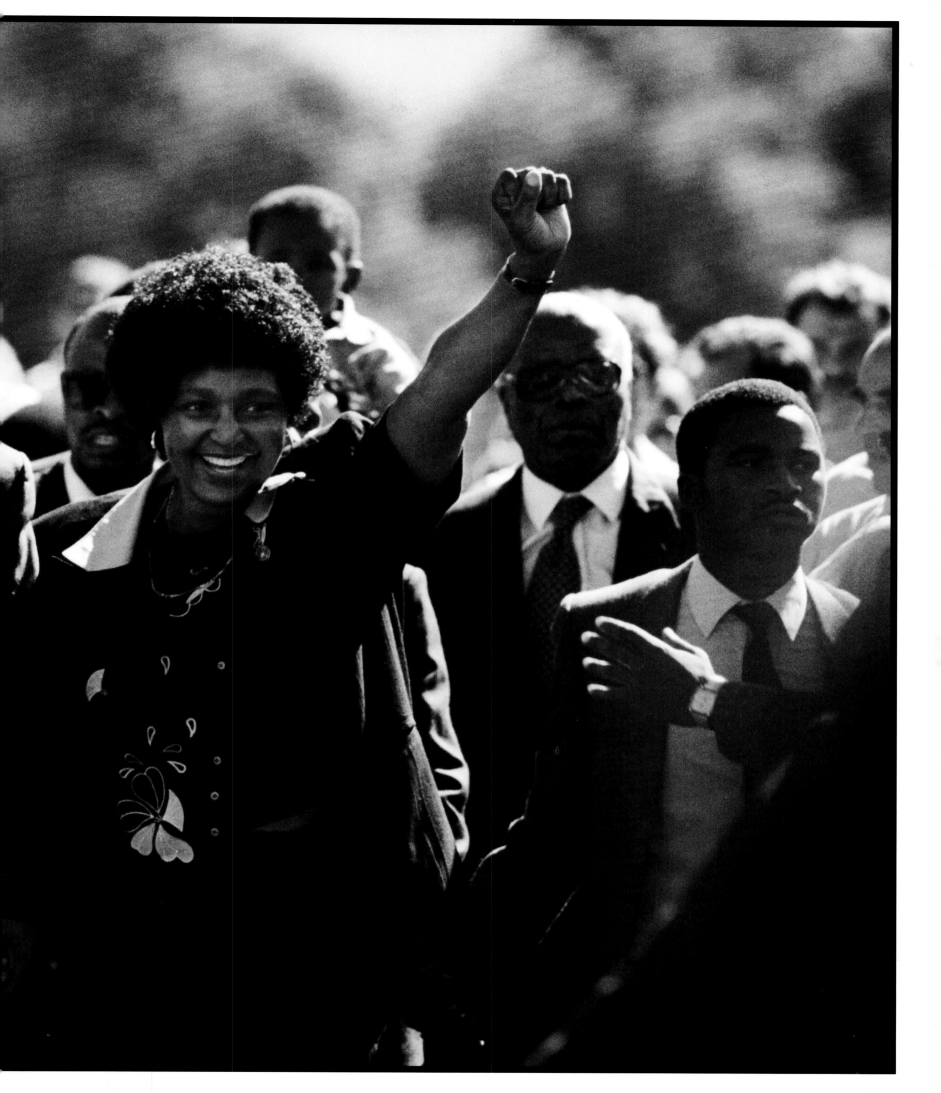

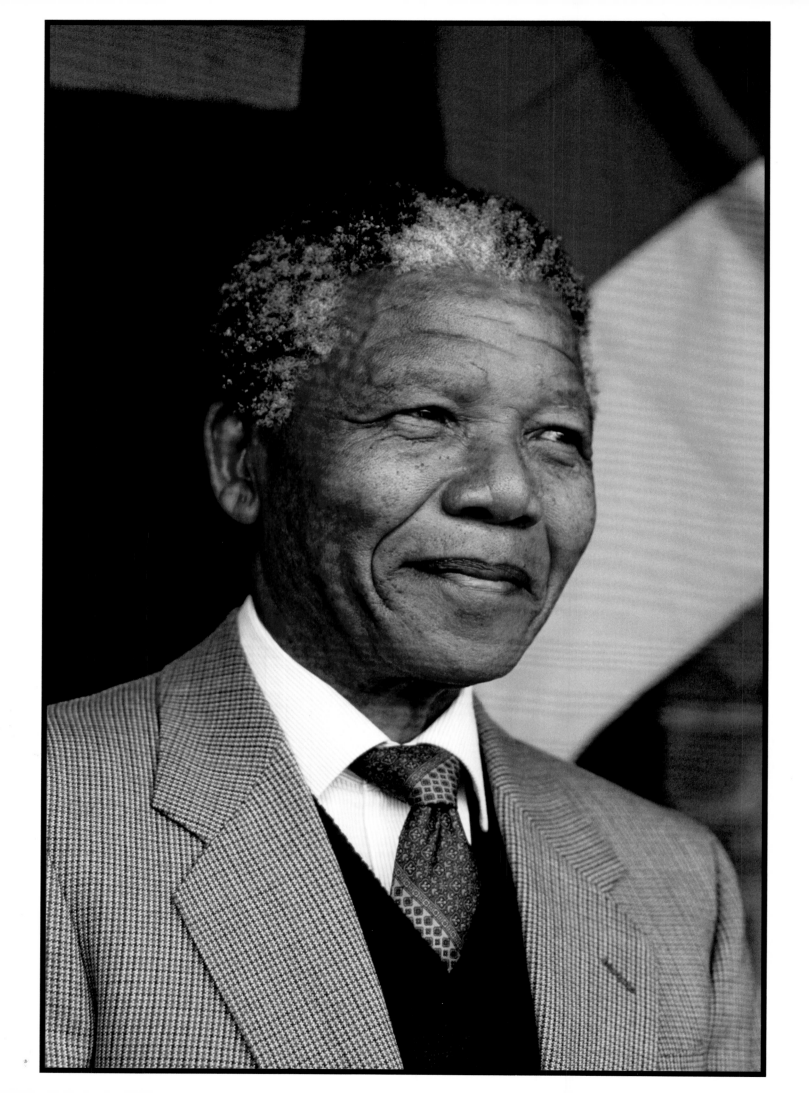

MANDELA! struggle & triumph

DAVID TURNLEY

Abrams, New York

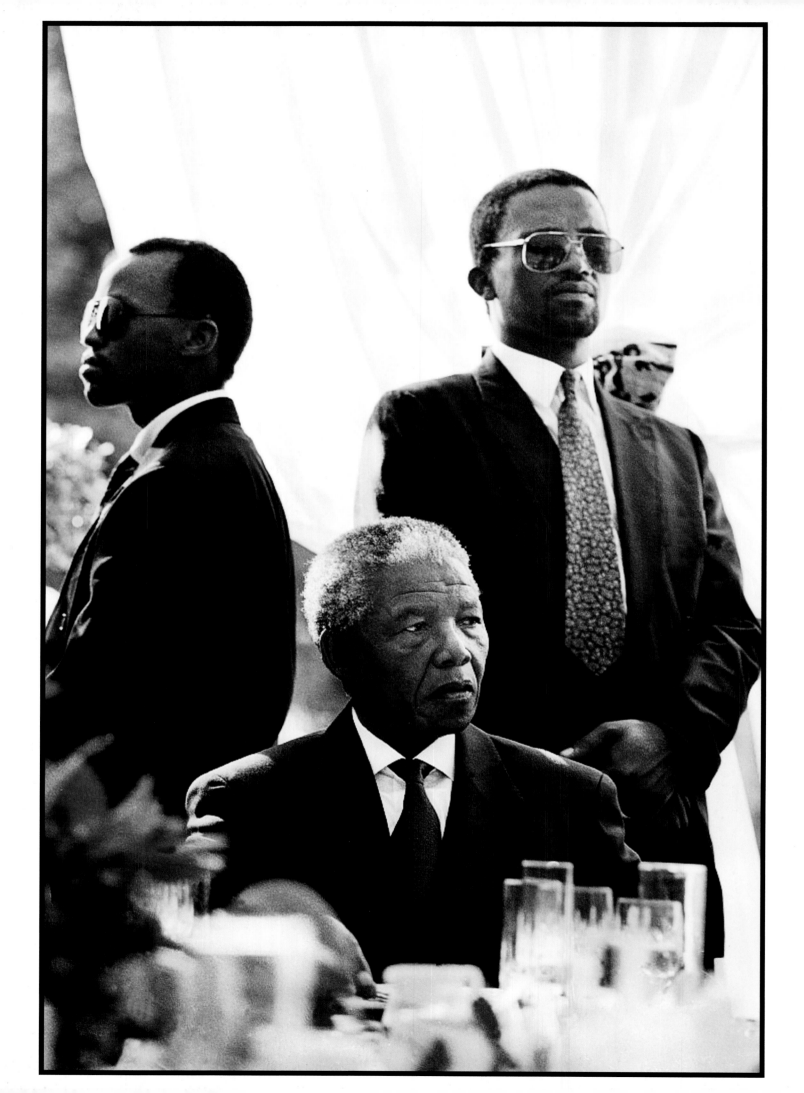

Nelson Mandela revisits the cell on Robben Island where he spent nineteen years, 1994.

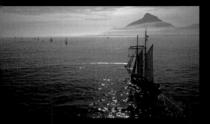

Yachts head out to sea from Cape Town in the Cape to Rio Race. The first white arrived in South Africa in 1652 by sea.

Women mourn at the wake for a black farmer who worked in the Orange Free State.

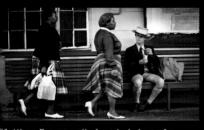

Matthew Pearce waits for a train home from Bishops, a private school in Cape Town, during the apartheid period. Though apartheid prohibited blacks from living in white areas, many worked in white homes.

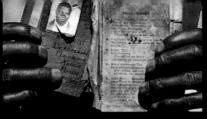

Under the Group Areas Act, all blacks had to carry passbooks like this one. One of the tenets of apartheid was that every black had to be a citizen of one of eight black homelands.

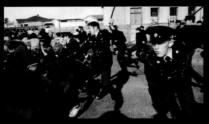

South African policemen use horsewhips to disperse protestors marching on Pollsmoor Prison, where Nelson Mandela was imprisoned. This was one of the events that precipitated the State of Emergency in South Africa in 1985.

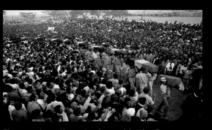

Thousands gather at a funeral in the Duncan Valley, a township outside of East London, in 1985. Mass funerals were the only places blacks were permitted to gather in a political fashion.

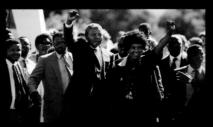

Nelson Mandela, accompanied by his wife, Winnie, leaves prison for the last time on

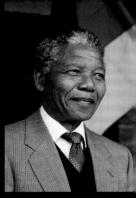

Mandela in Soweto, 1990, shor release from prison. Soweto is a township in southwestern Johan now simply a section of the cit

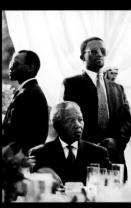

Mandela is seated at the state Pretoria held in honor of his ina president, 1994.

MANDELA'S CHILDREN

Over the course of the last quarter century, I have photographed the epic struggle to end apartheid in South Africa and the emergence of a new inclusive democracy in that country. This book is a testament to the privileged access that I earned over the years to the lives of President Nelson Mandela, his family, and his people.

Beyond his stature as an international icon of freedom and as a leader—some would say a savior—of his own nation, Nelson Mandela is perhaps the great underdog of the twentieth century. His life has inspired ordinary people around the world to persevere in their own struggles and to challenge whatever stands in the way of togetherness and human progress. With great magnanimity and his unique force of character, Mandela has shown us how transformation, rather than obliteration, can achieve lasting peace among enemies, and that even the bitterest foes can find, and share, common ground. As we struggle to meet the challenges that confront our world today, and those that will confront our children in the future, we can only benefit from the spirit of Nelson Mandela.

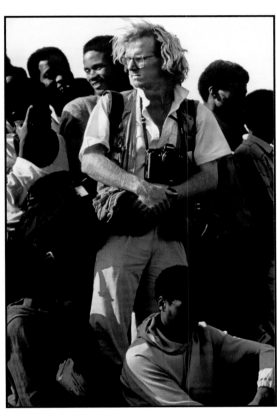

This photograph of me was taken by Sarah Leen in Duncan Valley township in 1985, during a funeral for apartheid protest victims.

I remember when I first heard of Nelson Mandela. Not coincidentally, it was also my first exposure to the word *apartheid*. It was the late 1960s, and I was a teenager at home in Fort Wayne, Indiana, seated at the dinner table, our family forum for discussing the events and ideas shaping our lives and the world. My parents believed that what really defines us is how we treat one another and the ideal of fairness. They taught me to dream of a world where, as Dr. Martin Luther King had said, "humanity is no longer tragically bound to the starless midnight of racism and war."

On this particular evening, it was clear that my father was uncharacteristically down. I asked him what was wrong. The local Rotary Club had invited two white South African speakers to address its meeting, and he had set up a one-man picket in front of the club's entrance. He had half expected the meeting to go on and the South Africans to be unmoved by the DOWN WITH THE APARTHEID REGIME placard he carried. What he hadn't anticipated was that none of the Rotarians would know what the word *apartheid* meant. He explained to us that apartheid was a legal system separating racial groups and preserving the white supremacy practiced in South Africa. He went on to say that a black South African named Nelson Mandela had been sent to prison for life for his struggle to end apartheid.

It was only during my sophomore year that my own high school became integrated. After football practice, my black teammates would board a bus that took them back to their homes in inner-city Fort Wayne, far removed from the suburban reality of my white teammates. In many respects, it was this divide, and a desire to see it transcended, that excited me when I fell into photography. With a camera I found a voice. I relished the idea of exploring unknown quarters of my hometown, propelled by curiosity and a deep belief in universal dignity.

I became a staff photographer at the *Detroit Free Press* in 1980. In the wake of the 1967 riots and the ensuing white flight to the suburbs, Detroit had become as beat-up and segregated as any place I would encounter in South Africa. I spent my time in Detroit trying to tell stories about people of color whose lives I felt deserved coverage. The first story I did for the paper was about an older black autoworker I met at a hotdog stand during his lunch hour. The man was named Henry Ford, and the story was titled "The Other Henry Ford."

As a white photojournalist in the post–civil rights era, my interest in such stories was not politically uncomplicated. Some of my black colleagues expressed proprietary feelings about stories germane to "their people." Though I understood their perspective, the notion of "their people" conflicted with my idealism.

In 1985, I proposed that the *Free Press* send me to South Africa to attempt to photograph everyday life under apartheid. I was convinced that the reality, the indignities, and the ambiguities of daily existence in South Africa also spoke to the tragedies of segregation and prejudice in my own country.

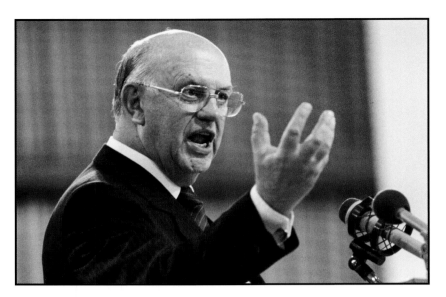

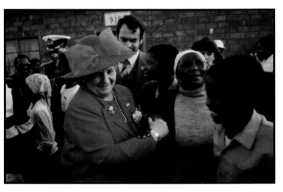

President P.W. Botha (top) delivers his "crossing the Rubicon" address at a National Party meeting in Durban in 1985.

Elize Botha, wife of P. W. Botha, visits a blacks-only hospital in Soweto in 1987.

Upon my arrival in South Africa in August 1985, I flew immediately to Durban for a meeting of the National Party, the ruling party that had conceived and implemented apartheid in 1948. Durban had the largest population of Indians outside of Asia at the time, and I visited the township, on the outskirts of the city, that had been home to Mahatma Gandhi at the beginning of the twentieth century. Beyond implementing the separation of blacks and whites, apartheid demarcated "group areas" for specific ethnicities. The Indian township was ablaze with violence and street battles that had spilled over from an adjacent black township that day, and the evening proved to be an infamous one in the history of the country. In what was expected to be a reconciliatory speech, then president P. W. Botha delivered what became known as his "crossing the Rubicon" address, announcing to the country and the world with hard-nosed intransigence that apartheid was here to stay.

In the aftermath, townships and cities around the country erupted in a barrage of violence and outrage, further intensifying the state of emergency that had been declared. Over the next several months, I followed the constant flow of protest across the country, attending demonstrations, prayer vigils, street marches, and the invariably violent confrontations between the police and the predominantly black protesters. Too often these situations would end with the police opening fire into crowds refusing to disperse. All political parties and gatherings had been declared illegal, and as a result, massive public funerals for slain protestors were the lone venue where those in the struggle against apartheid could gather, mourn, and express their collective solidarity without fear of suppression.

Traversing the country, I was able to access all racial groups and was welcomed into diverse communities. I was humbled by the goodwill I was shown by blacks and whites alike. Even with the mood of oppression and fear that pervaded the country, everyday dialogue, especially on topics like race and class, was far more open and unfeigned than I'd encountered elsewhere. Few subjects were taboo: People spoke their minds without looking over their shoulders; and those who made their opinions—even their prejudices— known seemed to be held in greater respect than those who concealed their feelings.

Before my arrival, I hadn't the foggiest notion that Cape Town was so beautiful. It's no wonder that in 1652 the first Dutch to arrive got off their ships and decided never to leave. On the beach one Saturday, I was overcome with guilt as I realized that not only were all the people around me white but there was a sign declaring the beach for whites only. I struck up a conversation with a young woman who told me her family was Jewish and that they had emigrated from Lithuania in the 1920s, during the time of Stalin. I asked her how she, coming from a background of persecution and a persecuted people, could enjoy lying on this whites-only beach. Her response was revealing: "I guess this proves that we are all human."

As I spent the next three years covering the bifurcate reality of South Africa, the sentiment she expressed that day became my overriding realization. I sprang out of bed each morning energized to make the strongest images possible, feeling compelled to do what I could to not only show that apartheid was unquestionably wrong, but also to reveal the tragedy and limitations of prejudice wherever it was felt.

In early 1986, I was doing an essay on one of South Africa's most prominent anti-apartheid activists, the reverend Allan Boesak. After we had traveled together for some time, Reverend Boesak asked me late one evening to accompany him to a small motel outside of Durban. It was only when we arrived that I realized we were attending a leadership meeting of the underground anti-apartheid movement; had the police learned of the gathering, everyone would have been arrested. As we entered, Winnie Mandela swept in, accompanied by a black South African photographer named Peter Magubane.

I had first encountered Peter when he presented his work at a National Press Photographers seminar in Cleveland, Ohio. He had spent more than five hundred days in solitary confinement for his images of the 1976 Soweto uprising, and I had been so moved by his quiet audacity and his determination to bring to light his generation of South Africans—men and women prepared to die rather than continue being dictated to; capable and courageous people who sought simply to be considered human beings. Peter had grown up in Sophiatown and ran in the same activist circles as the Mandelas. He covered them as a photographer for *Drum* magazine. When the authorities put Winnie Mandela in solitary confinement for two years, with Nelson Mandela already imprisoned, it was Peter who took care of their daughters, Zenani and Zindzi. During the volatile stretch of

time that marked my first months in South Africa, I had crossed paths with Peter in the townships on a number of occasions; seeing him always inspired me to continue with the work I was trying to do. Though I looked forward to an eventual face-to-face exchange, I felt that I would first have to earn his respect.

It now seemed, at last, that my chance had arrived. At this clandestine African National Congress (ANC) gathering, we were allowed to photograph for several minutes and then asked to go outside. That I had been trusted enough to be brought along to such a meeting may have given Peter a sense that there was something to me. He invited me to follow him into Durban, and we spent the night wandering the streets together. I still vividly remember one of the first things Peter said that night. "David, there is only one thing you need to know to work as a photojournalist in this country. Don't talk. Listen. And if you do talk, don't say anything." It was a valuable lesson, and certainly not the last bit of wisdom I've gained from observing Peter Magubane approach the world. He and I went on to become close friends and colleagues, keeping rooms next to each other in the Carlton Hotel in Johannesburg for the next two years. This hotel, one of the few places where people of all races and nationalities could mix freely, had evolved into something of a hub for the city's local and visiting intelligentsia. On any given day, one could find oneself seated beside Ismail Ayob—Nelson Mandela's lawyer—or Winnie Mandela, or any one of a number of academics, visiting politicians, and journalists, the latter of whom often came to banter with the black waitstaff for their daily reports on the townships.

In many ways, my relationship with Peter Magubane came to embody for me what South Africa could be.
Two colleagues from entirely different backgrounds, we shared not only the complexities of our competitive profession but also similar values. We believed in working hard and being considerate in whatever we did; we believed in the pleasure of humor, in humility, and we had a deep love of photography, which I think both of us recognized as a gift that had landed in our laps. We frequented restaurants together—on expense accounts from our respective publications—and we gleefully observed the confusion and discomfort of white patrons and black busboys alike over seeing the two of us have so much fun together.

My life took another fortunate turn one rainy Sunday in Johannesburg, when I met a beautiful olive-skinned South African woman named Karin Louw, as she waited to meet her parents for coffee in a hotel lobby. She described her father as an architect and a farmer. It wasn't until sometime later that I learned that this "farmer," in fact, was the descendant of the mistress of the first governor of the Cape, Simon van der

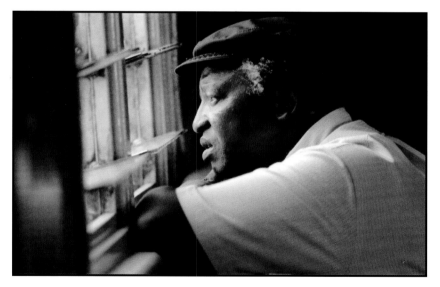

Photographer Peter Magubane.

Stel, and that Karin's family lived on the oldest wine estate in South Africa, at the foot of the Constantia Mountains in the Cape Town suburb of Tokai. Ironically, it was her grandfather who had sold the state the land, a few thousand feet from her home, on which Pollsmoor Prison—where Nelson Mandela was incarcerated—now stands. Karin and I were married (now divorced) and became the proud parents of a son, Charlie, who presently attends school just steps away from the spot where Mandela spent more than a decade in jail.

Later that year, *Life* magazine asked me to photograph Winnie Mandela, to whom I had been introduced by Peter Magubane. At that time, Winnie had become, along with Archbishop Desmond Tutu, one of the most articulate and vocal anti-apartheid leaders in South Africa. Her beauty, her welcoming presence, her clearheaded composure, and her elegant, unfailingly honest way of speaking were absolutely captivating and were surely qualities that had captured Nelson Mandela's heart during their courtship. Winnie's life seemed to be inseparably intertwined with the anti-apartheid movement. Beyond paying daily visits to the homes of so many people suffering under the weight of apartheid, she was much sought after by the international press and foreign delegations, who wanted to pay their respects and hear her opinions. To black South Africans, Winnie Mandela was the mother of the nation; in the eyes of the world, as her husband remained unseen in prison, his words unheard, she was the public face of Nelson Mandela.

From the moment I was introduced, largely because of my friendship with Peter, I was made to feel like a friend of the family. When I wasn't on assignment, I often went to visit Winnie simply to chat, sometimes staying to babysit her grandchildren or to converse with her daughter Zindzi and her friends. In the family's one-room home in a section of Soweto called Orlando West, there was only one small picture of Nelson Mandela. Clipped from a newspaper, it was a photograph that had been taken when he was going

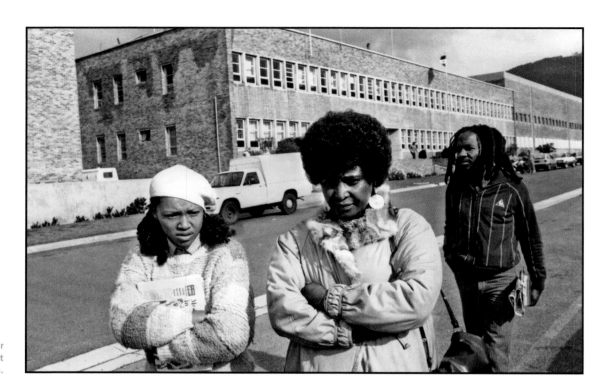

Zindzi and Winnie Mandela leaving Pollsmoor Prison in Cape Town, where they have just visited Nelson, mid-1980s.

underground to seek funding and military training for Umkhonto we Sizwe, the military arm of the ANC, in the early 1960s. In the picture, Mandela had a beard and a part in his hair, and formidable broad shoulders reminiscent of the boxer he once was. Often Winnie would hold her grandson, Gaddafi, on her lap and tell him about his absent grandfather.

While the crisis that had engulfed the country continued and South Africa appeared more and more on the verge of exploding into total bedlam, Winnie made the trip to visit her husband in prison at least once a month. I asked if I could go along sometime, at least to enter the prison and wait with her and her daughters in the waiting room. She consented, and I accompanied her in the guise of a lawyer. When we entered the prison, we were screened by security and led to a nondescript waiting room. Eventually a warden appeared and led Winnie away to the visiting room. After about an hour, she reappeared at the doorway. She was motioning me to come forward. At first I was baffled by her gesture, but I quickly figured it out and approached her. She whispered that I should look down the corridor to the right. I peered in that direction and saw, in the darkness of a dimly lit corridor, a very tall black man in his prison attire, standing between two prison guards. Though I could not really see his face I knew it must have been Nelson Mandela. As we returned to the car, Winnie told her daughters to look up at a certain window—there was a hand waving good-bye. It was Mandela's custom to wave from this very same window at the end of each visit. I recall how concerned Winnie was as we drove back to the Cape Town airport that afternoon. During this period of his captivity, the prison wardens were taking Mandela on excursions throughout the Cape, allowing him to walk through a park or along a beach. No one seemed to recognize him—there had not been one photograph of him in more than twenty years—but it made her uneasy. She was gravely concerned that the government was setting up an incident where it could look as if he were inadvertently killed.

I asked her how she felt when she saw him. Winnie always said that she loved Nelson as her husband and respected him as her leader. She looked pained to acknowledge that the system of apartheid, their struggle, and his imprisonment had left them very little time together over the course of their marriage. She felt it was her mission to carry the torch of his ideals and keep everything he stood for alive. The struggle really was—through and through— Winnie's life too.

In the course of my work in South Africa, I was arrested more than a dozen times, simply for doing my job. Like so many others who operated in and around the anti-apartheid movement, I worked under the assumption that I was being monitored and came to expect harassment and intimidation. I'll never forget the night in early 1987, when, figuring it might be my newspaper calling at such a late hour, I awoke to pick up the phone. "Mr. Turnley?" a man inquired in a hoarse voice thick with the tint of Afrikaans. "If I were you, I wouldn't be so concerned with Winnie Mandela." He hung up, and though I knew the tactic, I was still shaken.

This was during the height of a strong crackdown on dissidents, activists, and members of the media thought to be sympathetic to the anti-apartheid movement. The week before, an activist had been driven off the road and killed in what had been officially ruled an accident, though it was more than obviously not.

A few weeks later I was arrested as I accompanied a group of white South African women, activists in a protest group known as Black Sash, on a visit to New Brighton Township, outside of Port Elizabeth. This area, the center of what's known as the Eastern Cape, had been one of the most militant and one where the police responded with the strongest force to counter any challenge to their authority. After some time alone in a jail cell, I was led to a windowless room and greeted by a police interrogator offering me a warm cup of tea. It seemed a transparent attempt to soften me up before he began his probing questions. He asked me who I knew in the township, but I refused to offer up any names. At that point he left the room and a robust young man with blond hair and ice-blue eyes, wearing civilian clothes, came into the room. With cold sternness, he made it clear that they weren't playing games and would summarily take necessary physical action if I didn't cooperate. I repeated my position and requested a lawyer. After a few uncertain minutes I was led to a telephone and, presented with a phone book, told that I could make one call. I looked through the Yellow Pages and found the number of the Port Elizabeth Legal Resources Centre, where I reached a man who listened attentively as I rattled off the details of my predicament. Without hesitation he assured me that he would be there within minutes to secure my release.

About a half hour later the cell door opened and I was told I was free to go; the lawyer I phoned had paid my bail. Outside, I was greeted by a handsome black man in a sharp suit who introduced himself as Fikile Bam. Later, over coffee, he told me about himself; he had spent ten years as a political prisoner on Robben Island and, for much of the time, was held in the wing they called "the University," with Mandela. When I asked him what it had been like, he said it was hard to explain, but the level of intellect and commitment among the political prisoners was so high he had considered it a bright time in his life. In many ways, his spirits had been higher on the inside than on the outside. The political prisoners, all members of the ANC, believed in active debate as a political philosophy, and he recalled with fondness how, each day, they would each take the other side of an issue in a vigorous argument. They were committed to a vision of a secular, multiracial republic and were preparing to create a new constitution, with democratic architecture, for a new South Africa.

The next day Bam got my arrest removed from the record. Indeed, a new day was not far off—though my time in South Africa would soon be cut short. Despite the protests of my newspaper and the American embassy in Pretoria, on November 30, 1987, the South African government revoked my press credentials and expelled me from the country.

When I returned to the United States, I was asked to put on a thirty-minute slide show for the National Press Photographers Association. I spent nearly a week locked away in a room, simultaneously decompressing and furiously preparing my presentation, getting little sleep. Following my procession of images, set to South African music, I projected the now well-known words that Mandela uttered in the dock on April 20, 1964, at the beginning of the case for the defense in the Rivonia Trial, which ended in his conviction for treason and sentencing to life in prison:

Below: Winnie Mandela holds her grandson, Gaddafi, up to a newspaper clipping with a photo of Nelson taken in the early 1960s on the wall of her home in Orlando West, mid-1980s.

Right: Winnie waits with her daughters, Zenani and Zindzi, for a visit with Nelson at Pollsmoor Prison, mid-1980s.

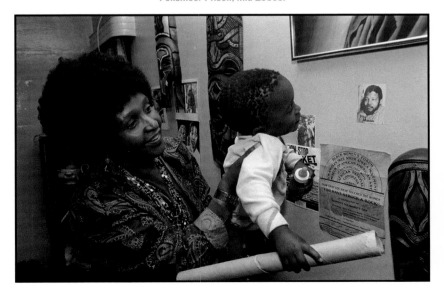

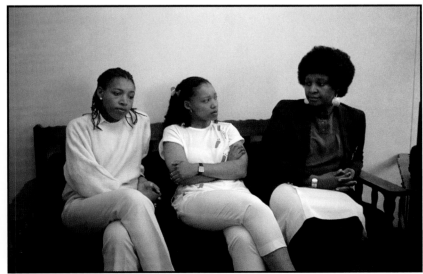

"During my lifetime I have dedicated myself to this struggle of the African people. I have fought against white domination, and I have fought against black domination. I have cherished the ideal of a democratic and free society in which all persons live together in harmony and with equal opportunities. It is an ideal which I hope to live for and to achieve. But if needs be, it is an ideal for which I am prepared to die." The next time I would hear Mandela's words they would be spoken by Mandela himself.

After I was forced to leave South Africa, Paris became my home and my base for covering the world as a photojournalist. With the dissolution of the Soviet Union, the fall of the Berlin Wall, revolutions in Eastern Europe, and the student movement in China, strong winds of rebellion and reform were sweeping through the world. It was a hopeful time.

Then, one January afternoon in 1990, I got a surprise phone call from a high-ranking diplomat at the South African Embassy in Paris, asking me to lunch. I agreed to the meeting—albeit with the caution and skepticism I'd been conditioned to exercise in my interactions with apartheid officials. As I sat with the affable Afrikaner at the fancy restaurant of his choosing, he revealed his motive for contacting me: "Things are about to change in my country, and we need people with credibility like yours to go back and cover those changes." I was suspicious at first—I'd come to regard my expulsion from South Africa as something of a compliment—but as he continued, my heart rate began to increase. Naturally, I told him that I'd love to go, but on two firm conditions: First, that I be able to travel and record what I saw without any restrictions or interference; second, that he let me buy lunch.

He was more reluctant to agree to my second stipulation than my first, and soon after we parted, I was en route to South Africa, visa in hand. When news broke the following week that Nelson Mandela was going to be released from Victor Verster Prison after more than ten thousand days in captivity, I was on a flight to Cape Town within the hour. Mandela had become a universal symbol of freedom for South Africans and millions of others around the world.

At dawn on Sunday, February 11, after driving through the glorious vineyards of Cape Town, I arrived at the prison gates to find many photographers already on the scene. A group of us went to greet the police standing guard. We really knew it now: The rules of the game were about to change. These police, from whom many of us had come to expect hostility and harassment, showed a new deference to our requests. We politely established that we would create a photographers' pen in front of the prison gates and that we would maintain proper decorum. They politely agreed.

By 7:00 A.M., in the blazing heat of the South African summer, there were dozens of photographers standing side by side, each of us the tenant of a very small piece of land—from which we would not

The motorcade carrying Nelson Mandela from prison to the Cape Town City Hall is marooned in a sea of people, February 11, 1990.

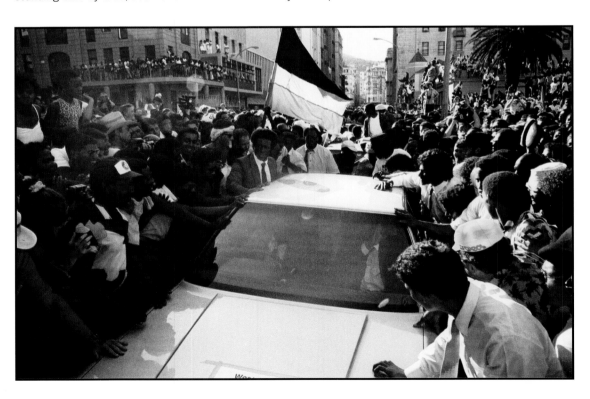

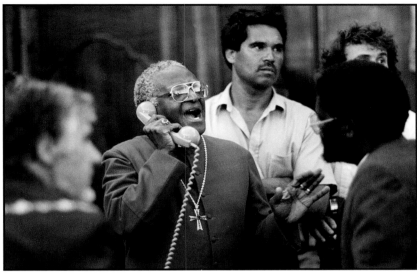

and could not move for the next nine hours. The release was scheduled to occur at 3:00 P.M., but the planes sent to collect Winnie Mandela and Walter Sisulu—Nelson Mandela's cell mate of nearly twenty-seven years, freed four months earlier—were delayed. With the deafening sound of helicopters circling above the prison adding to the intensity, thousands of people gathered to get a glimpse of their hero. Finally, at nearly 4:00 P.M., through the long photographic lenses that we kept focused like lasers on the prison gates, we saw a group emerging from deep inside the prison grounds. The crowd began to roar with euphoria and celebration, and as the prison gates opened we spotted at the center of the entourage, holding hands with his wife and right fist raised in the air, a smiling Nelson Mandela. In a shutter-flash, the "invisible" leader returned to steer his country into a new era.

I was able to shoot about three frames before the crowd broke in front of our photographic pen and Nelson Mandela sped away in a motorcade, headed to the center of Cape Town to join a grand parade in his honor. More than half a million South Africans of all hues and affiliations were waiting to see the man they affectionately called "Madiba."

I reached Cape Town City Hall ahead of Mandela's motorcade and found a mighty sea of people pressing forward to see him. When he arrived, the crowd surged and began to shake his car from side to side. It was beyond loud, and I so seriously feared that I might be crushed to death that I pulled myself onto a man's shoulders. From there I managed to get across the crowd, grabbing on to the building's balcony to pull myself to safety. Once there, however, I felt a new sense of desperation as I realized that I was totally out of position to see Mandela emerge from his car. I sprinted into City Hall and down the first corridor I came upon, hoping to find a window from which I could photograph the scene. I opened the first door I came to and looked inside. Staring back at me was the archbishop Desmond Tutu. Behind him were Walter Sisulu and his wife Albertina, the reverends Jesse Jackson and Allan Boesak, the mayor of Cape Town, and several others. In my sweat-soaked panic I had serendipitously stumbled upon Mandela's reception committee.

Archbishop Desmond Tutu (above, top) gets Mandela on the phone from a room in the City Hall: "Papa, you have to come and show yourself to your people."

Nelson Mandela greets his reception committee. To his left is Gordon Oliver, the mayor of Cape Town.

Tutu, with whom I'd developed a personal friendship while working on a story for *Life*, motioned me in, and I took a place quietly in the corner. The room stirred with the collective anticipation of Mandela's arrival. Suddenly the phone rang. Though the cacophony from the crowd still blared, the room went silent. We heard the archbishop say, "Papa, you have to come and show yourself to your people at least for a few minutes, or I'm afraid they will tear down the city tonight." And then, "OK, we will wait for you." He put down the phone and informed us that Mandela, thunderstruck by the intensity of the crowd after so many years of isolation, had asked to be driven away.

Time passed, and then the door opened and in walked a youthful, formidably built (at six-three) seventy-one-year-old man—with a radiant smile. Nelson Mandela, accompanied by his wife and daughters, had been driven to the rear entrance of City Hall, where the crowd was thinner. Everyone in the room came forth to greet him, and in each case he was totally in command, with a laugh and words that made each person feel important. After several minutes, in the midst of the ebullient chatter in the room, Archbishop Tutu began striking a glass with a spoon in a call for silence. He looked straight into Mandela's eyes. "I just need to tell you what your life has meant to me," he began, launching into a heartfelt soliloquy that brought everyone to tears.

As Tutu finished, Mandela, with gracious thanks and begging the room's pardon, excused himself. "I think I have to go and talk to my people now." He walked toward the window, opened it, and climbed out onto the balcony to address South Africa and the world for the first time in twenty-seven years.

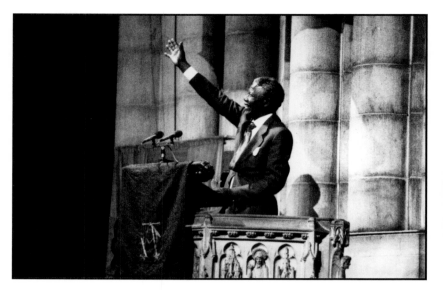

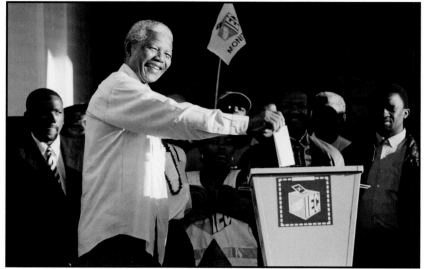

Above: Nelson Mandela speaks from the pulpit of New York's Riverside Church in June 1990.

Right: Nelson Mandela casts his vote in the 1994 South African national elections.

When he came into view, thousands of South Africans raised their fists in unison and began to sing "Nkosi Sikelel' iAfrika," the anthem of the anti-apartheid movement. Tears ran down Winnie's and his daughters' cheeks as they gazed down at the overpowering sight. Mandela closed his speech with the stirring conclusion of his 1964 court address.

Some four months after his release, Nelson Mandela, along with Winnie, made his first visit to the United States. Peter Magubane and I joined their entourage, which included Harry Belafonte and a number of American politicians and civil rights activists. The Mandelas were greeted by hundreds of thousands of exultant Americans in each of the eleven cities they visited. For the duration of the trip, Trump Airlines provided an African American pilot to fly Nelson Mandela across the country. Though we never heard a word from the pilot during the flight, he was at the door saluting Mandela as we disembarked at each stop. Our group had become very tightly knit by the end of the tour, bonding in a mutual awareness of how fortunate we were to accompany one of the great men of our time on such a historic journey. As we prepared to land at Dulles Airport in Washington, D.C., from where the Mandelas would return home to South Africa, a voice came over the loudspeaker for the first time: "Mr. Mandela, I would just like to tell you what an honor it has been and how proud I will always be to tell my grandchildren that I flew Nelson Mandela across America." And then the Boeing 727 made a pillow-soft landing.

Though much began to change in South Africa after Nelson Mandela's release, the formal end of apartheid and a peaceful beginning to a pluralistic, democratic, unified republic did not happen overnight. Like nearly everything else in Mandela's life, his path to the presidency was a hard-fought struggle, achieved with pride, grace, and a steadfast resolve in his hopes for a brighter future. All this made April 27, 1994, the day of the first-ever democratic elections in South Africa, all the more monumental.

To document the occasion, I devised a whirlwind tour of key locales I thought reflected the "Rainbow Nation," as Archbishop Tutu had nicknamed his new multicolored country of South Africa, for myself, my twin brother, Peter Turnley (then a photojournalist with *Newsweek*), and correspondents from our publications. Chartering a Learjet for the day, we began in Durban, where Mandela cast his vote that morning, and then flew to the Transkei to take in the scene outside the polls in Mandela's natal village of Mvezo. In the afternoon we first visited a so-called coloured township in the wide-open countryside of the Karoo, and then a farming town and Afrikaner stronghold in the country's heartland. Next it was on to the polling stations in Tokoza, one of the most militant black townships east of Johannesburg at that time; we finished the day at the voting box in Sandton, an affluent white suburb. It was one long celebration, and though the election results were something of a foregone conclusion, the euphoric atmosphere would only be trumped by the official announcement that Nelson Mandela had been elected president by a landslide.

Still curious to know more about the place where Nelson Mandela was raised, I traveled to Umtata, in the Transkei, driving the thirty-odd miles to the serene pastoral village of Qunu where he spent much of

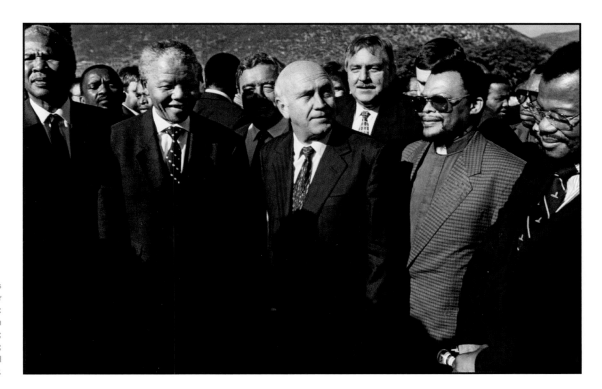

Warring political leaders commit themselves to a peaceful reconciliation of their differences on the eve of national elections: Zephania Mothopeng of the PAC, Nelson Mandela; State President F. W. de Klerk; Pik Botha, South Africa's Foreign Minister; Reverend Frank Chikane of the ANC; and Chief Buthelezi of the IFP.

his boyhood. It would be hard to imagine a place any more different from the urban environments where Mandela went on to live; amid the rolling verdant hills dotted with *rondavels*—the traditional round dwellings of southern Africa—time seems to waltz, rather than fly, by. Watching children herd sheep and cattle under a wide-open, deep blue sky brings to mind Mandela's affectionate description of the wonder and playfulness that marked his own idyllic country childhood. On this day, a group of women were celebrating the return of several sixteen-year-olds who had just come back from the bush after ritual circumcision. I asked them their names—many of them were Mandelas. On a hillside far from where the tour groups stop to see Mandela's place of birth, a sweet elderly man led me to a small cemetery where his parents and many members of his extended family lay buried. It is here that Nelson Mandela will one day come to rest.

I last saw Nelson Mandela at Christmas 2005. Having retired from public life, he was spending most of his days at home in Johannesburg, enjoying the company of his wife of eight years, Graça Machel, and his many children, grandchildren, and great-great-grandchildren. The former South African rugby captain François Pienaar and his two young boys came by to pay their respects. Mandela and Pienaar had first become acquainted at perhaps the most pivotal moment of unity after Mandela's release from prison. Though Nelson Mandela and the ANC made it clear that all South Africans, regardless of color, had a place in the new country, many white South Africans remained concerned for the future, unconvinced about the sincerity of

Mandela poses with the two sons of former South African rugby captain François Pienaar, 2006.

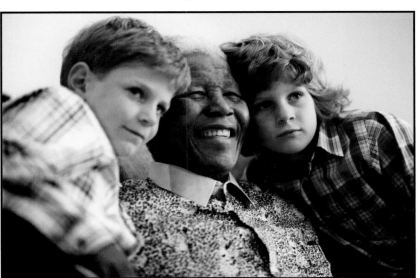

such promises. The South African rugby team was (and remains) the icon and centerpiece of Afrikaner pride, and in the wake of the team's victory—as the host nation—in the World Cup final in 1995, when Nelson Mandela stepped onto the playing field clad in the green Springbok rugby jersey and hugged Pienaar, this skepticism began to fade. After that, many white South Africans embraced Mandela not only as their president but also as their grandfather, as "Madiba."

On this day, Mandela played with the boys as Pienaar knelt at their side. In his innocence, one the boys asked, "Madiba, how could they have put you in prison for twenty-seven years if you didn't steal anything?"

"Sweetheart," Nelson Mandela replied with a soft and knowing smile, "I'm afraid I did steal something. I stole freedom for our people."

And that day a thought dawned on me, something as applicable to my own life as to my own son, who grows taller and wiser by the day in a new South Africa: We are all Mandela's children.

—D.T.

On July 18, 1918, in the placid village of Mvezo, on the banks of the Mbashe River, Rolihlahla Mandela was born. In the Xhosa language of his people, Rolihlahla means, "pulling on the branches of trees." Little did little Rolihlahla's father know that his youngest son would go on to shake the world.

Mandela's family belonged to the Madiba clan—in South Africa, "Madiba" is widely used as an affectionate honorary name for Nelson Mandela—from which came the kings of the Thembu nation that had once, before the arrival of the British, ruled the sprawling countryside of South Africa's Eastern Cape known as the Transkei. His father was a counselor to the Thembu royal family and—until he was unseated for defying an order to appear in front of a white magistrate—the village chief. Stubborn pride ran in the family.

COMING OF AGE IN THE TRANSKEI

While still an infant, Mandela's mother moved the family to a tiny country village called Qunu, where he would spend most of his childhood. Here, wandering over the vast fields and rolling hills surrounding his village, he learned to swim, fish, and herd, and honed his stick-fighting skills with other boys. In keeping with the Xhosa traditions of *ubuntu*, people in Qunu regarded one another, and lived together, as one great family. At the urging of the village elders, Mandela was sent to a missionary school at the age of seven, the first in his family to attend such a school. On his first day, his Methodist teacher gave him his new Christian name, Nelson.

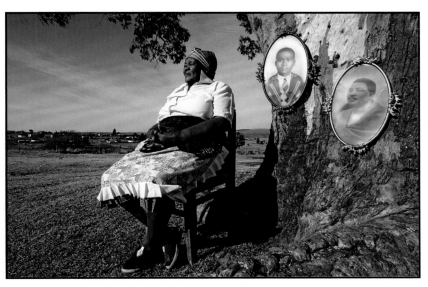

Justice Jongintaba's wife sits under a tree at the Great Place. The framed photographs are of Justice and his father Chief Dalindyebo.

When Nelson was nine, his father died of tuberculosis, and his mother brought him to Mqhekezweni, the provisional capital of Thembuland and seat of the Thembu ruler Regent Chief Dalindyebo Jongintaba and his wife, No-England. The regent had offered to be Nelson's guardian and see that the bright boy was educated. The semiwesternized, church-influenced life Nelson encountered at Mqhekezweni (or "Great Place") was markedly different from the sheltered, pastoral existence he had known in Qunu. He moved into the royal cluster of huts, continuing his education at the Wesleyan missionary school next door.

Regarded initially by his more refined peers as an unsophisticated country boy, he assimilated quickly by listening to and observing those around him. He came to admire and emulate the charm, style, and physical presence of the regent's eldest son and heir, Justice, who became his closest friend. Though he was not in line to the throne, Nelson was nonetheless raised and treated as equal to the regent's other children.

The young boy was particularly captivated by the Thembu council gatherings held under the oak tree at the Great Place. Such meetings were open forums where every person present, regardless of tribal status, was permitted to speak without interruption, and decisions were decreed only when a consensus had been reached among the majority of those present. Not only did this inspire Mandela's lifelong belief in democracy as the most rational and equitable form of government, but it gave rise to his conviction that consensus rule was as much an African tradition as it was a Western one.

In 1925, at the age of sixteen, along with Justice and twenty-six other initiates, Mandela retreated to a secluded hut on the Mbashe in preparation for the traditional Xhosa circumcision ceremony. Custom dictated that the initiates endure the painful coming-of-age experience with poise, calling out "Ndiyindoda!" ("I am a man!") at the moment of truth. Covered in red ocher, Mandela returned to the village bearing a new praise name, Chief Dalibunga, as a badge of honor. He continued his education at the Clarkebury Boarding Institute and then at Healdtown, a Wesleyan college, both nearby.

It was preordained that Mandela would be a tribal councillor to the Thembu chieftaincy one day. After graduating from Healdtown, he was sent off in his first suit to study at the University College of Fort Hare. Located in the town of Alice, in the Eastern Cape, Fort Hare was the only center of higher education then available to blacks in South Africa and was a destination for black scholars from across the continent. Though Mandela thrived in its enlightened, intellectually invigorating atmosphere, he completed only two years of study—he was expelled for supporting a student boycott over meals. Soon after, rather than accept the marriages the regent had arranged for them, Nelson and Justice fled to Johannesburg. This rebellious act would lead Mandela down a new, unforeseen path.

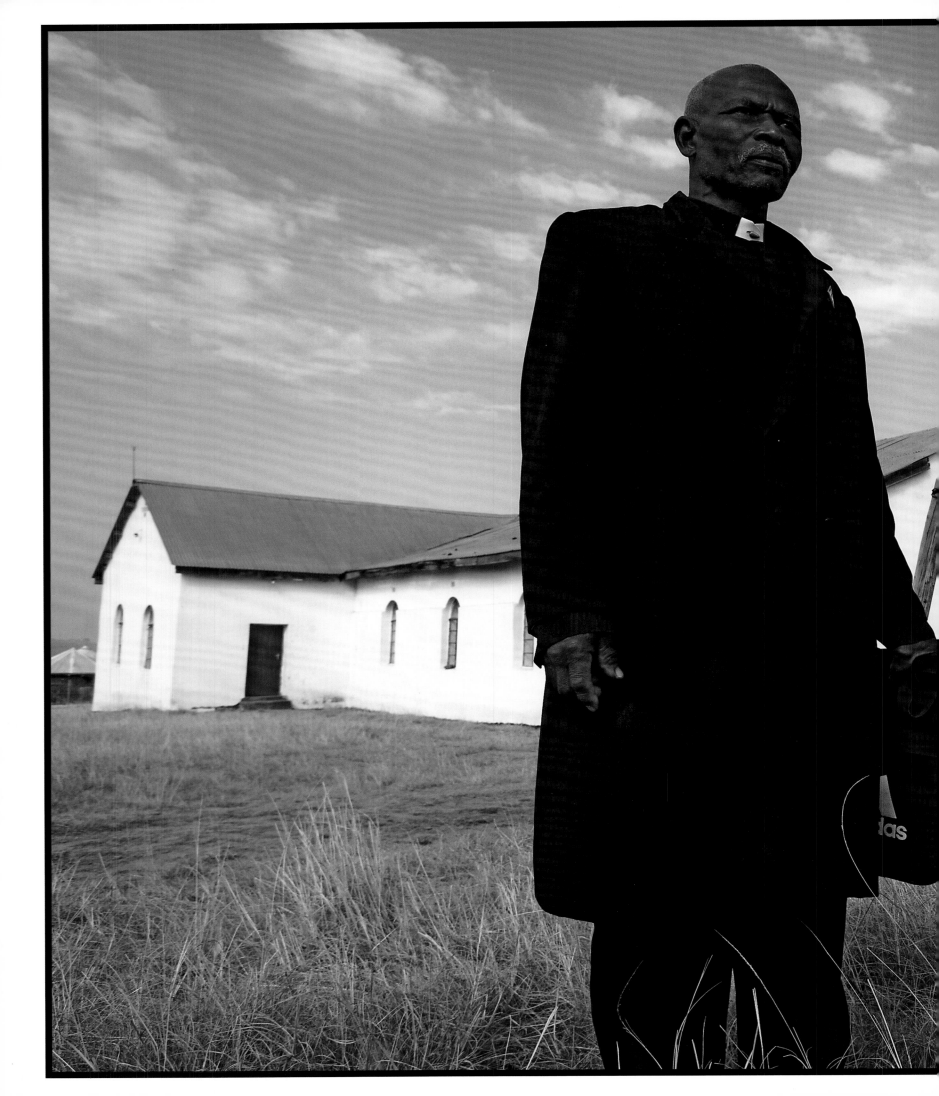

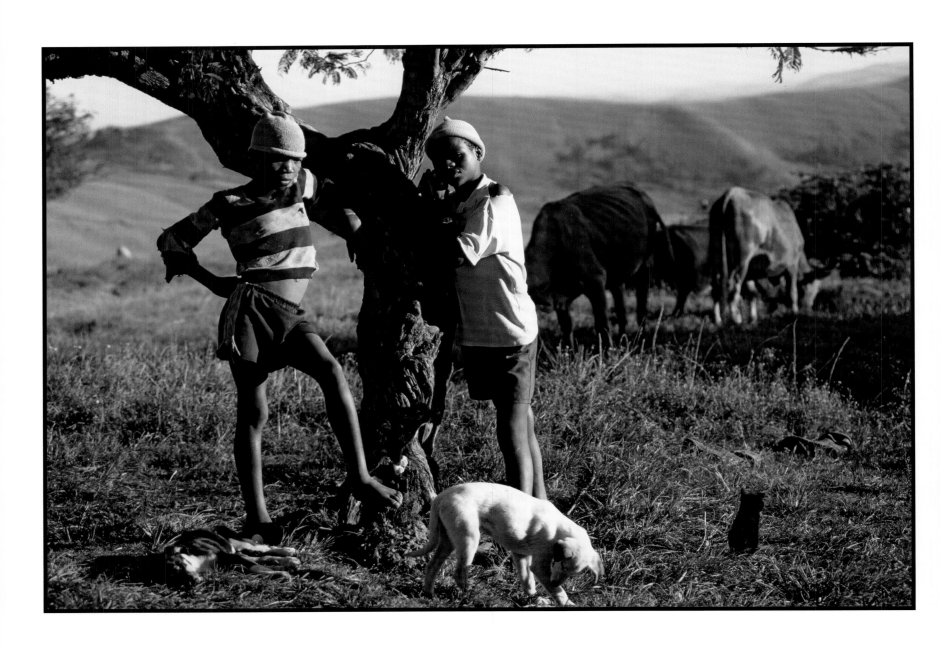

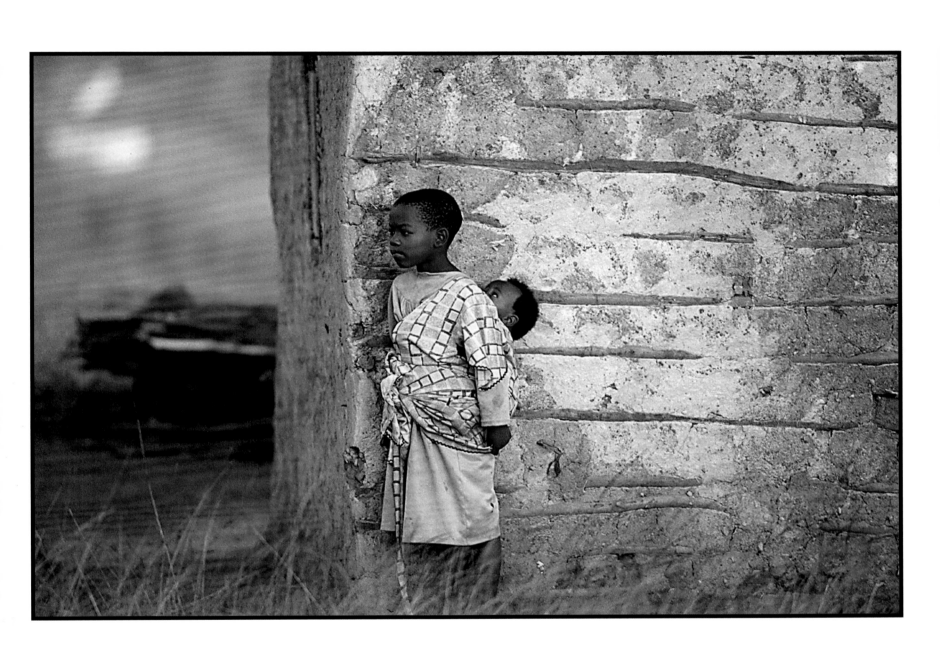

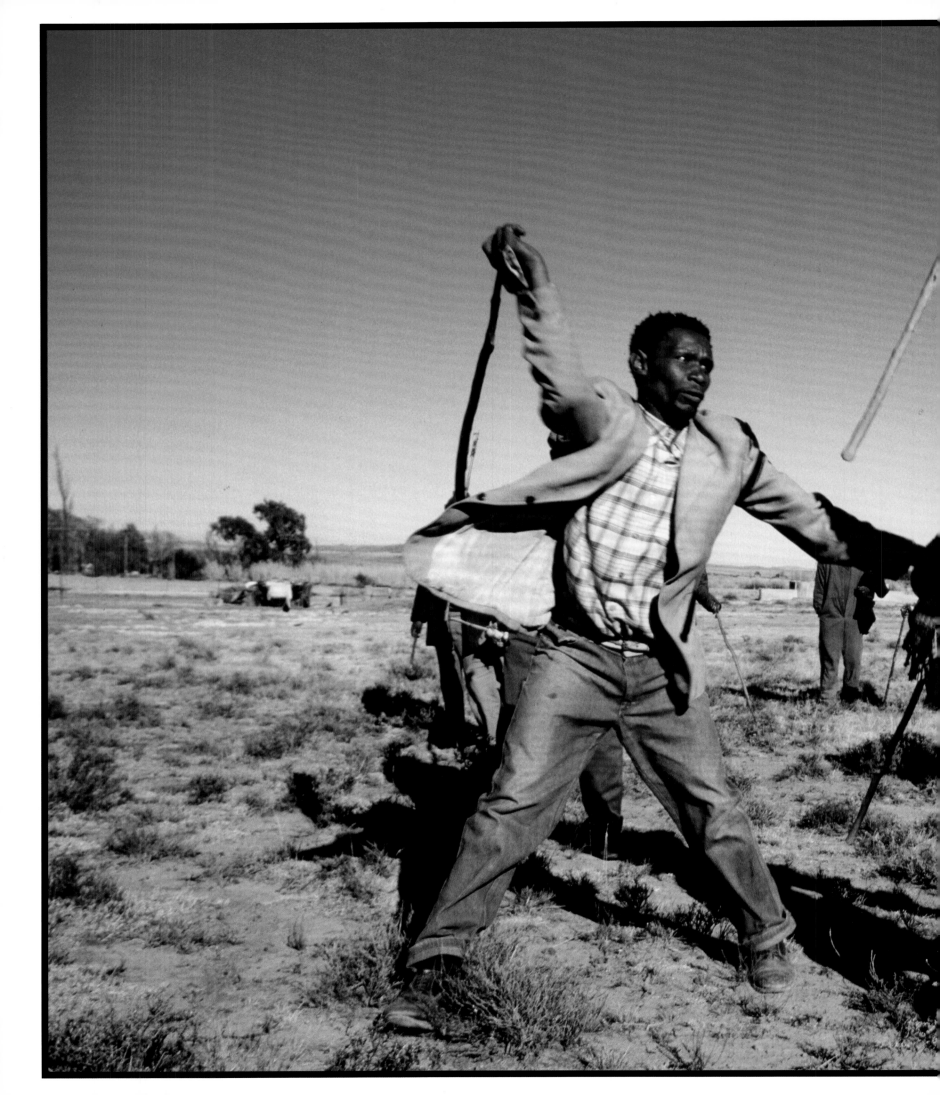

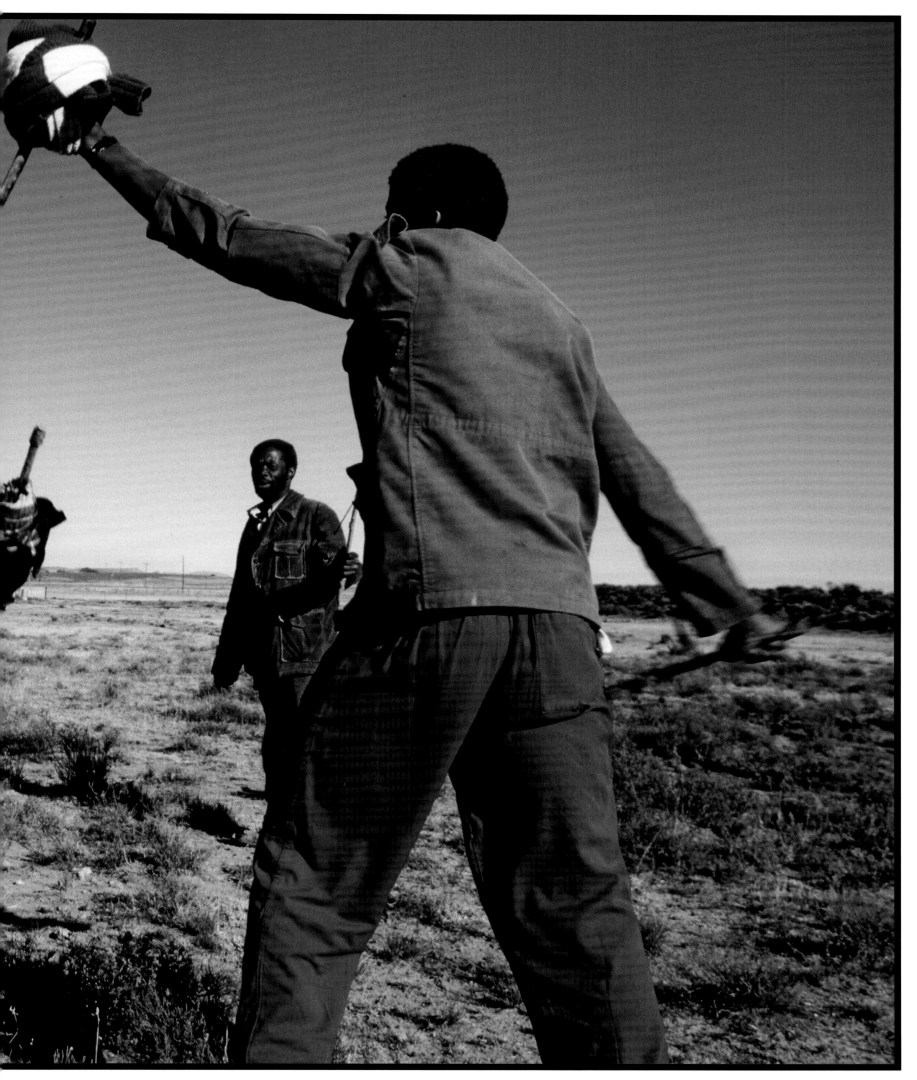

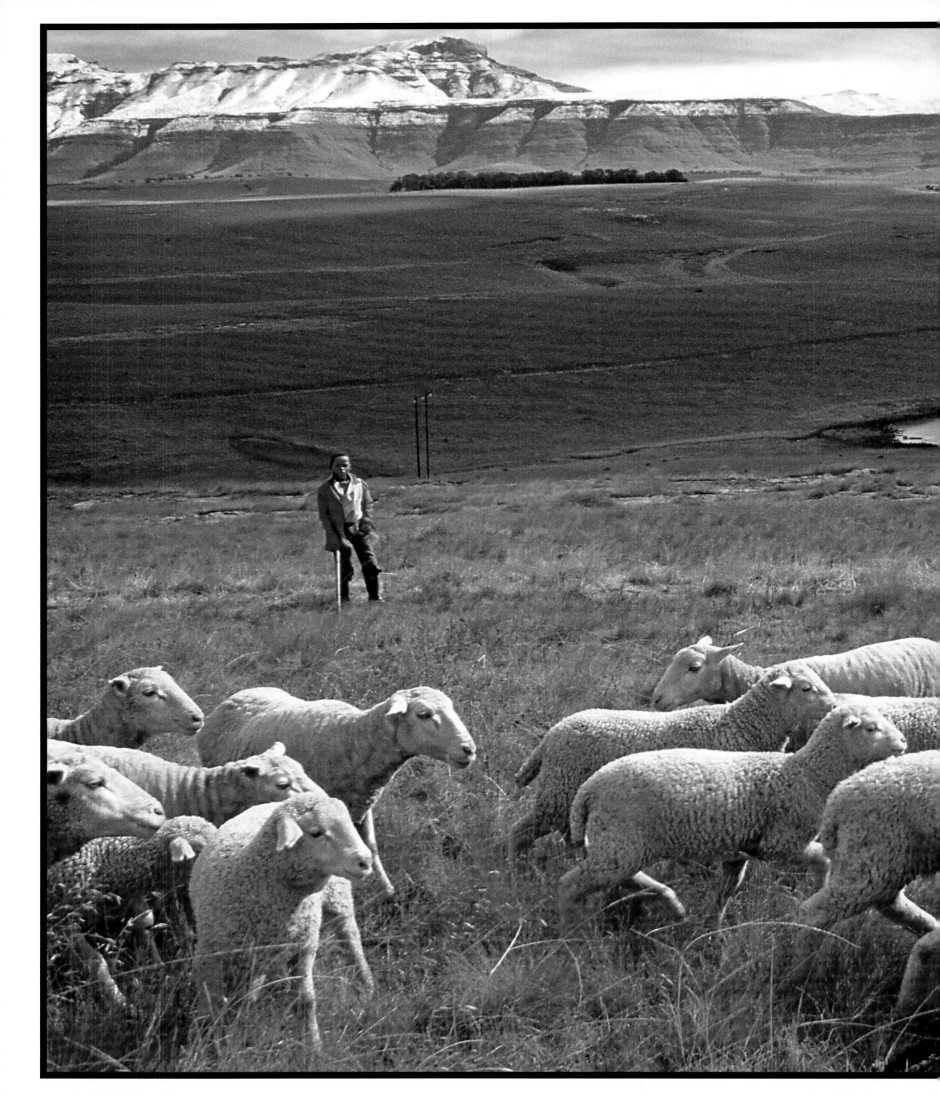

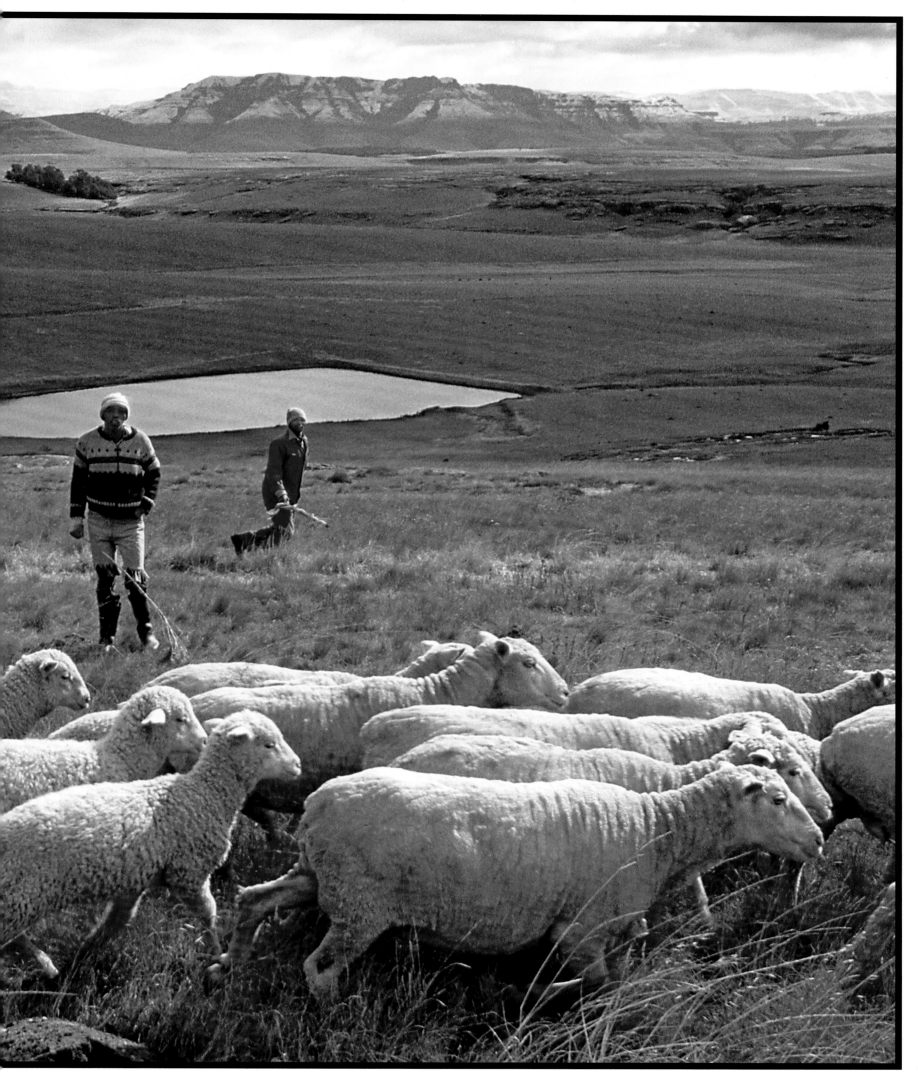

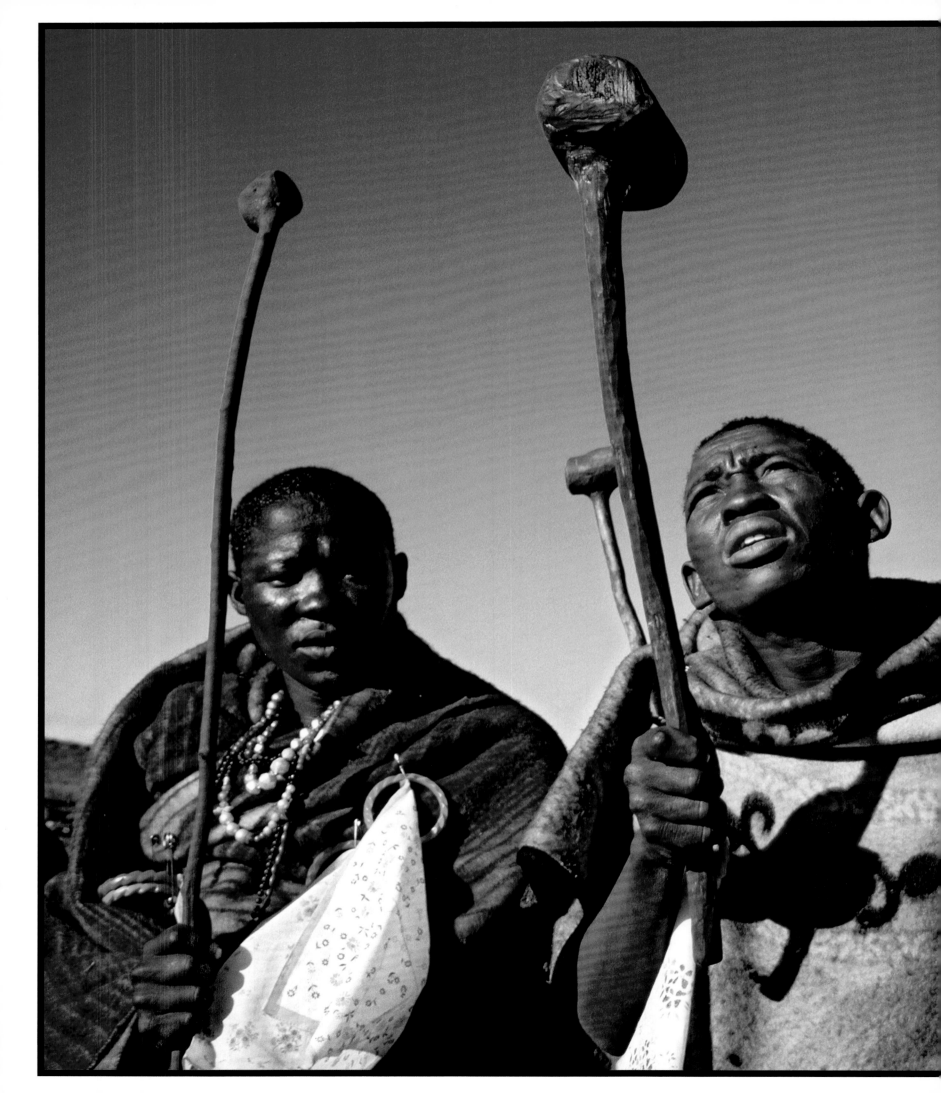

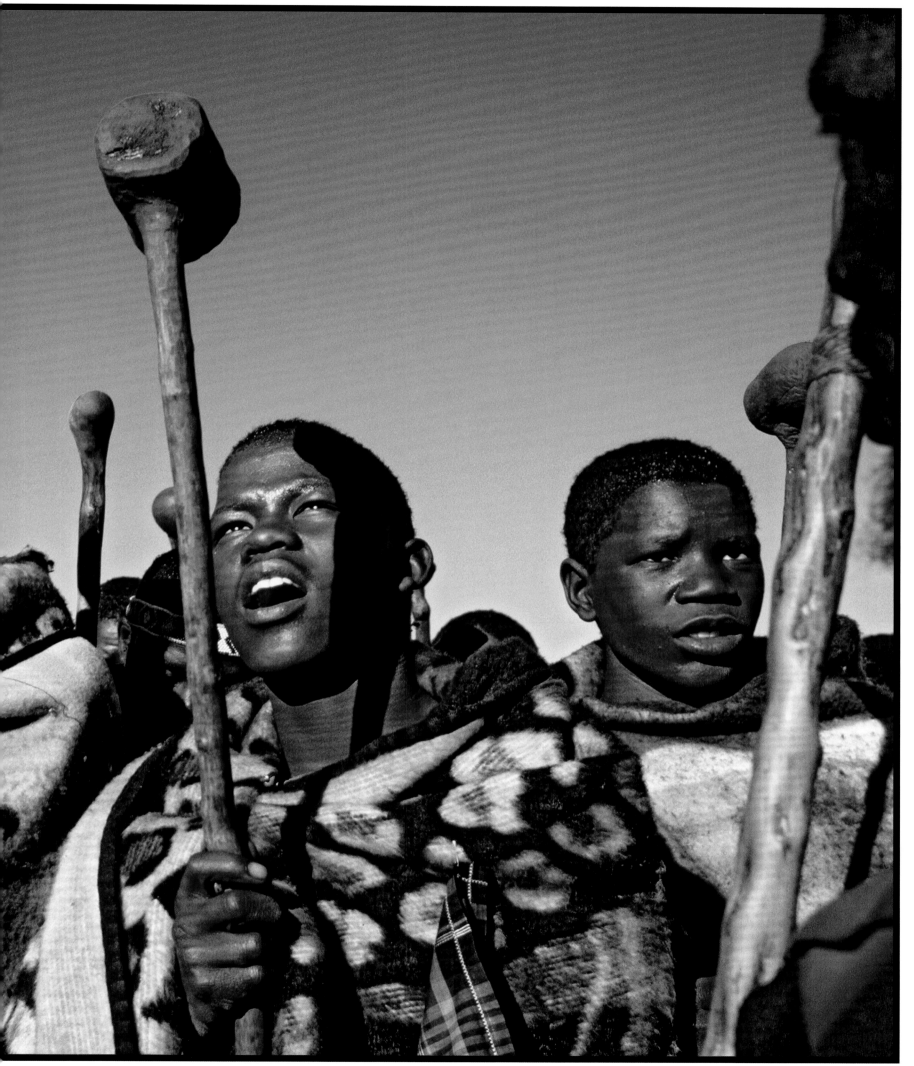

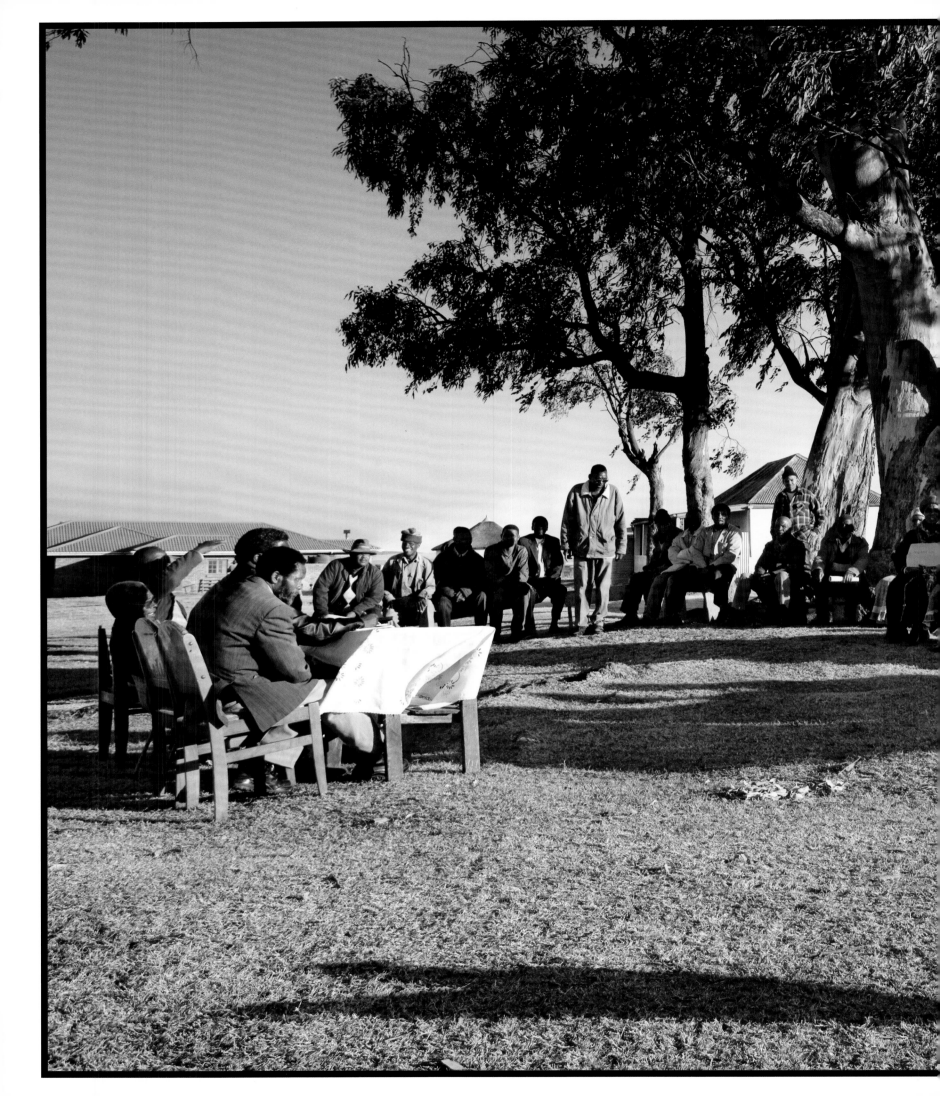

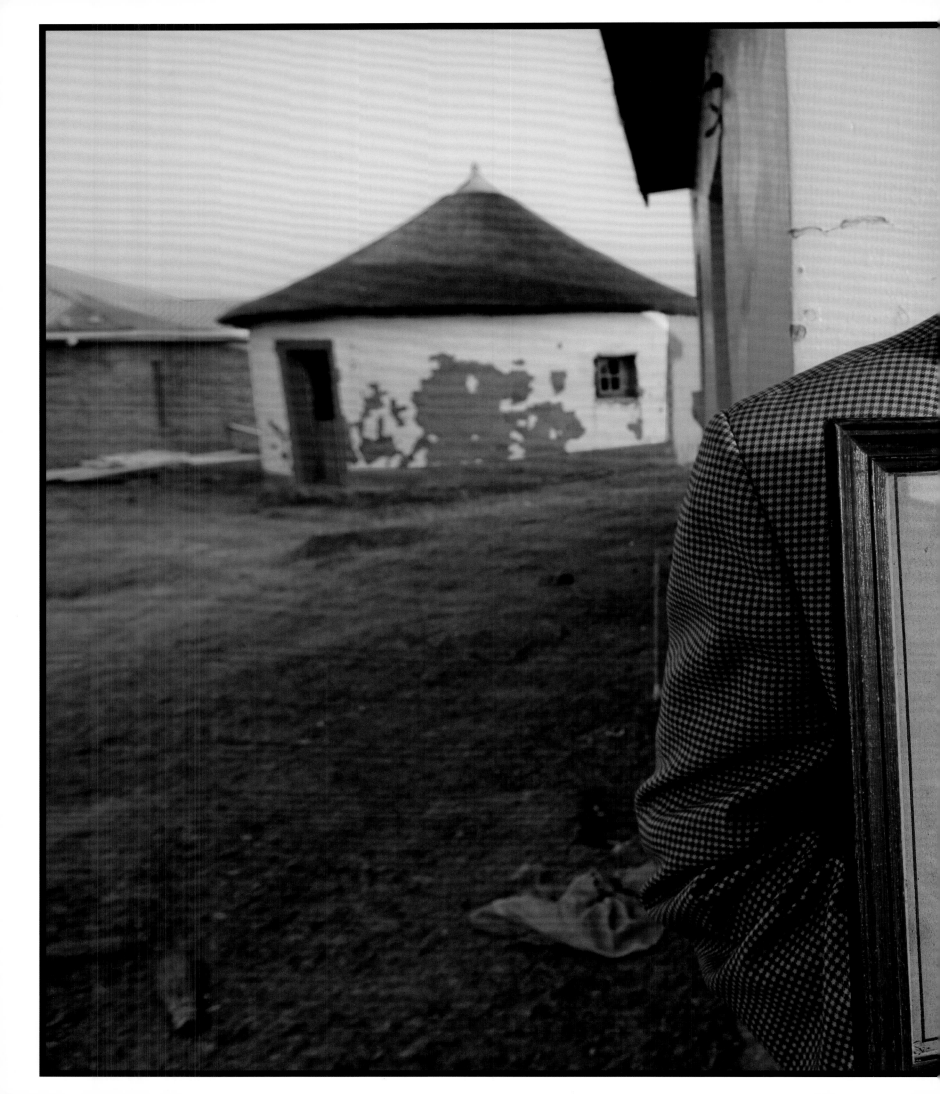

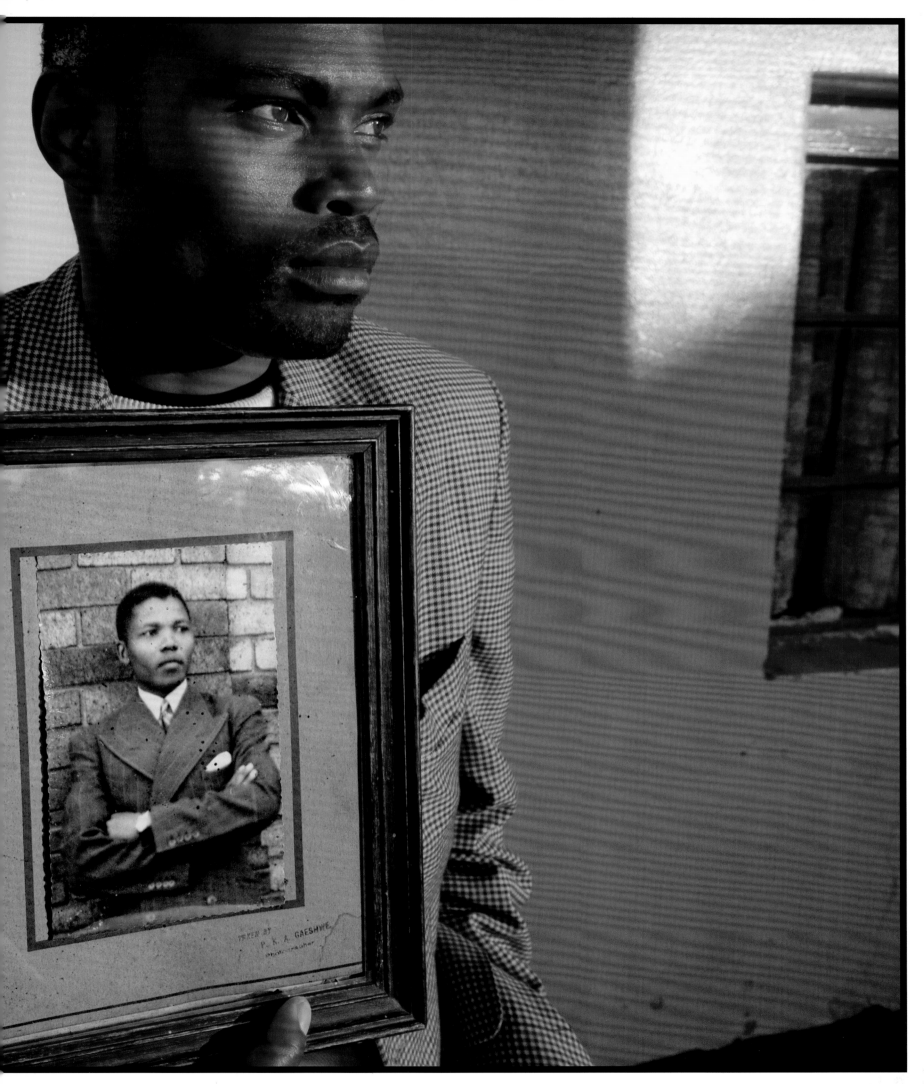

A priest stands in front of the church in Qunu where Mandela was baptized when he was eleven.

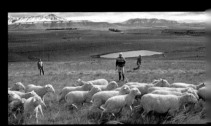

Shepherd boys tend to their flock in front of the Drakensberg Mountains, near Lesotho.

Two shepherd boys take a break in the Transkei.

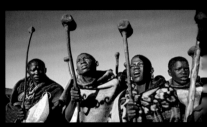

These young Xhosa men are returning from the bush after their circumcision ceremony.

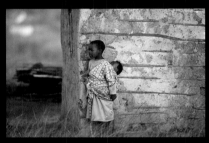

A young girl in the Transkei cares for a baby.

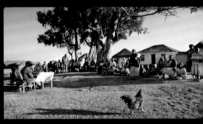

Village elders convene to discuss community issues under a tree at the Great Place. Observing such assemblies as a young man, Mandela came to appreciate the value of consensus politics.

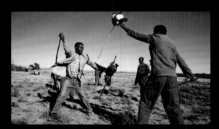

Stick fighters joust in the afternoon. Stick fighting is a Xhosa tradition that Mandela excelled at in his youth.

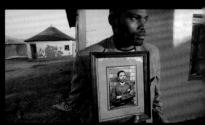

Justice Jongintaba's grandson holds up a portrait of Nelson Mandela wearing his first suit, taken during his college years.

POLITICAL AWAKENINGS

By the early 1940s, South Africa was a country of more than 10 million blacks and fewer than 2 million whites. Johannesburg, its largest city, was transforming itself from a colonial outpost into a burgeoning metropolis, as black South Africans from rural areas came to work in nearby mines and factories. At the same time, far-right Afrikaner Nationalists, a fringe group that expressed solidarity with the Nazis, began to call for a radical strategy to ensure their power and security in the face of this growing black population. They had a word for it: apartheid.

Possessing little more than his suit and his princelike demeanor, Nelson Mandela arrived in Johannesburg in 1941. Twenty-three years old, six feet three inches tall, and imposingly built, he soon found his footing. A well-connected local leader and savvy businessman named Walter Sisulu referred him to Lazar Sidelsky, a Jewish lawyer and partner in a downtown Johannesburg law firm. In a bold move that testified to Sidelsky's progressive ideals, he offered Mandela a job as an articled clerk with his firm. Steady in his habits—with his sunrise jog and lamplight studies—Mandela completed his undergraduate education and embarked on a law degree while working by day. But it was his friendship with Sisulu and with a fellow black law clerk named Gaur Radebe that helped make him into a political activist. The indignities and humiliations of the new segregated reality he was experiencing made an indelible impression. When the regent died in 1942, the family urged Mandela to return and become a councillor at Mqhekezweni, but he declined. He had found his calling and his cause, and he would never turn back.

Mandela began to spend more time with Walter Sisulu, whose house in the Orlando section of the huge black township of Soweto was a meeting point for African National Congress (ANC) activists and progressive thinkers. The ANC had been formed in 1912 as a means to unite the tribal, religious, and political organizations working in defense of the rights and freedoms of black South Africans. As policies of segregation and disenfranchisement became further entrenched in law, the ANC would emerge as the country's strongest movement of resistance and its catalyst for political opposition.

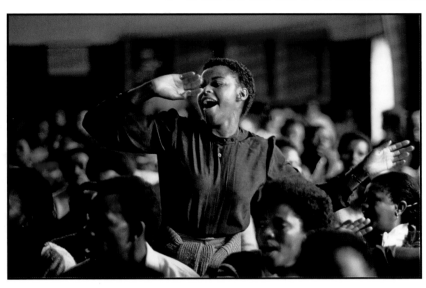

A young woman celebrates Mandela's release from prison at a rally in Umtata in the Transkei, 1990.

With his sharp suits, boxer's mettle, and flair for persuasive argument, Mandela cut a commanding figure. Through the Sisulus he met his first wife, Evelyn Mase, a nurse who, like him, had come to the city from the Transkei. Enrolled in law school and moving into a new house in Orlando, Mandela was starting to settle down just as he was becoming a man on the move. In 1944, along with Sisulu, his old Fort Hare classmate Oliver Tambo, and others, Mandela created the ANC Youth League (ANCYL). With the aim of mobilizing a broader and more active legion of supporters, the Youth League would rejuvenate the resistance movement in the challenging years that followed.

In the South African elections of 1948, Churchill war ally and political moderate Jan Smuts was narrowly defeated by D. F. Malan's National Party, whose supporters were nearly all whites who traced their roots back to the 1652 Dutch settlement of the Cape. Intent on making apartheid not just an ideology but a system of governance, the new administration immediately began to pass sweeping legislation. Imposed on an already segregated society with numerous laws preserving white supremacy, apartheid classified South Africans as "black," "white," "Indian," or "coloured"; established geographically separate living areas; rigorously segregated public institutions such as hospitals and schools; outlawed mixed marriages; and virtually disenfranchised nonwhite voters.

The ANCYL effectively took control of the ANC in 1949, and by 1951 Mandela was president of the Youth League. The following year, he spearheaded a nonviolent program of action against apartheid known as the Defiance Campaign. In the spirit of Mahatma Gandhi, he organized thousands in mass protests, often making himself a conspicuous target of arrest. His visibility caused the government to crack down on his activities, and in 1952 it imposed its first ban on him—for six months he was barred from attending meetings, talking to more than one person at a time, and leaving Johannesburg without authorization. Throughout the 1950s, he would pursue his political work under almost constant government bans.

In spite of these pressures, Mandela settled down to a full life in Johannesburg. He and Oliver Tambo opened their own law firm, Mandela and Tambo, offering free representation to victims and protesters of apartheid laws. His marriage to Evelyn produced two sons and a daughter before it ended in divorce. In 1958 he married Winnie Madikizela, with whom he would have two more daughters.

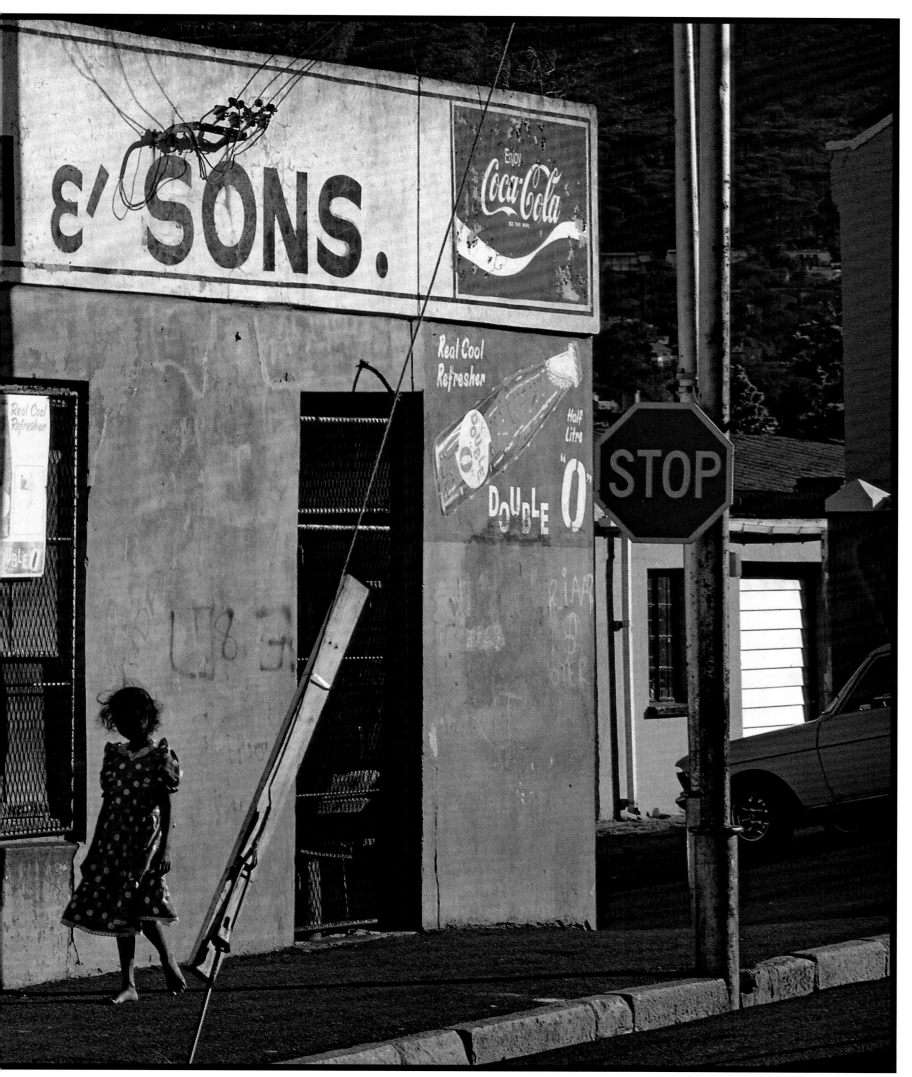

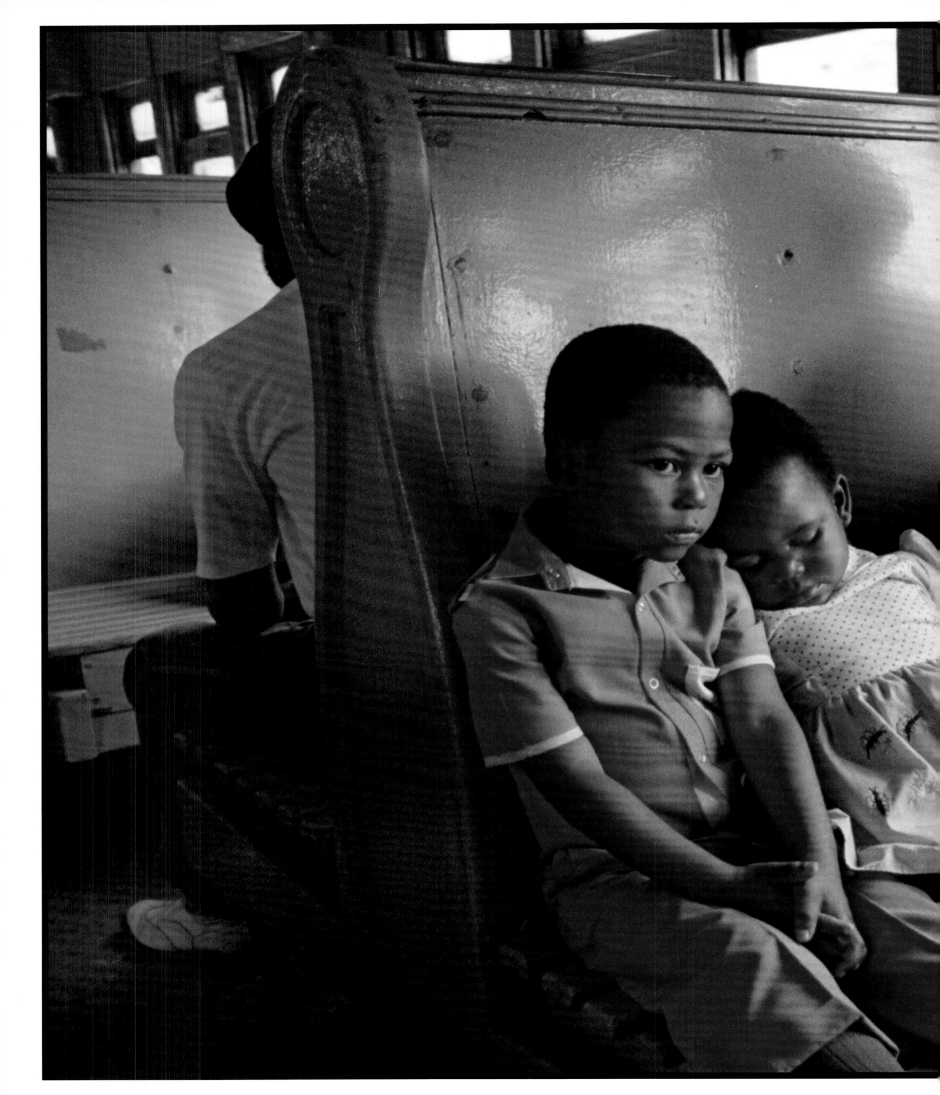

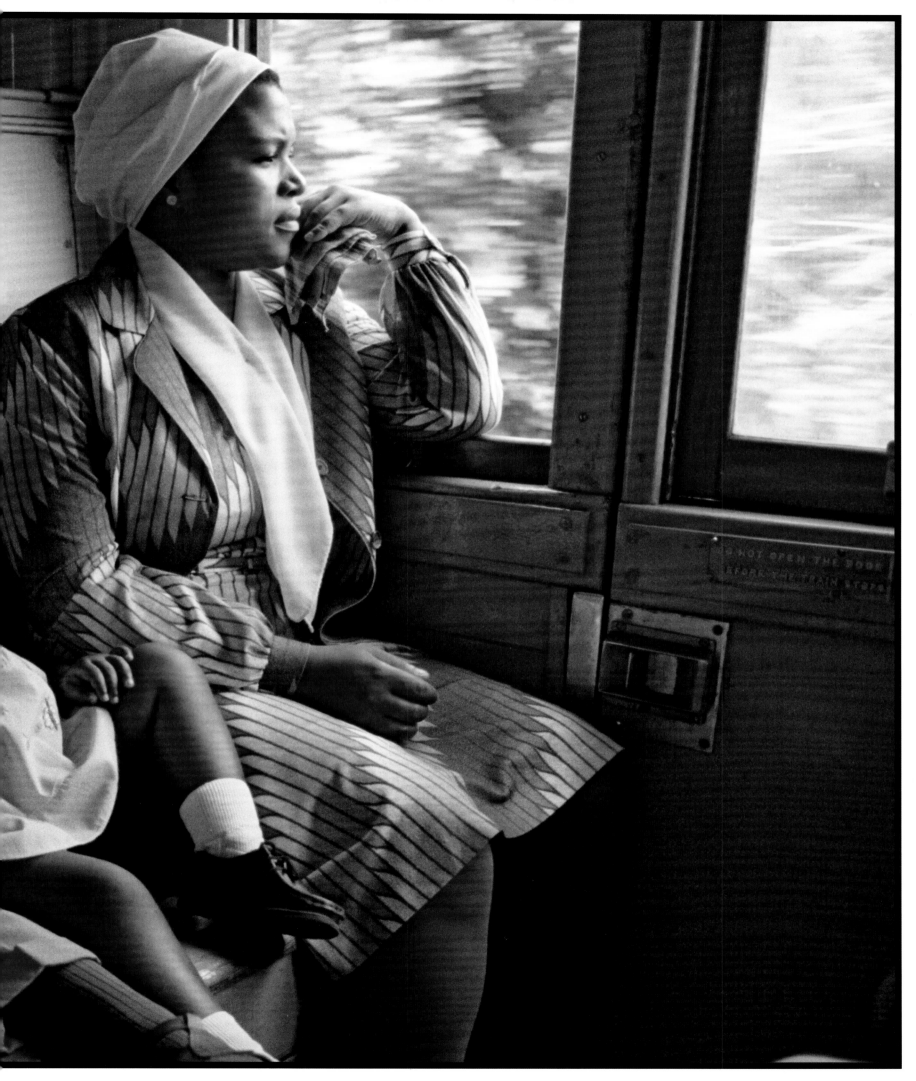

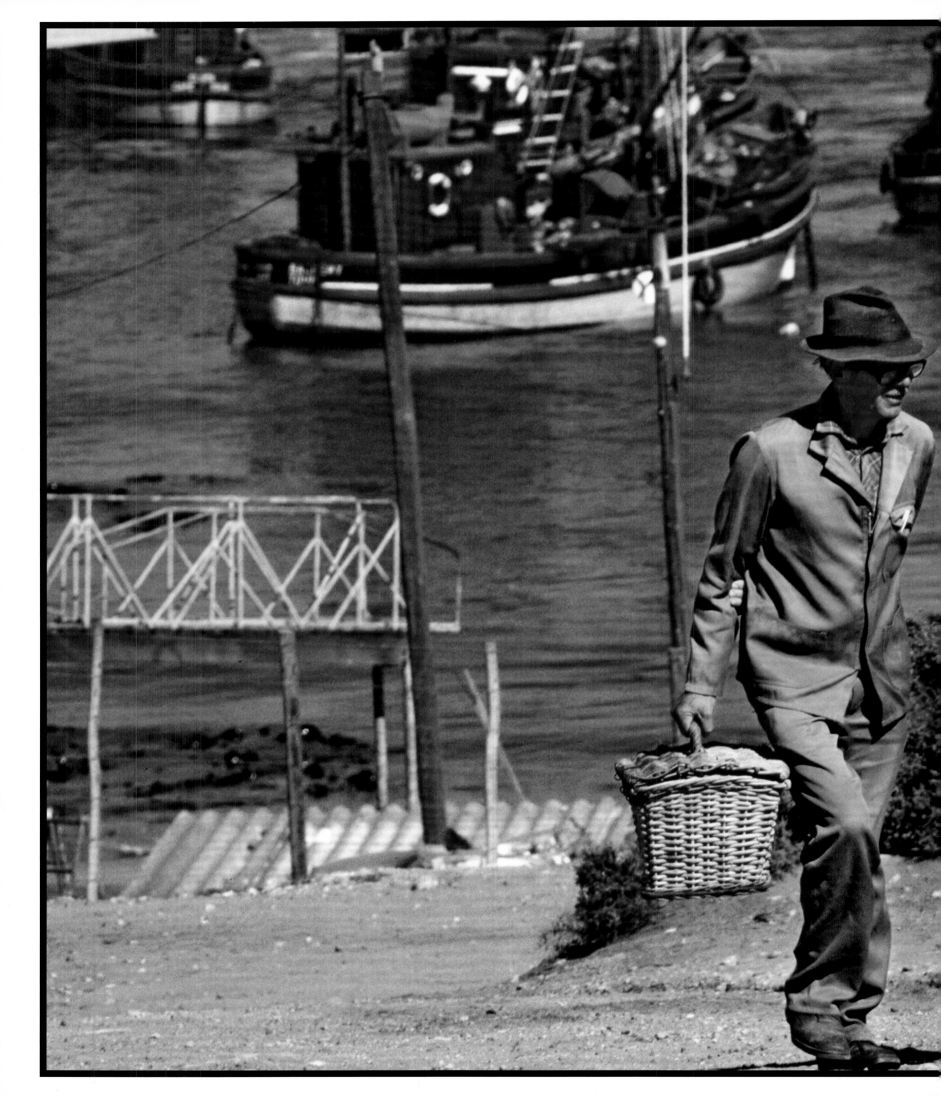

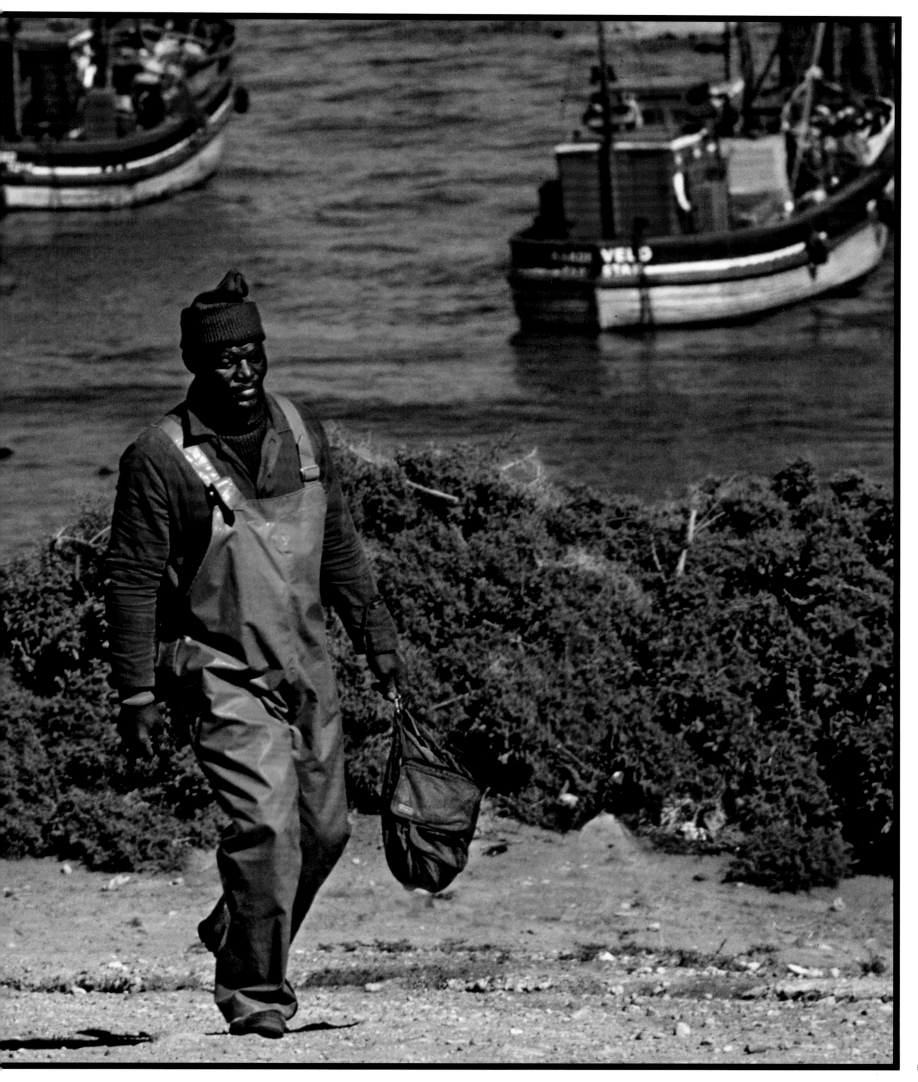

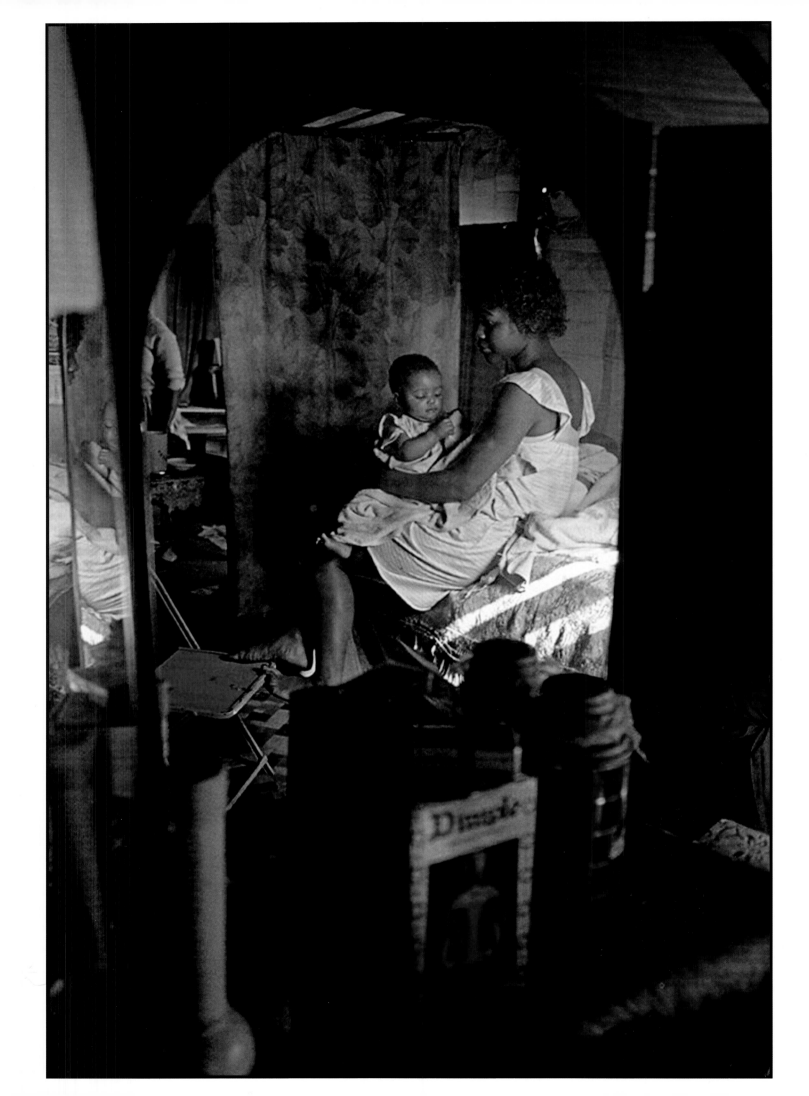

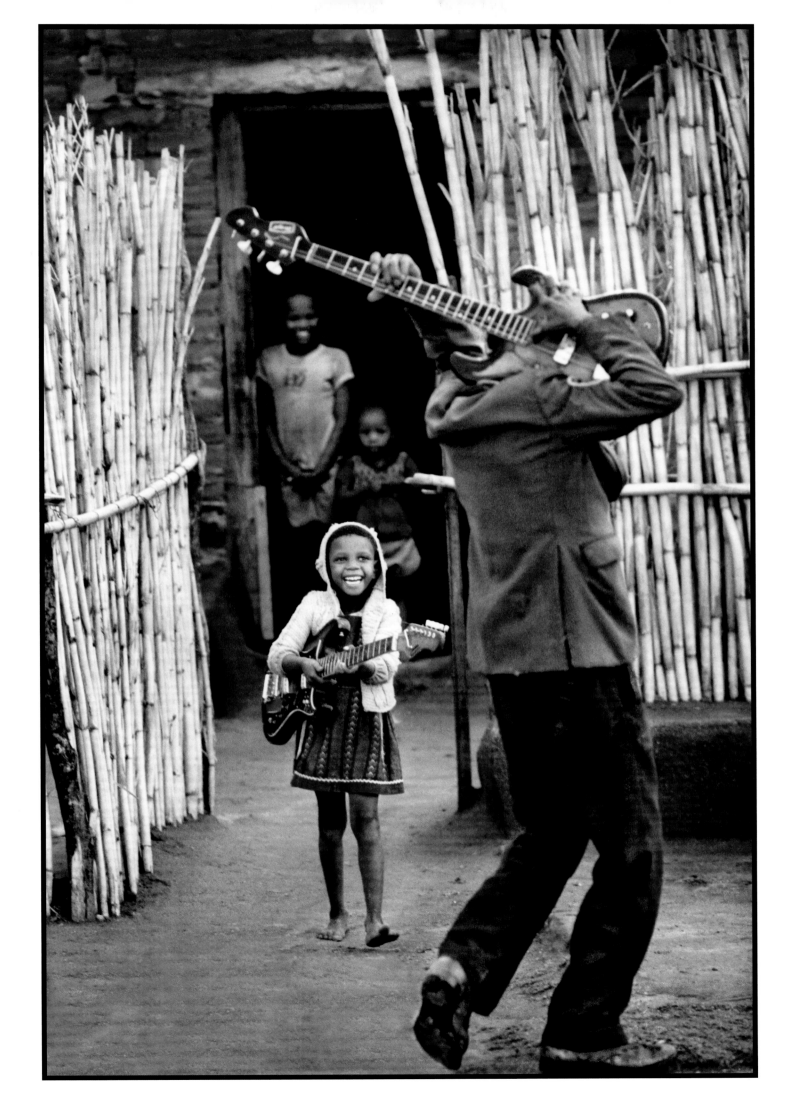

A girl walks along a back street in the Bo-Kaap, the Muslim quarter of Cape Town.

A woman ties a scarf to her head as she prepares to leave her Soweto home to go to work in Johannesburg. It is likely that she works as a domestic in a white family's home.

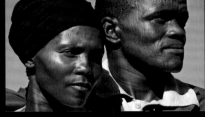

Like thousands of black Africans, the husband in this Transkei couple travels to Johannesburg to work in the mines; he spends eleven months a year in the mines, and one month at home.

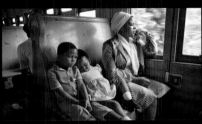

A mother and her two children ride in a segregated train compartment outside Durban during apartheid. Mandela took his first train trip in the blacks-only carriage to Johannesburg.

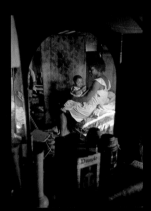

In a typical one-room corrugated shack in a township of Johannesburg, a woman sits with her child.

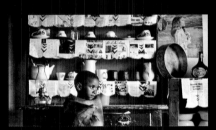

A farm laborer's daughter stands in her family's small home on the land of an Afrikaner farmer.

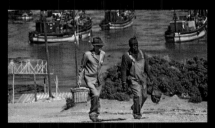

Crayfishermen walk along the shore at Lambert's Bay, on South Africa's West Coast. One of the fishermen said that the only place apartheid didn't exist was at sea.

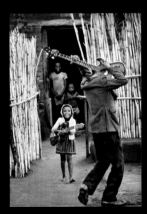

An Orange Free State farm laborer plays guitar on a Sunday, his day off. This man worked sixty hours a week, earning a monthly salary of thirty rand, or about twenty dollars.

In 1955, Mandela helped draft the Freedom Charter, a nonracist, democratic platform for the anti-apartheid movement and a vision of a new South Africa. By then, the ANC was riven with internal conflict between the leadership, which pursued a policy of cooperation with white, Indian, and coloured anti-apartheid parties, and Africanists, who urged bolder mass resistance led exclusively by blacks. Mandela never wavered from the ideas set forth in the Freedom Charter, which declared "that South Africa belongs to all who live in it, black and white, and that no government can justly claim authority unless it is based on the will of all the people."

THE FREEDOM FIGHT GOES UNDERGROUND

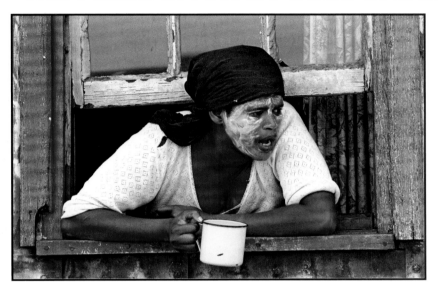

A woman who uses cream to lighten the color of her skin leans out of the window in her house near Port Elizabeth.

More and more in the 1950s, the activists in the South African anti-apartheid movement were preoccupied with defending themselves against the state. Producing the Freedom Charter provided a pretext to arrest most of the leaders of the groups that drafted and endorsed it in December 1956, on the grounds that they were conspiring to overthrow the government and install a Communist state. The Treason Trial dragged on until 1961, when the last of 156 defendants, including Nelson Mandela, were finally acquitted on all charges. That the white judges could return such a verdict bolstered Mandela's belief in the rule of law—but the conflict over apartheid was intensifying, and a dark new era of repression was beginning.

On March 21, 1960, tensions in South Africa escalated dramatically when a peaceful demonstration against pass laws—dictating that all people of color must carry identification books outlining their privileges—turned into a bloodletting. More than five thousand demonstrators had assembled in the township of Sharpeville, presenting themselves for arrest for refusing to carry their pass books, when police mounted on tanks opened fire, killing sixty-nine people, most of whom were shot in the back as they fled. The Sharpeville Massacre marked a turning point in the anti-apartheid struggle. In the wake of national protests, the government declared a state of emergency and then declared the ANC—along with the more militant Pan-Africanist Congress (PAC)—an illegal organization. Rather than disband, the leadership of the ANC decided to continue the struggle underground. After the Treason Trial, Mandela, whose years of bans had trained him to keep a low profile, went into hiding. He was known to his ANC comrades by the code name the Black Pimpernel.

At Liliesleaf Farm in Rivonia—a suburb of Johannesburg—where the ANC had set up its underground headquarters, Mandela took command of the group's military wing, Umkhonto we Sizwe ("the Spear of the Nation"), in a campaign to sabotage infrastructure sites across South Africa. Its operations commenced on Dingaan Day, December 16, 1961, as Afrikaners celebrated the defeat of the Zulu leader Dingaan in the Battle of Blood River. Branded the leader of a terrorist group in a fierce government counteroffensive, Mandela slipped out of the country. Aided by the ANC's international allies, he was given refuge and protection as he traveled abroad. In visiting sixteen African countries as well as England, Mandela raised funds for ANC activities and received paramilitary training before secretly returning to Johannesburg. On August 5, 1962, while attempting to cross the border undetected, Mandela was apprehended in Durban and charged with leaving the country without a passport. More than a year later, a raid on the Rivonia farm yielded sufficient evidence for the government to charge Mandela and eleven others with sabotage.

At what became known as the Rivonia Trial, Mandela pled his case by delivering a sweeping four-hour oral manifesto that would stand as a grand proclamation of the aims and beliefs of the ANC. Rather than closing with a plea for clemency, he ended his speech with these words of conviction, which he believed could be his last before being sentenced to death:

"During my lifetime, I have dedicated myself to the struggle of the African people. I have fought against white domination, and I have fought against black domination. I have cherished the ideal of a democratic and free society in which all persons live together in harmony and with equal opportunities. It is an ideal which I hope to live for and to achieve. But if needs be, it is an ideal for which I am prepared to die."

Of the twelve people who had been arrested, eight, including Mandela and Walter Sisulu, were found guilty. Though it had been expected that they would hang, the judge sentenced them to life in prison. Thus, at the age of forty-six, Nelson Mandela, who was already serving five years for his unauthorized travels abroad, was faced with the prospect of spending the rest of his life in captivity.

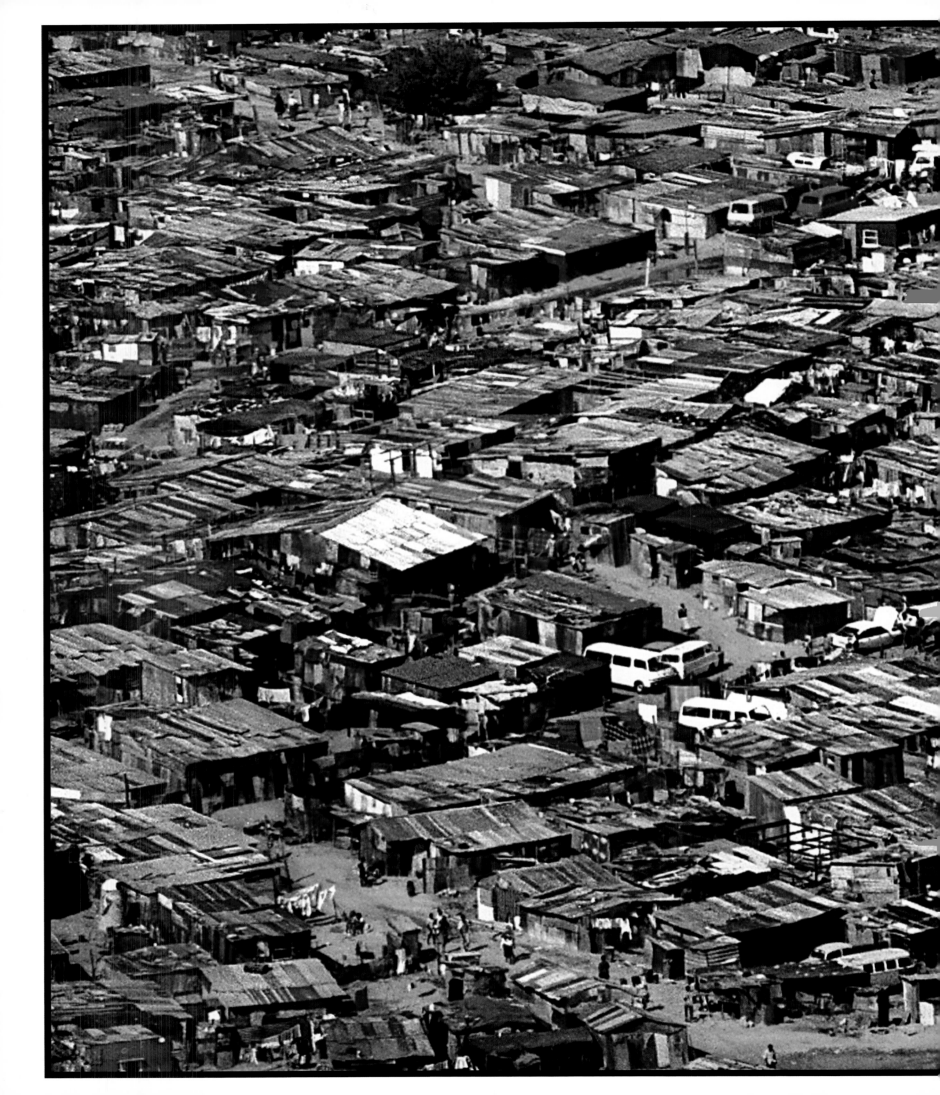

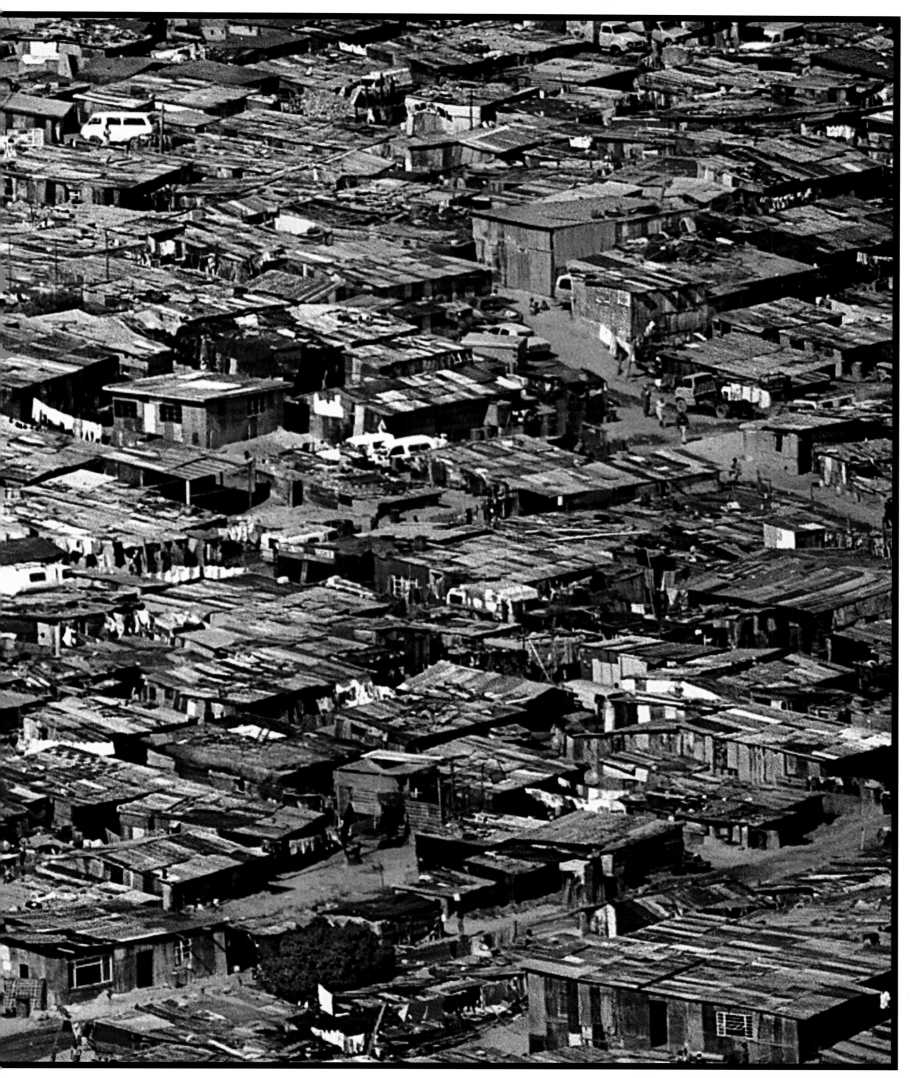

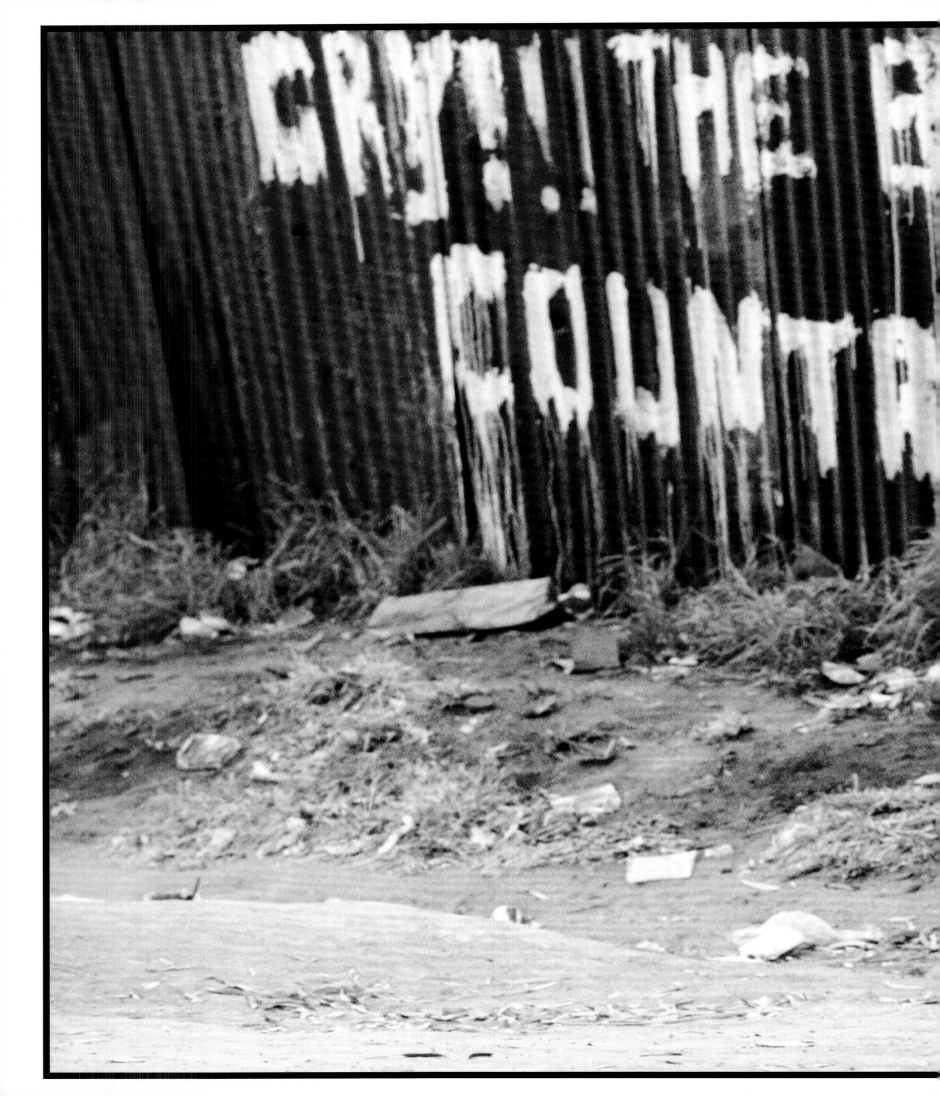

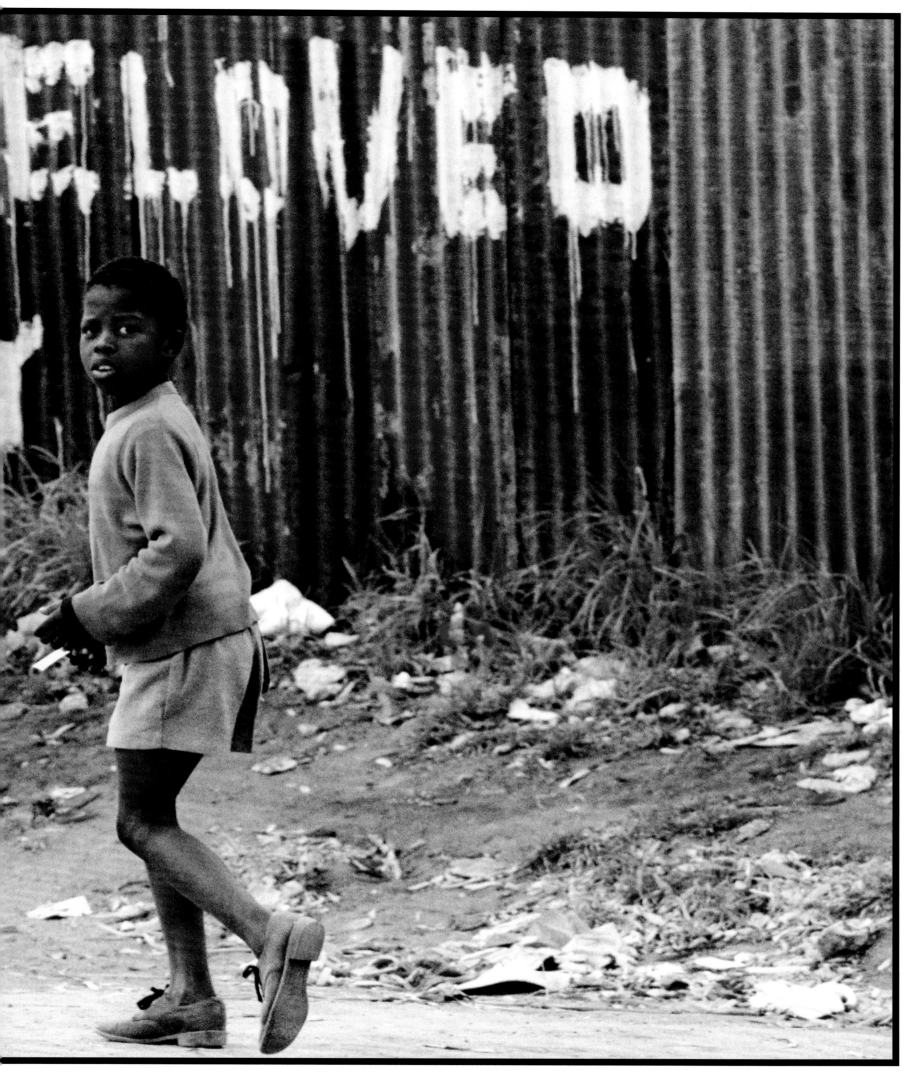

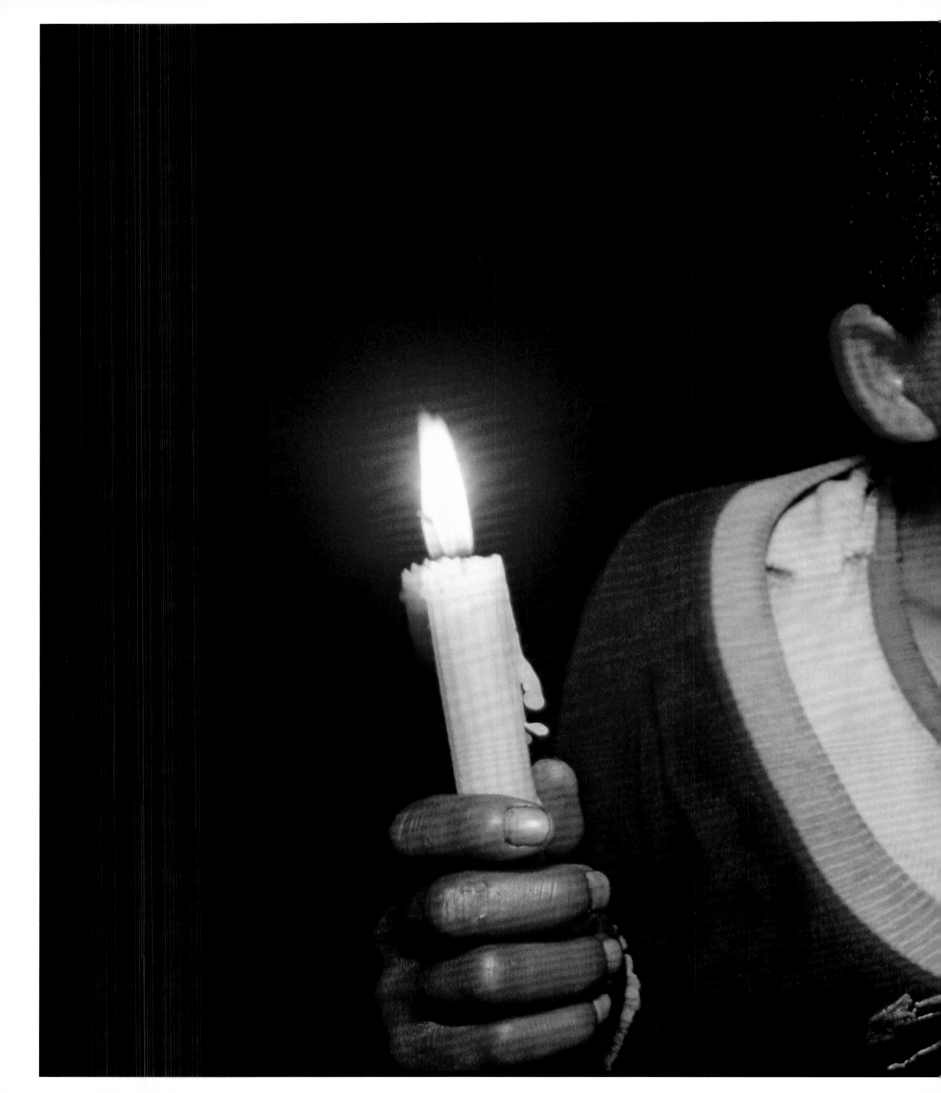

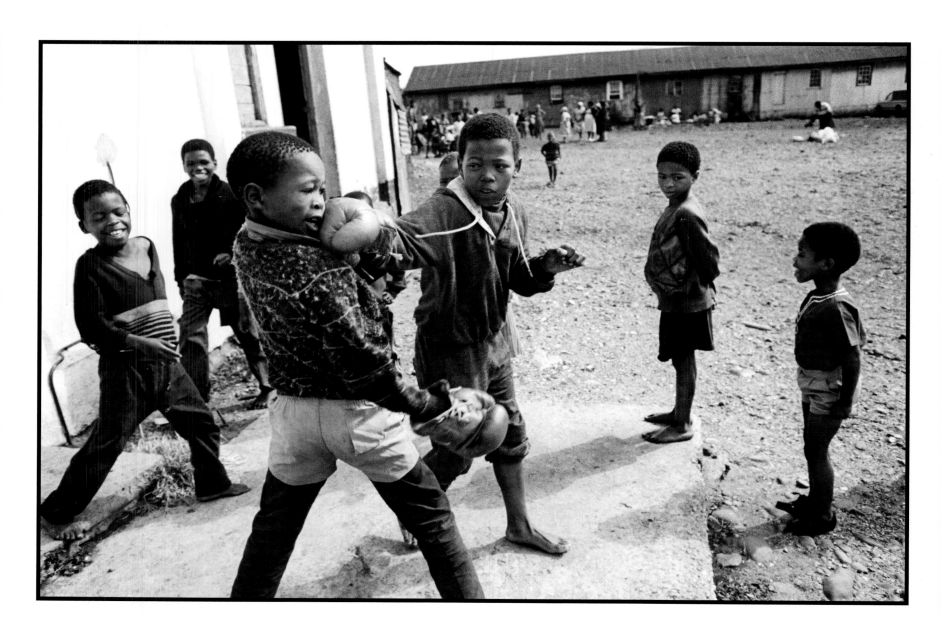

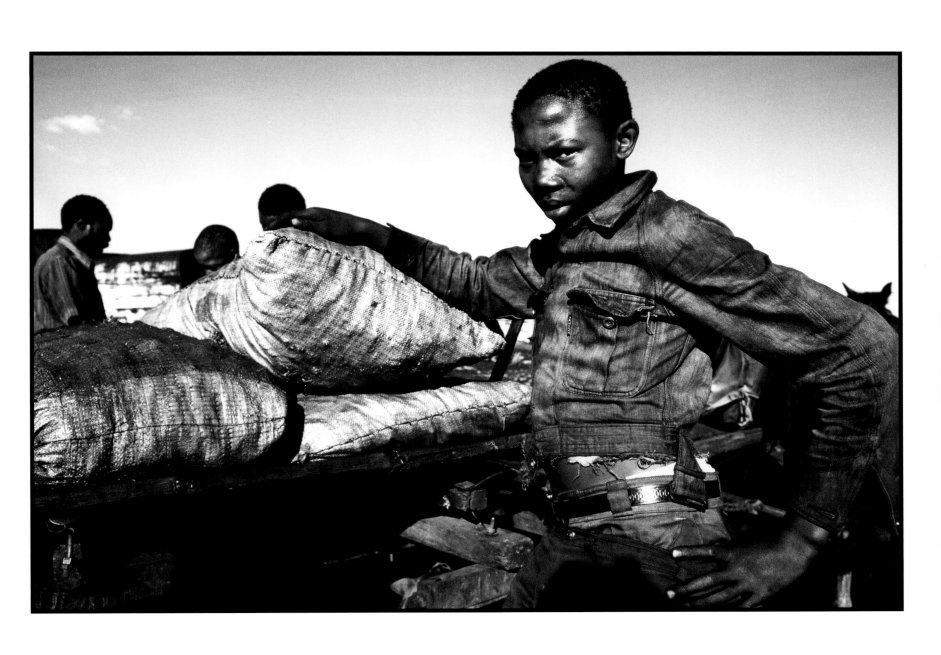

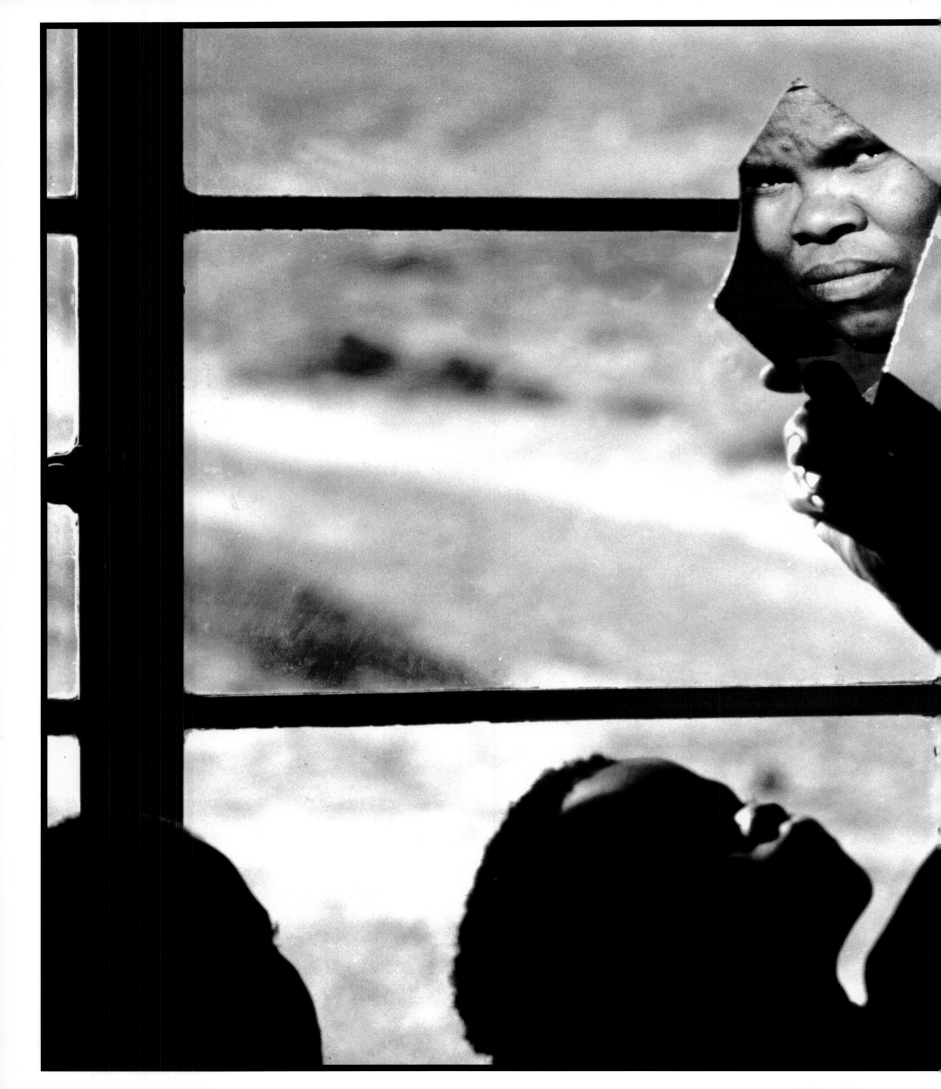

Crossroads, near Cape Town's airport, is home to millions of people of color. In late spring 1986, it was the scene of forced removals by the government and escalating violence.

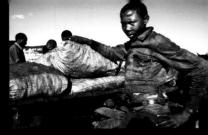

A young boy loads coal on a horse-drawn wagon to be delivered to homes in Soweto.

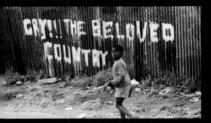

A boy walks by a wall graffitied with the title of Alan Paton's novel, *Cry the Beloved Country*, in Soweto, 1985.

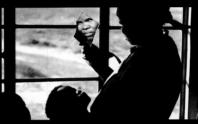

A domestic worker takes time with her children in their quarters in an Afrikaner farmhouse in the Orange Free State during apartheid.

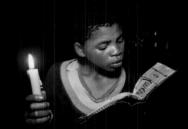

A young girl studies by candlelight because her rural Transkei home lacks electricity.

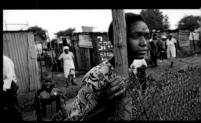

Scene in a squatter camp outside Johannesburg. Squatter camps, or shack-towns, arose as blacks moved from the countryside in search of jobs in or near cities.

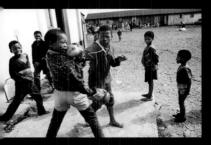

Young boys box in New Brighton, a black township outside of Port Elizabeth. Mandela was an avid boxer, and continued to shadow box to stay fit while in prison.

Robben Island sits in Table Bay, in the South Atlantic, less than eight miles off the coast of Cape Town.
For nearly a hundred years, the island had been used as a leper colony, until, in 1959, it was converted into a maximum-security prison, something of a South African Alcatraz. On the morning of June 13, 1964, seven of the eight defendants convicted in the Rivonia Trial began serving their term there (the eighth, the white Denis Goldberg, went to Pretoria Central Prison, the apartheid system functioning to segregate the races in this as in all matters).

The daily regimen at Robben Island was designed to exhaust, demoralize, and break prisoners. All new political prisoners were put to work in a lime quarry, filling wheelbarrows with crushed stones under the watchful eye of a warden. The spirit of apartheid permeated even the meals—blacks were given the smallest and least nutritious portions. There were no clocks or watches allowed; days began and ended with sirens or with shouts from the prison guards. The prisoners worked and ate in silence.

PRISONER 46664

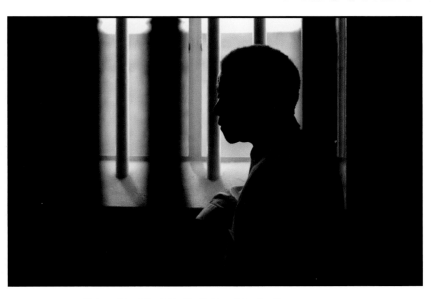

Nelson Mandela visits the Robben Island cell where he spent nineteen years in prison, 1994.

Nelson Mandela, prisoner number 46664, received a "D" group classification upon entrance, the lowest possible, allotting him fewer privileges than a criminal felon. He was allowed only one letter and one visitor every six months. Sometimes, by the time a letter passed from the prison monitor to the security police, who scoured it for banned phrases and covert communications, it was totally illegible. Mandela's words and his image were banned in public, and an embargo was placed on the use of his name. His children were unable to visit. In 1969, when Nelson learned that his eldest son Thembi had died in a car crash, his request to attend the funeral was denied.

In these first "dark years," as he has called them, Mandela would come to know life as a constant battle to keep his nerve. As much for himself as for the other prisoners, who looked to him as their leader, he had to remain strong. He was determined above all else and at all costs to prevent the wardens from robbing him of his dignity, and he chose the tactic of greatest resistance; for each and every personal humiliation that was heaped upon him, no matter how insignificant, he would respectfully call out his captors. The prison guards were, in Mandela's words, "the most unrepentant racists in the world." Yet still he tried to turn a negative into a positive, challenging himself to devise ways to make them change. He studied Afrikaans and, in discussions with white wardens, worked to deepen his understanding of the Afrikaner mentality and find points of identification with their history. If they could learn to treat him with dignity, he believed, anyone could.

Mandela's resolve and his growing rapport with some of the guards began to show results. Thanks in part to hunger strikes and prisoner protests, by the late 1970s hard labor was no longer imposed on the political prisoners on Robben Island, and they were allowed to read and to study. Newspapers were permitted, and more visits and letters were allowed. With Mandela, Walter Sisulu, and other senior ANC members actively moderating the debate and study among the prisoners, the political prisoner wing soon became known as Mandela University. At the lime quarry where they once worked themselves into exhaustion, political prisoners would now gather to recite poems and present lectures.

Though he was invisible to the public eye, Nelson Mandela continued to endure in the hearts of South Africans and people all over the world. This was at least partly thanks to the efforts of Winnie Mandela. Beyond having to endure the absence of her husband, the father of her two daughters, Winnie had been imprisoned on three different occasions since the late 1960s, including an eighteen-month stint in solitary confinement for a charge that was later dismissed. After being banished on imposed house arrest to the rural Afrikaner town of Brandfort, Winnie worked tirelessly to keep her husband's plight in the international conversation, while remaining a determined leader of oppressed black South Africans.

It would be difficult to calculate exactly how many days of his life Nelson Mandela spent in prison. He was arrested numerous times in the 1950s. When the Rivonia Trial defendants began serving their life sentences in 1964, he had already been incarcerated for almost two years on his earlier conviction of leaving the country illegally. In all, Mandela was imprisoned for more than twenty-seven years of his adult life. Through the experience, he had a remarkable ability to maintain his energy, focus, spirit, and purpose.

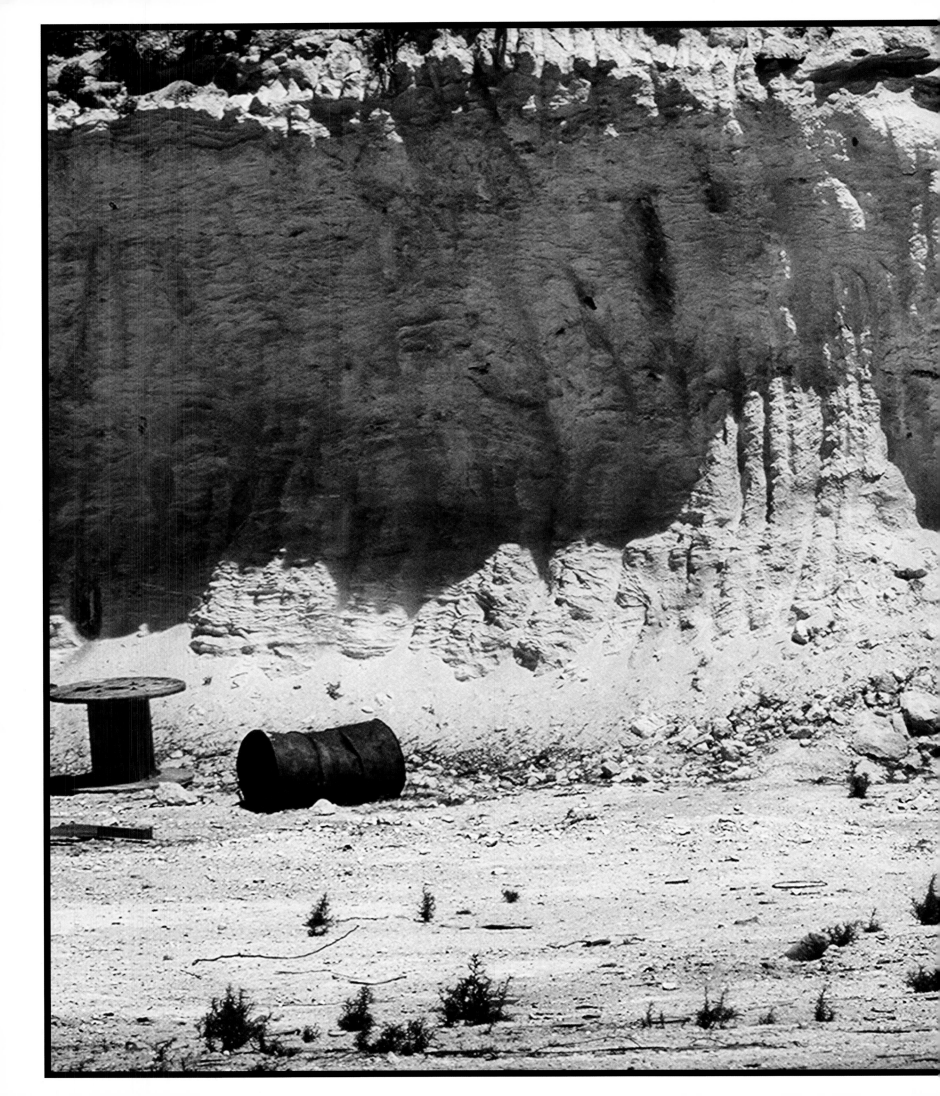

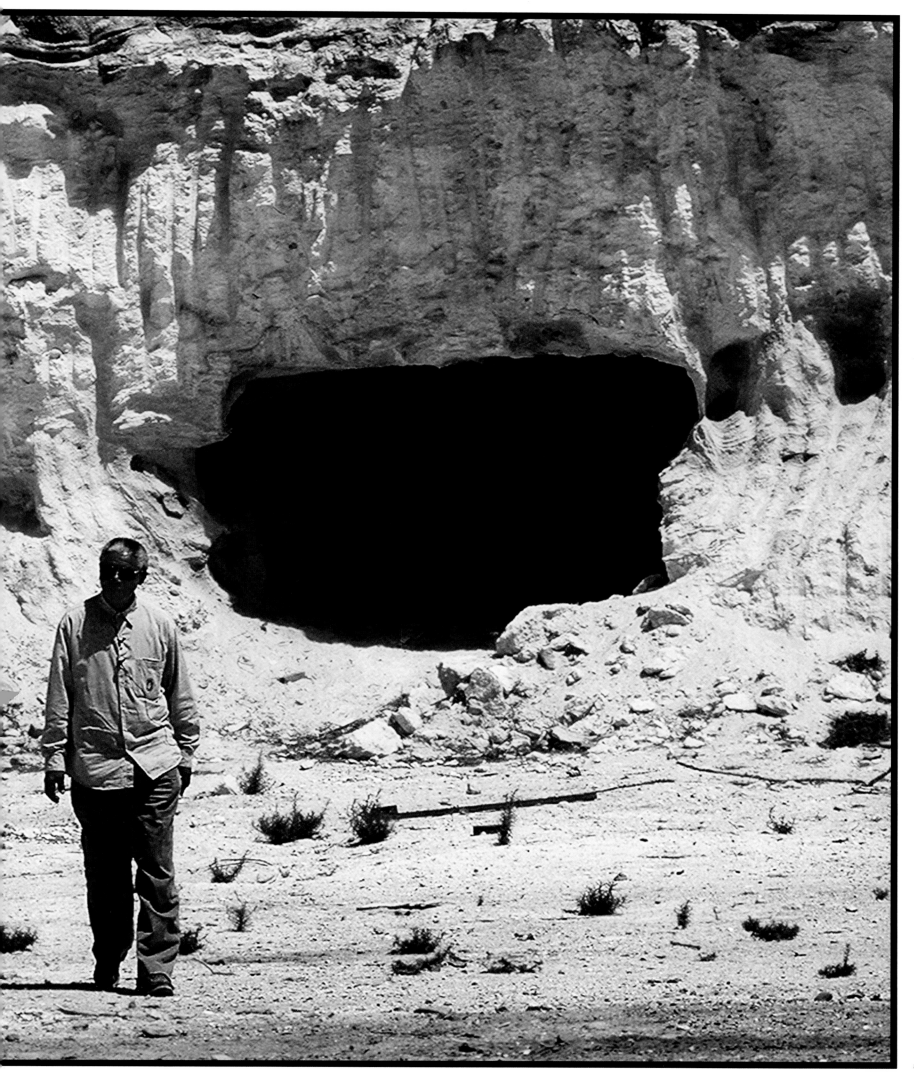

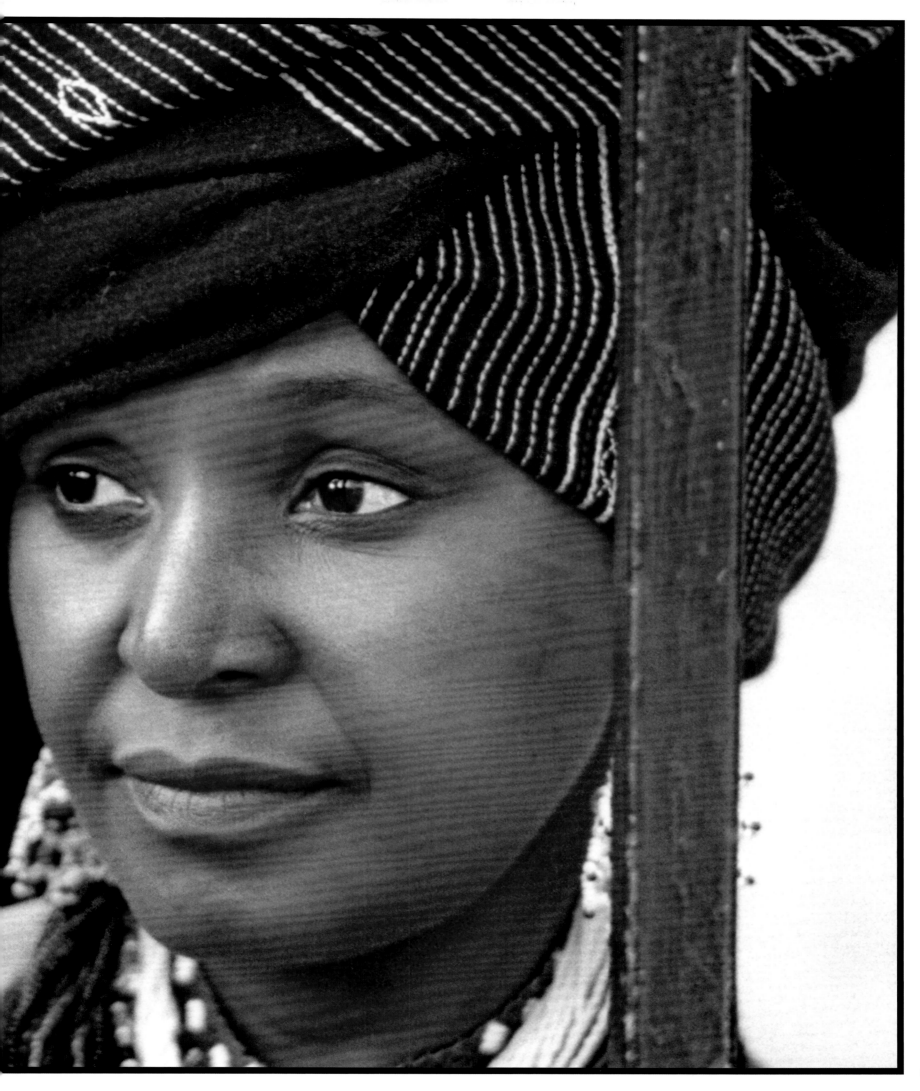

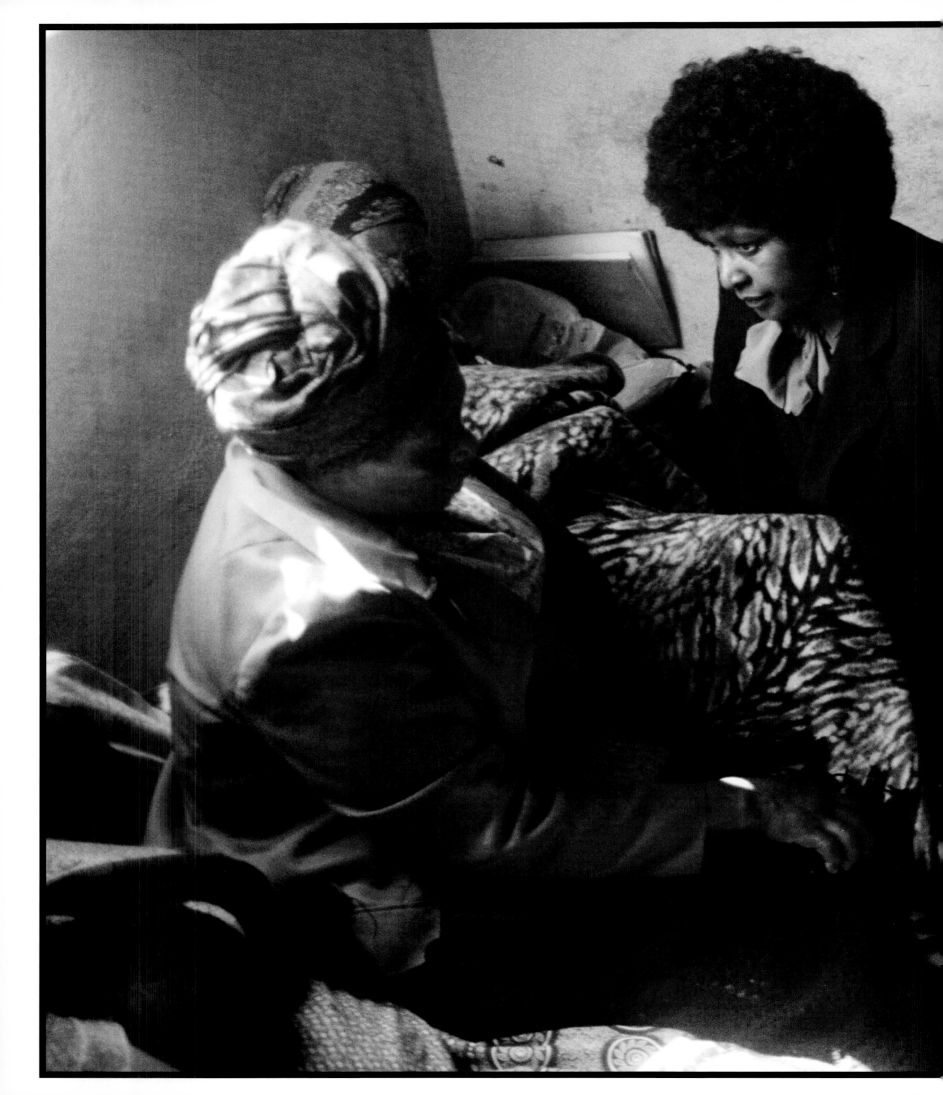

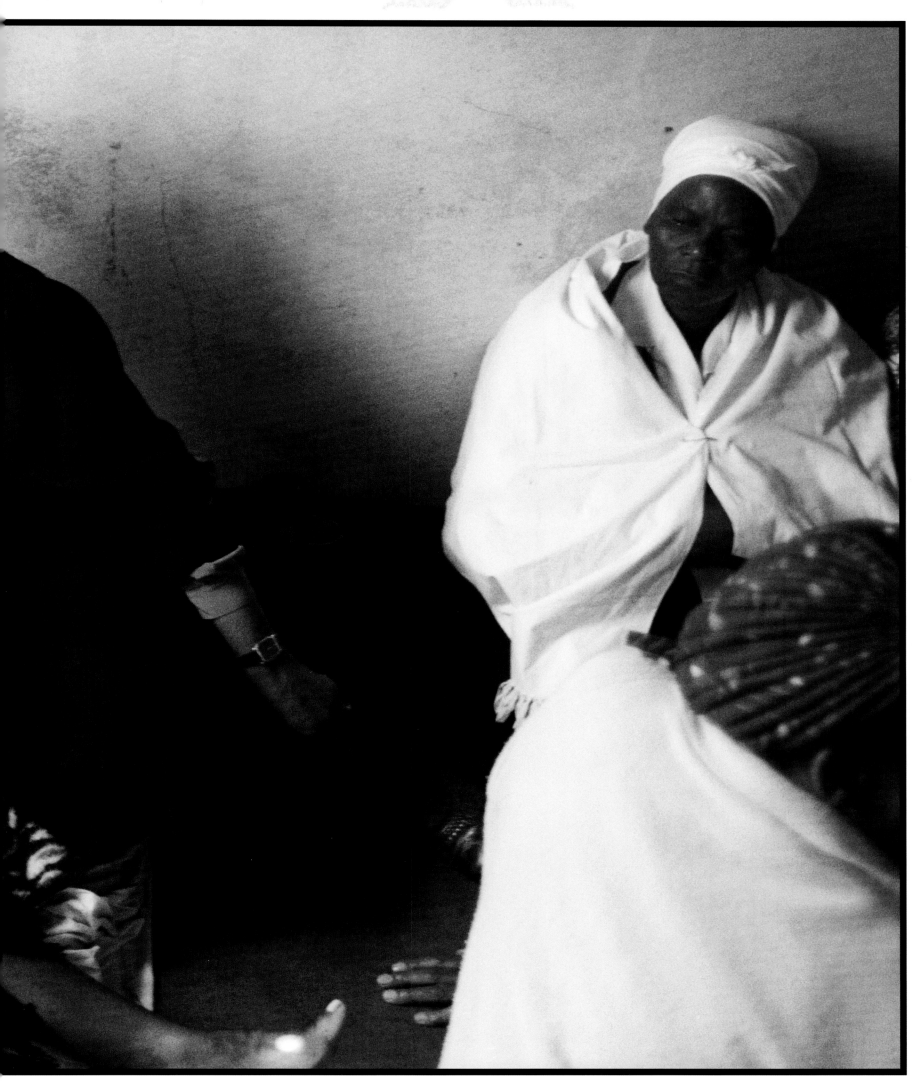

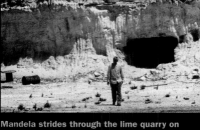

Mandela strides through the lime quarry on Robben Island where he and other prisoners were forced to work, 1994.

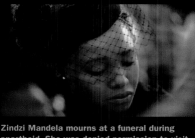

Zindzi Mandela mourns at a funeral during apartheid. She was denied permission to visit her father for most of his time in prison.

Winnie Mandela peers through the gate of her Orlando West home in the 1980s. She lived with Nelson in this house for two years before his imprisonment, and aside from the ten years she was banished to a rural town in the Orange Free State, Winnie continued to live here until her husband was released from prison.

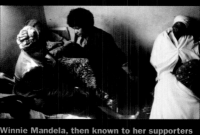

Winnie Mandela, then known to her supporters around the world as the "mother of the nation," mourns with the widows of young men killed in a township confrontation with South African police, mid-1980s.

While Mandela remained locked away in prison, neither apartheid nor the movement against it relented. South Africa was still a nation of two contending realities, rigorously defined by race. Official policy and municipal design were conceived not just to divide different populations but to isolate and enclose them. Through the 1960s and the Cold War, its staunchly anti-Communist stance afforded the government the leverage and justification to proceed without much protest from abroad. Eventually, a split occurred within the Afrikaner establishment over whether enforcing racial separateness was indeed in its long-term interest,

THE STRUGGLE OUTSIDE

but with each national election a new head of state emerged seemingly more tenacious in preserving white dominion in South Africa than his predecessor. Nearly all political parties were made illegal; the ANC was forced to operate in exile from its base in Lusaka, Zambia. Modest government concessions bypassed the most crucial issue of according rights and freedoms to the black majority; white paternalism and increasingly repressive countermeasures only fanned the flames of black unrest.

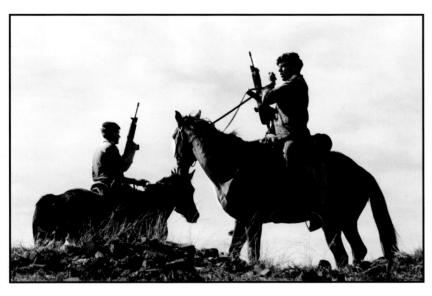

South African soldiers patrol a mass funeral outside of Alexandra Township in Johannesburg in February 1986.

In the effective absence of the ANC and PAC, whose leaders were in prison, younger activists took the initiative in the anti-apartheid movement. Chief among them were followers of the Black Consciousness Movement (BCM), under the leadership of the charismatic Steve Biko. The BCM injected an essential focus on black consciousness and black nationalism into the struggle for South African liberation, ratcheting up the will to resist assaults on everyday life and culture, no matter what the cost. Just how high that cost could be was demonstrated by the 1976 Soweto uprising, a student-led protest against the imposition of Afrikaans as a language of instruction, which left more than five hundred dead. Biko's death in 1977 while in the custody of South African security forces further inflamed the nation. Though the government was able to suppress the BCM in the same manner as it had the ANC and PAC almost twenty years earlier, it was finding it difficult to manage the majority of its people, and the outside world was becoming increasingly inhospitable to the apartheid regime.

Since political gatherings of any kind were banned, religious leaders began to fill the void of protest, becoming activists in rallying appeals to conscience and universal freedom. Most important among them was the Anglican archbishop Desmond Tutu, who, as the leader of the South African Council of Churches used the pulpit to unite and moderate the various flanks of the apartheid struggle. Tutu remained a supremely compelling, influential voice, and was as consistent in denouncing white-minority rule in South Africa as he was in rejecting the use of violence and terrorism as a response to apartheid power. Another activist priest, Reverend Allan Boesak, used his position as the president of the World Alliance of Reformed Churches to inveigh against the blatant injustices of apartheid. He became a visible leader in the United Democratic Front (UDF), an umbrella organization of more than seven hundred religious and civic anti-apartheid activist groups. Like the ANC, the UDF was influential in sustaining a long campaign of peaceful demonstrations in the face of extreme provocation. Both Boesak and Tutu would be critical in tempering the bloodshed that ensued when more militant factions took on the authorities in the volatile period of the 1980s, when a state of emergency was declared.

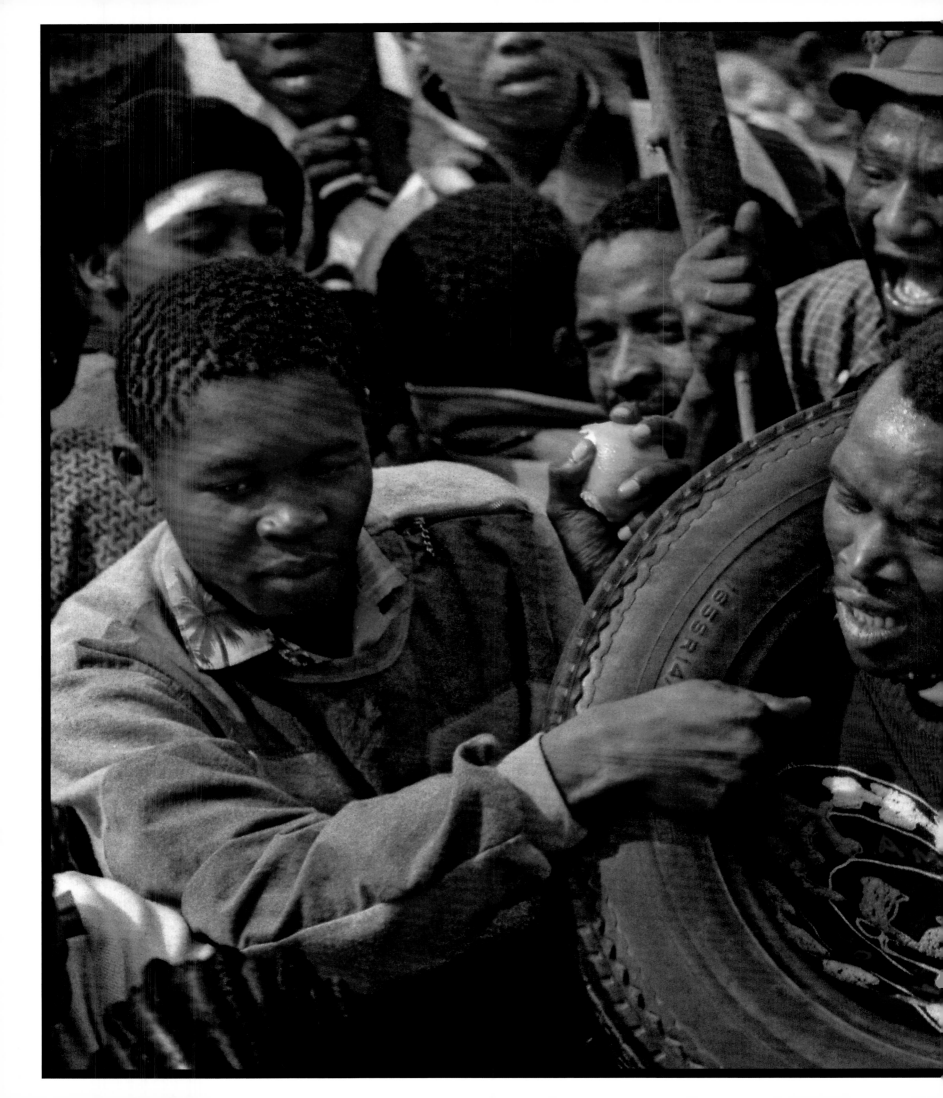

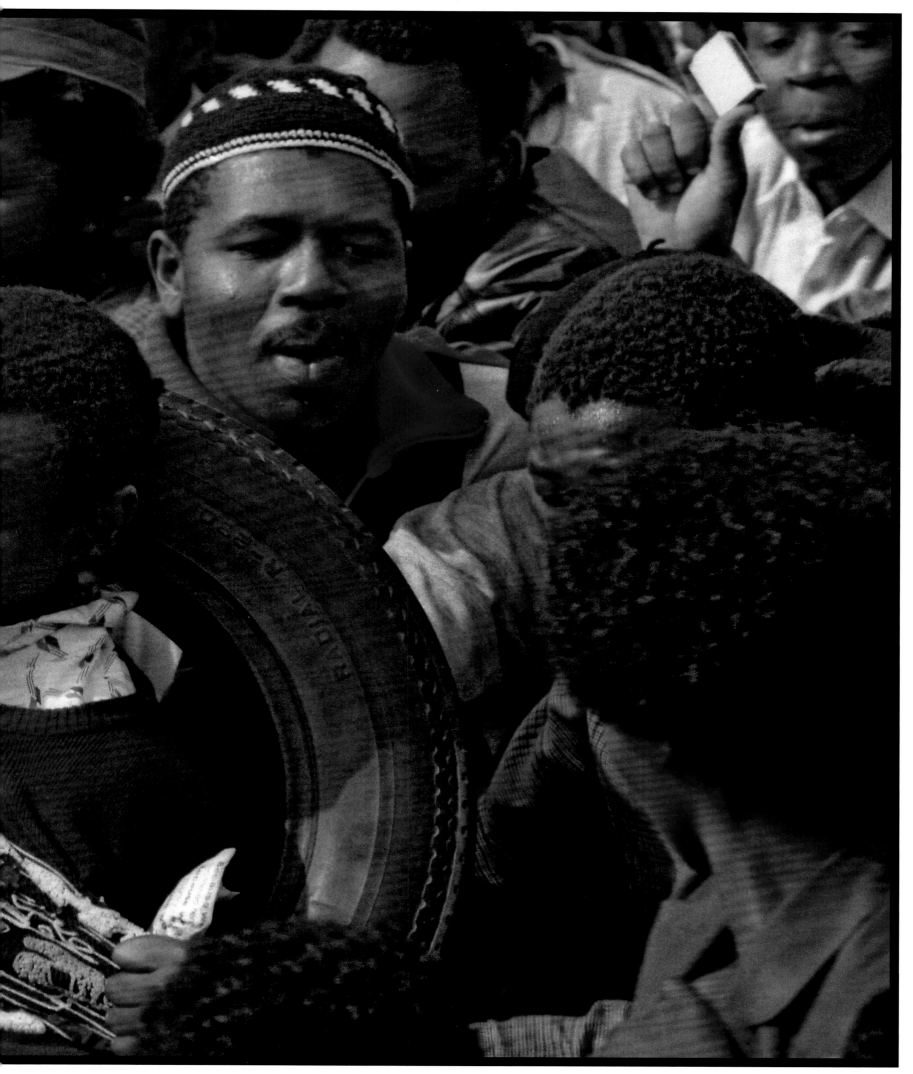

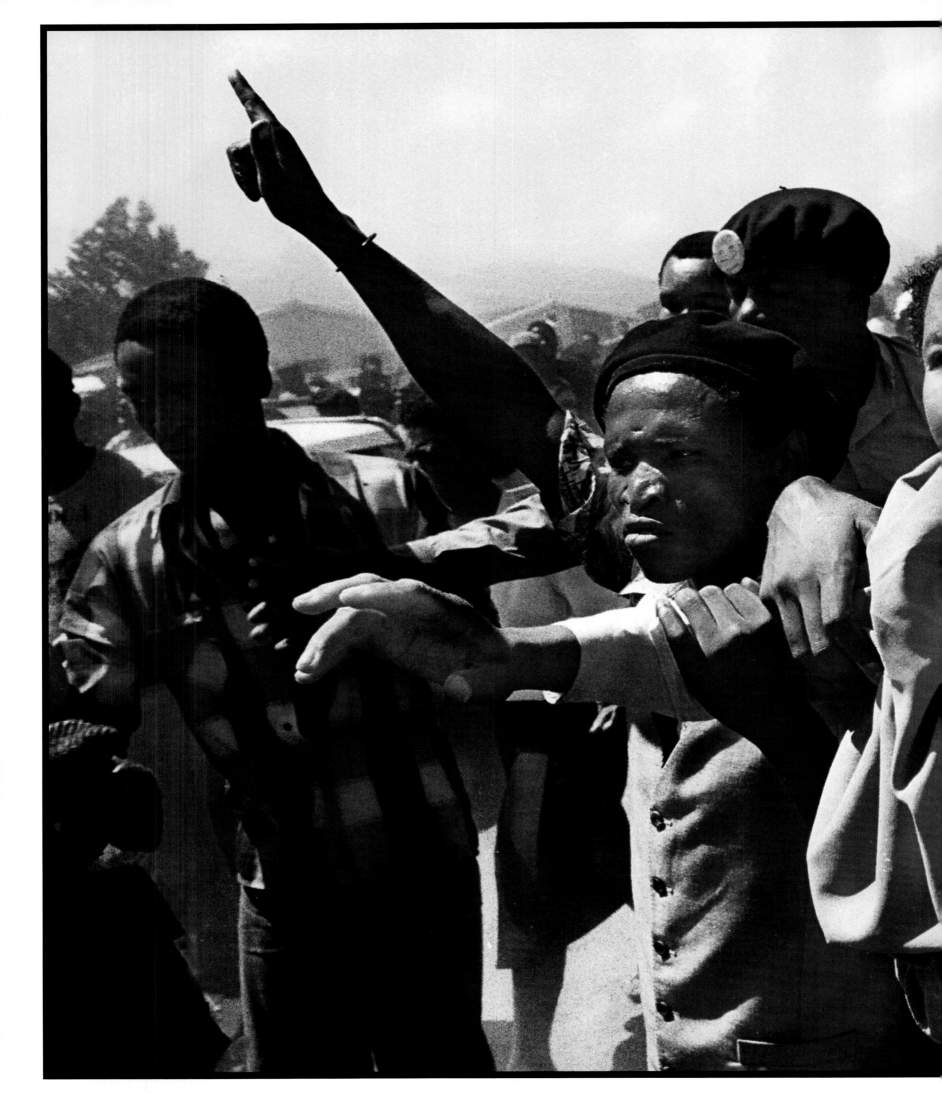

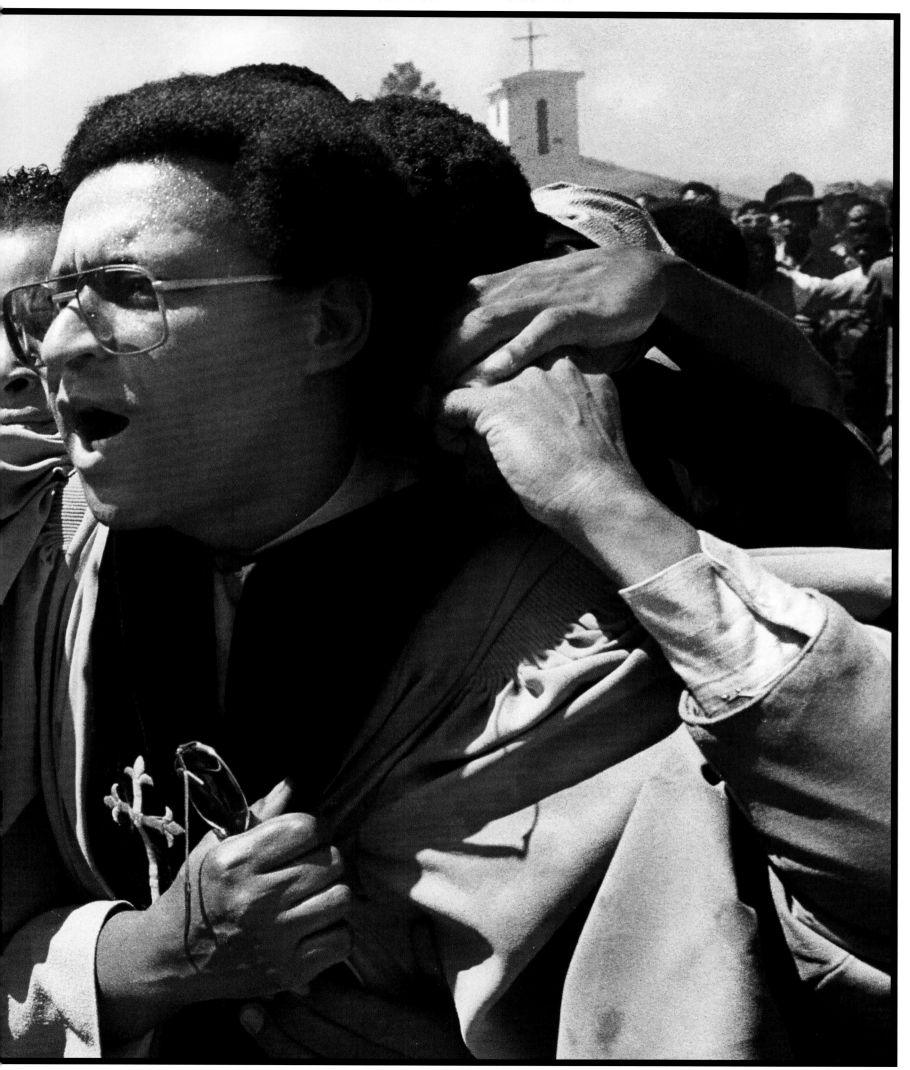

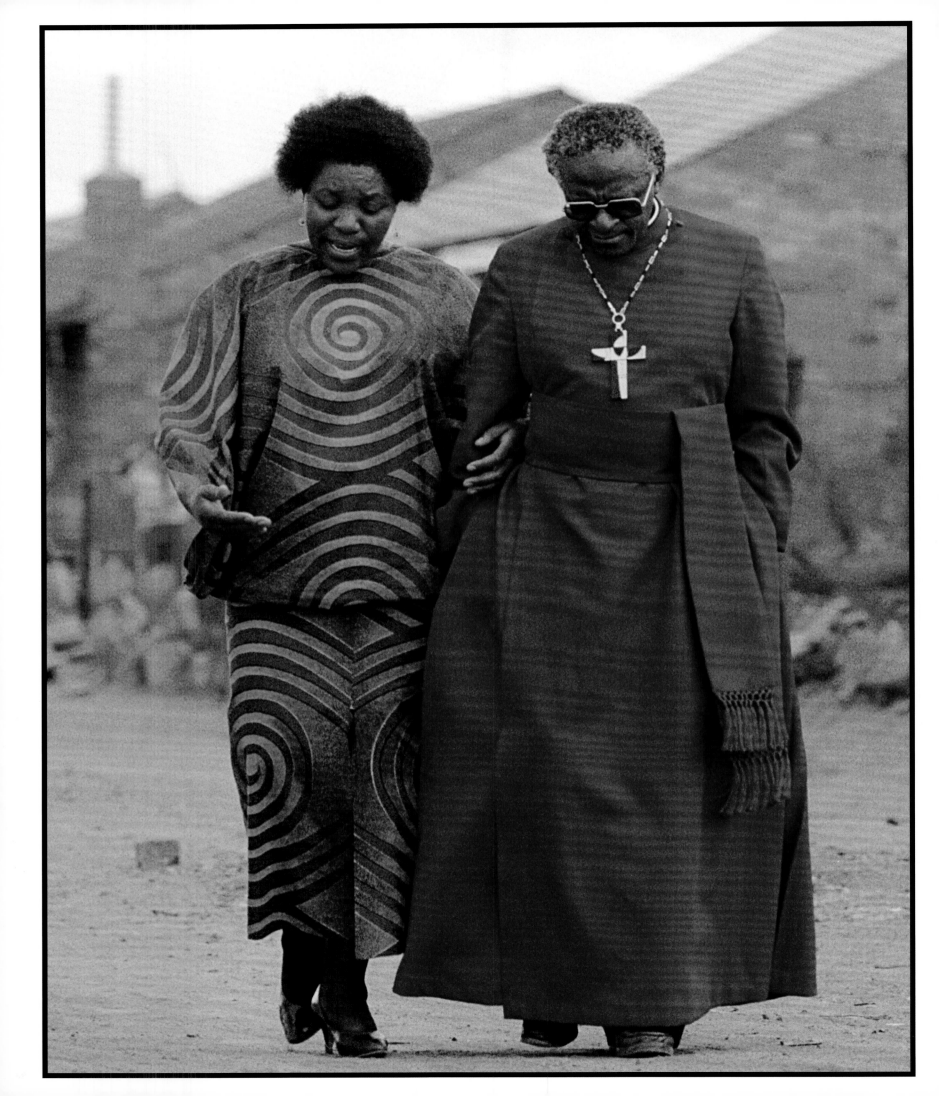

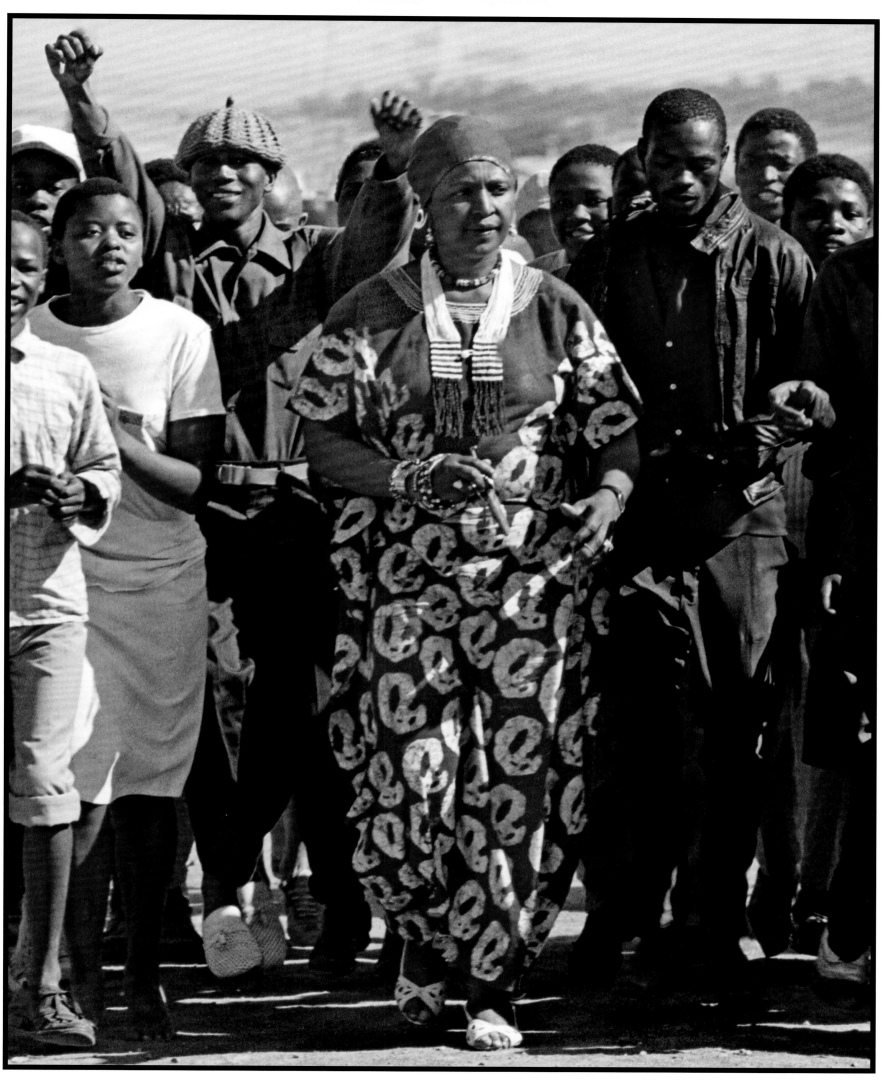

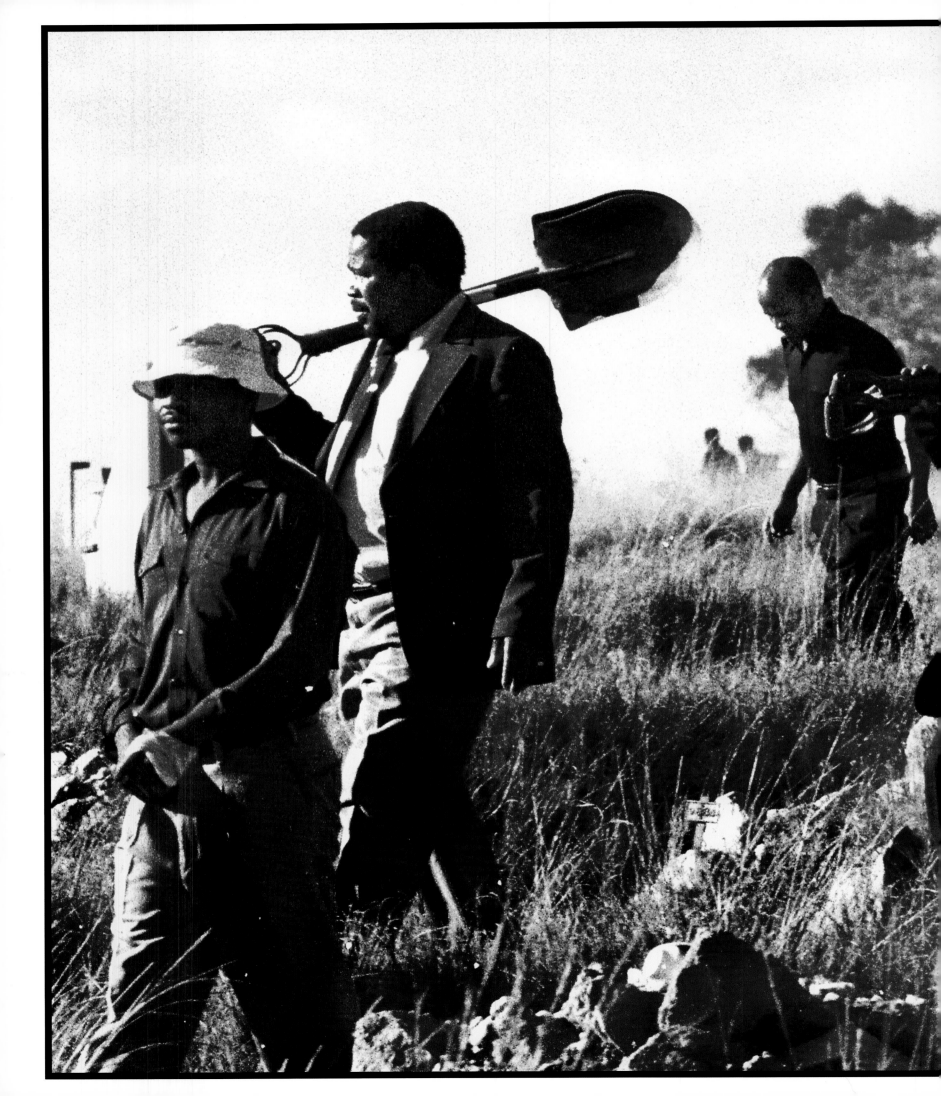

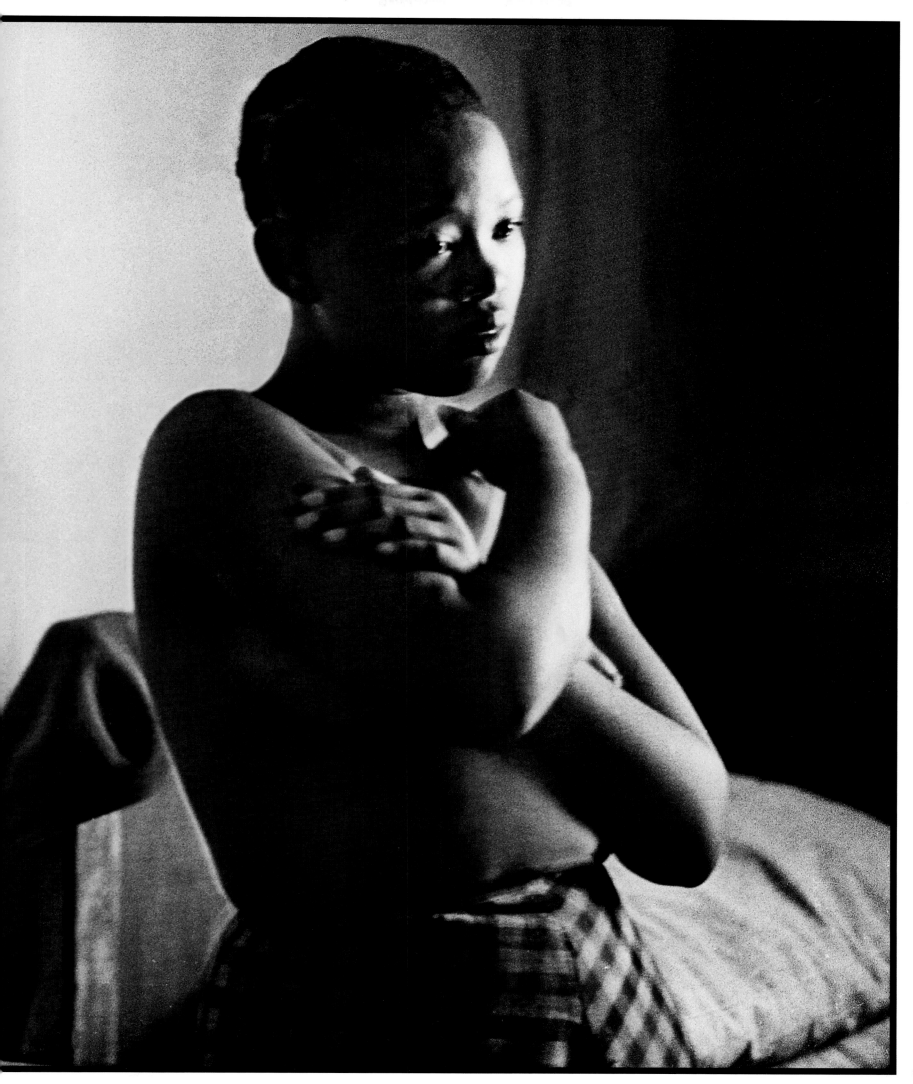

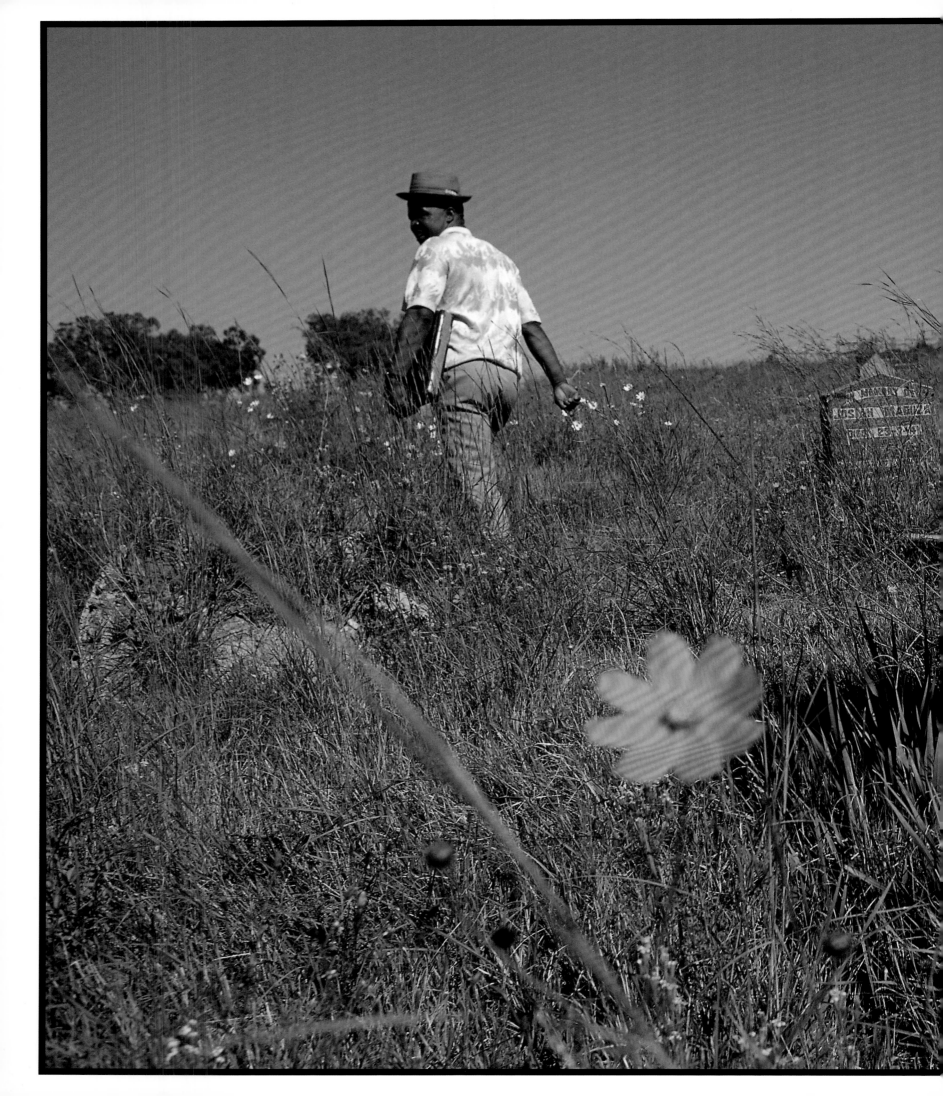

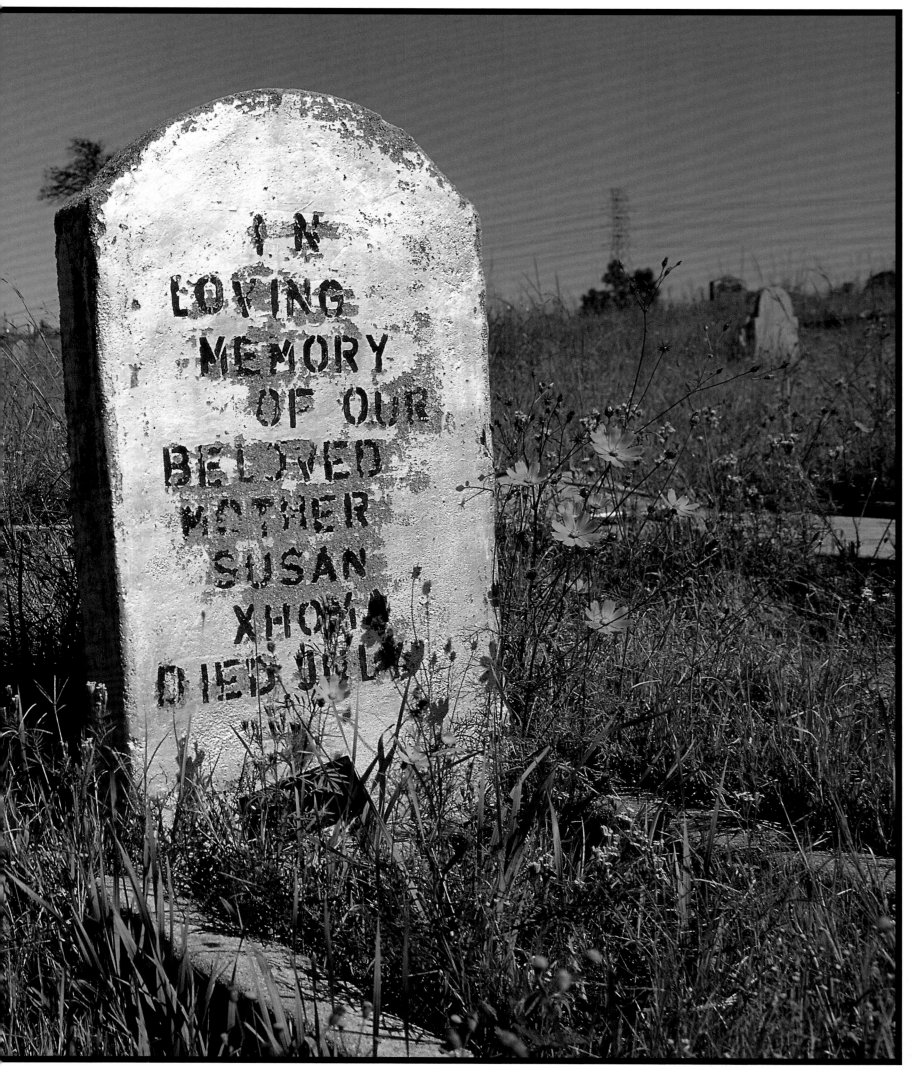

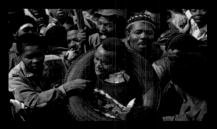

A man suspected of being a police informant narrowly escapes being killed when a crowd put a gasoline-filled car tire around his neck during a political funeral in the Orange Free State. This method of revenge killing became known as necklacing.

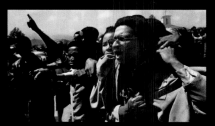

The Reverend Allan Boesak leads a man to safety during a mass political funeral in the Eastern Cape, March 1986. The man was suspected by the crowd of being a police informer.

Archbishop Desmond Tutu and his wife Leah walk in Orlando West, Soweto. The Tutus lived a block away from Winnie Mandela.

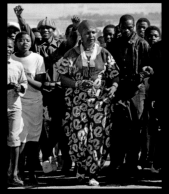

Winnie Mandela leads a group of young ANC members through the streets of a township outside of Brandfort in the Orange Free State, where she was banished for ten years beginning in 1977. There, for a decade, she was officially prohibited from meeting with more than one person at a time.

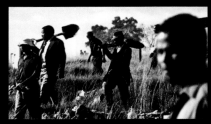

South Africans in a Soweto cemetery return from burying one of the dead killed in a police confrontation.

A young woman, whose brother was killed in a police confrontation, mourns before his funeral in Duncan Valley in 1985.

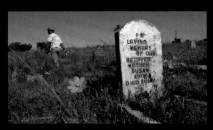

Widows sit during a funeral for victims of unrest in KwaZulu-Natal.

A man pays respects to his ancestors in a cemetery near Johannesburg.

In March 1982, Nelson Mandela, Walter Sisulu, and three other senior ANC political prisoners were transferred from Robben Island to Pollsmoor Prison, a maximum-security facility located on the mainland, in a suburb south of Cape Town. They were all put in the same communal cell on the roof, separated from the other prisoners. Though rumors of sinister motives were wide ranging, the transfer turned out to have a fairly straightforward purpose: The government wanted the imprisoned leaders closer by in order to begin secret discussions with them. The intent was to probe for an opening to negotiations, in an increasingly violent and polarized political environment.

A LEADER EMERGES

Though amenable to relaxing certain repressive laws when he came to power in 1984, President P. W. Botha's ultimate political ruthlessness earned him the nickname The Great Crocodile. Moreover, he was in the position of any political leader whose base is sensitive to even the slightest sign of weakness. When, in January 1985, Botha declared in a speech to the South African House of Assembly that the government would release Mandela in exchange for his renunciation of violence in the struggle against apartheid, Mandela refused. Not unlike Botha, Mandela believed he must appear resolute in his commitment to the ultimate aims of his movement—and he was aware of fears within the ANC that he might compromise his principles in return for his own release from prison. Soon after, in August 1985, Botha's "crossing the Rubicon" speech sent South Africa into a new spiral of turmoil. Against the expectation that he would announce broad reforms, and amid swirling rumors that the government would release Nelson Mandela from prison, Botha expressed his government's refusal to bow to pressure for change, defying the international community. Wave after violent wave of riots burned through the cities and black townships. As it began to feel the effects of the economic sanctions imposed by various nations, and as its international standing declined, the country only suffered further.

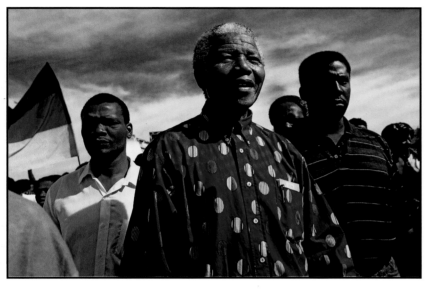

Nelson Mandela campaigns for the presidency weeks before standing in South Africa's first democratic elections, 1994.

Quietly, even as military and police forces were given free rein to use force in countering the growing unrest, Botha began talking with Nelson Mandela through his deputies. Though the two men would come face to face once in a clandestine meeting in Cape Town, they would remain at loggerheads over a complete dismantling of apartheid. Up until the bitter end, Botha refused to negotiate with the ANC or to consider giving political rights to the black majority. Mandela remained behind bars, although he was transferred again, in 1988, to a cottage on the grounds of Victor Verster Prison, about an hour northeast of Cape Town. Furnished with a pool and waitstaff, including one of his former wardens from Robben Island, Mandela was now a step closer to tasting a life of freedom.

In 1989 F. W. de Klerk, representing the wing of the National Party that recognized change would be necessary for South Africa to have a viable, peaceful future, was elected president of South Africa. Not unlike Mikhail Gorbachev, whose *perestroika*, articulated in 1986, would hasten the end of Communism in the Soviet Union, de Klerk began to repeal some of the most repressive apartheid laws. Finally, after a series of candid negotiations, he agreed to the unconditional release of Nelson Mandela and the other Rivonia Trial prisoners.

On February 11, 1990, after spending more than a third of his life behind bars, Nelson Mandela emerged from Victor Verster Prison a free man, at the dawn of a new day in South Africa. Greeted as a statesman, a freedom fighter, and an inspirational leader, Mandela was embraced within South Africa and around the world as a hero.

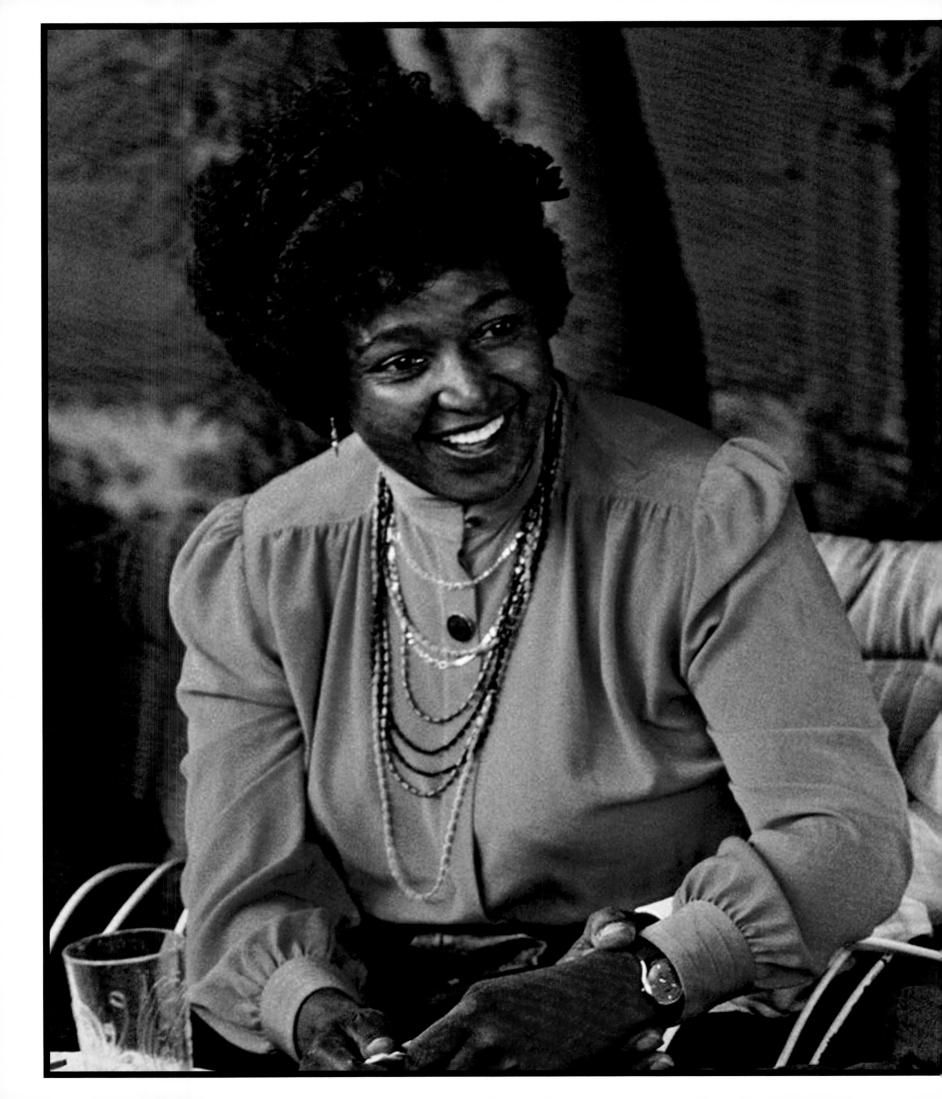

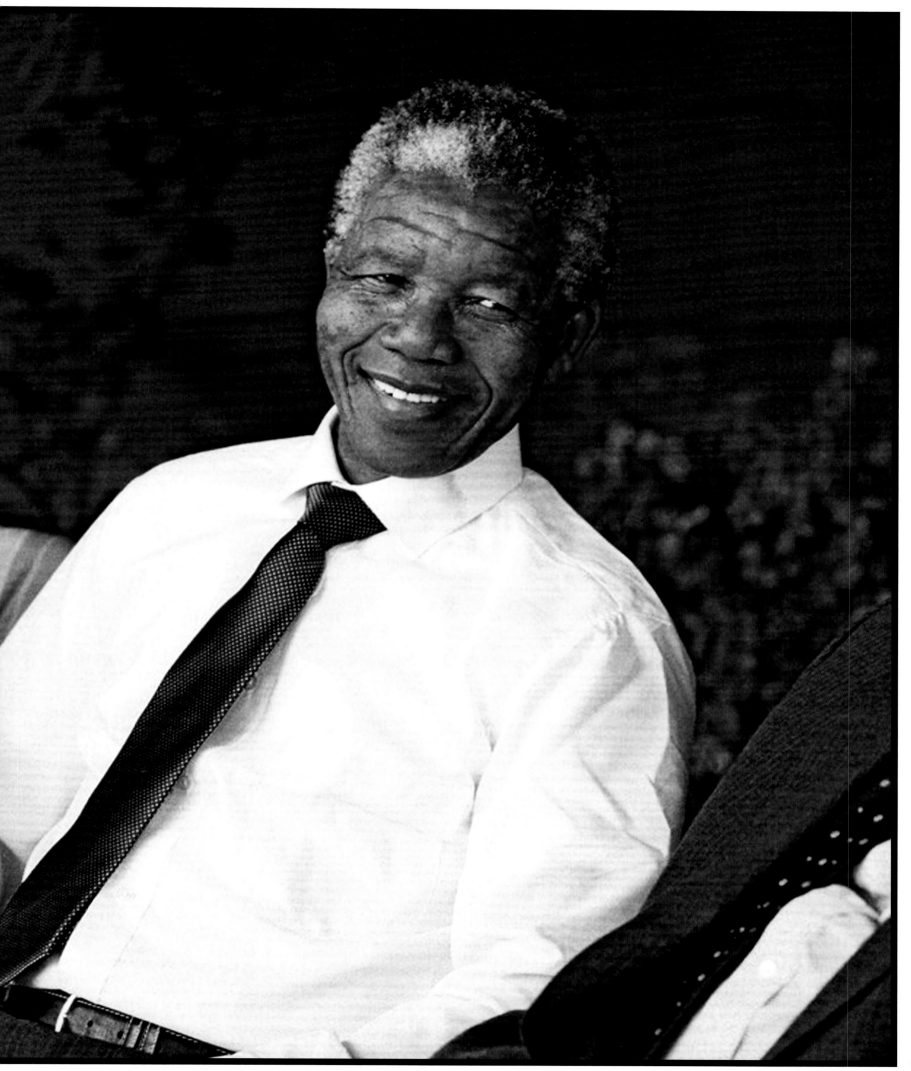

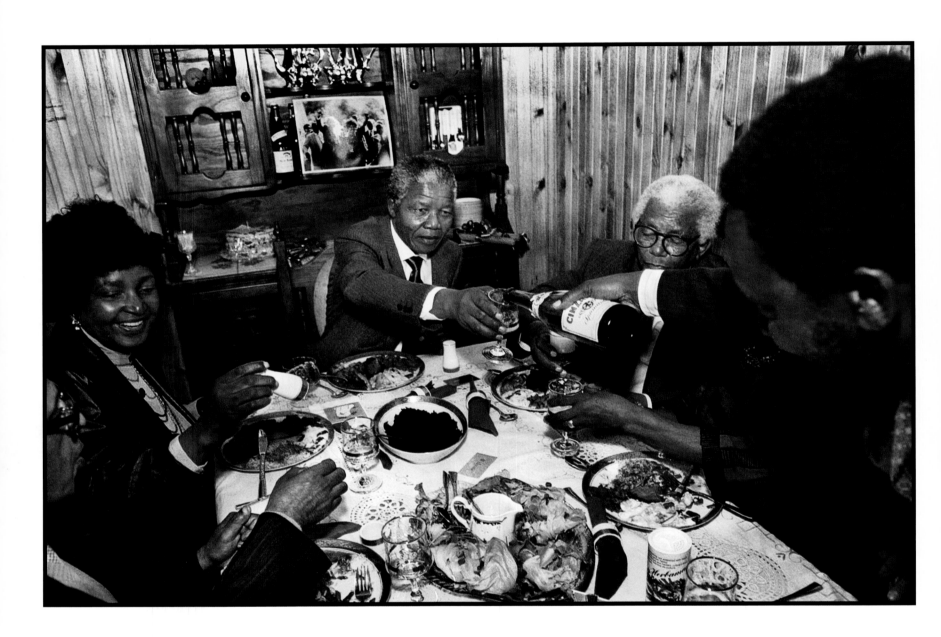

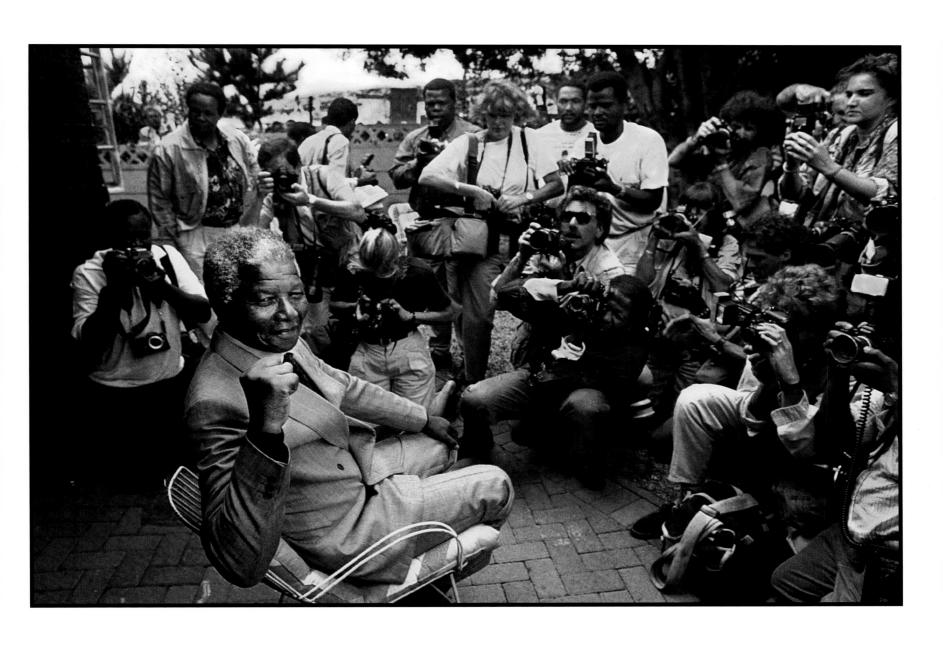

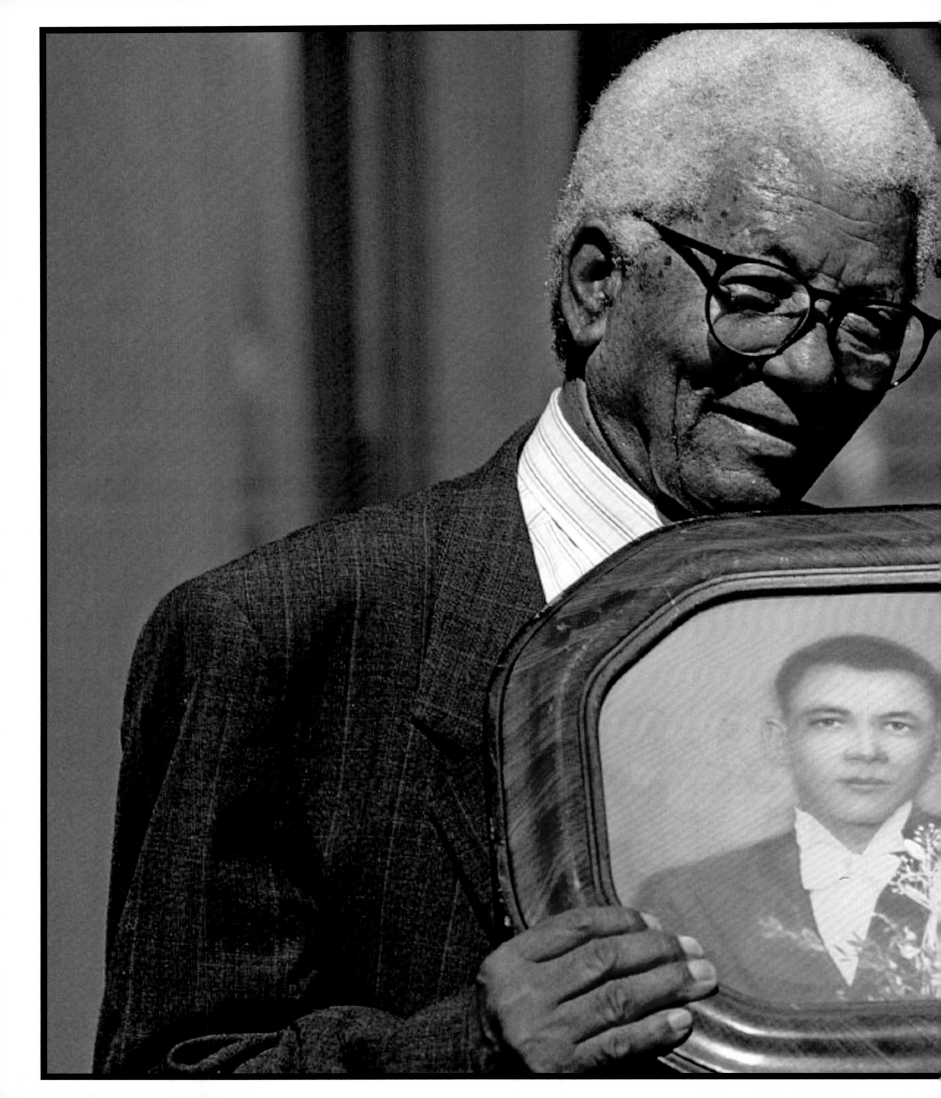

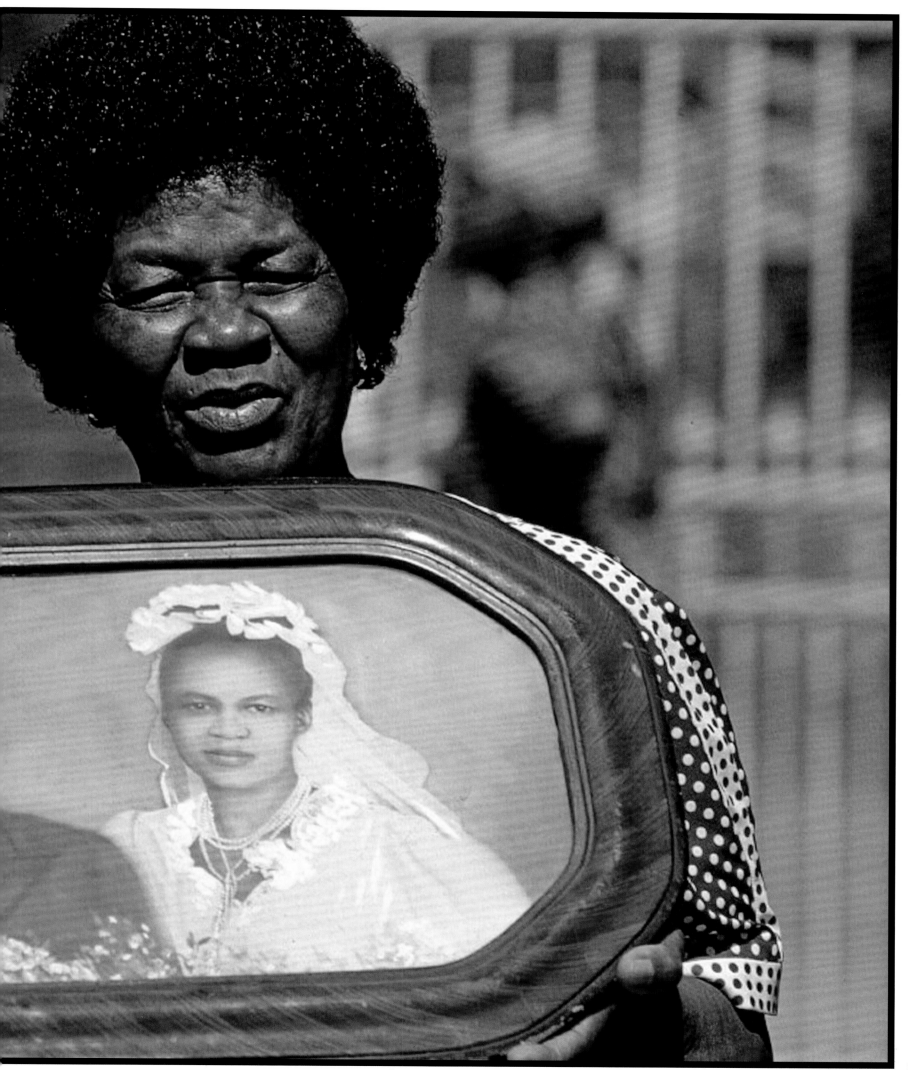

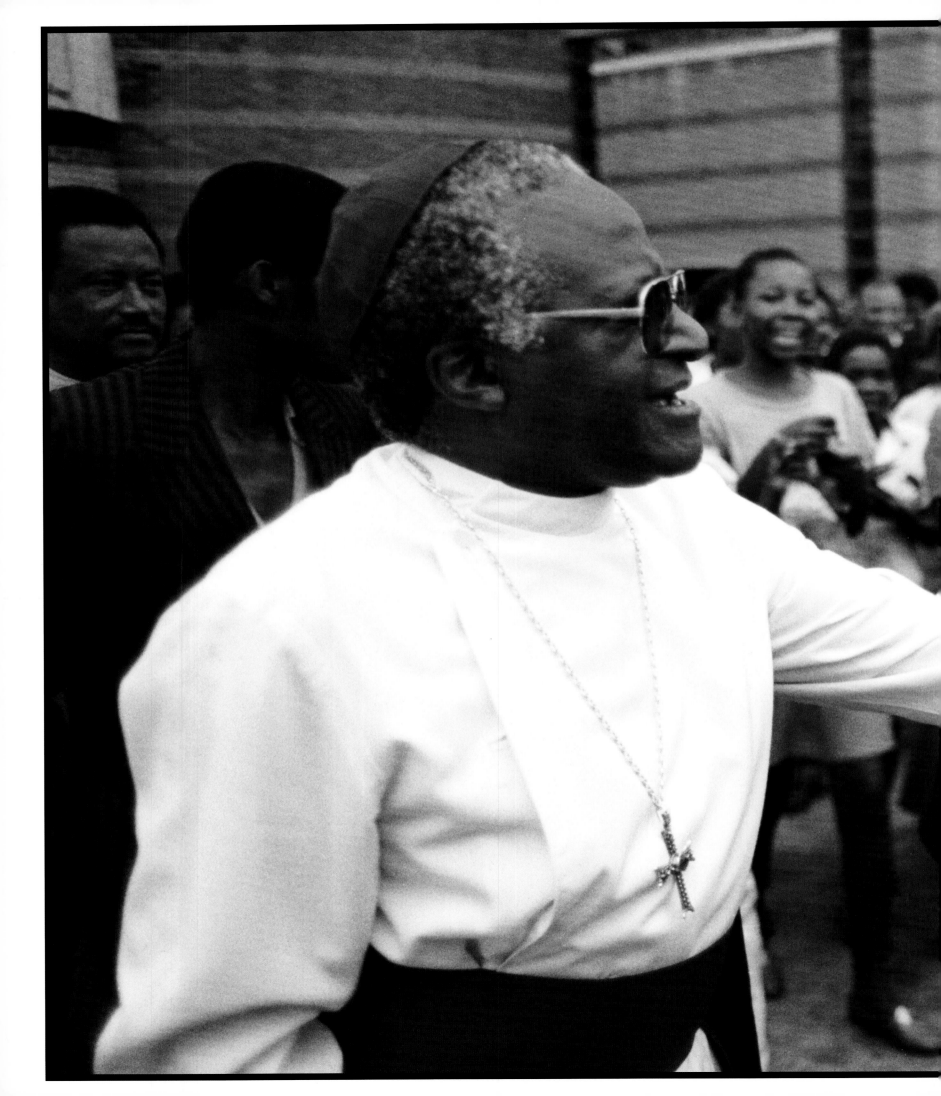

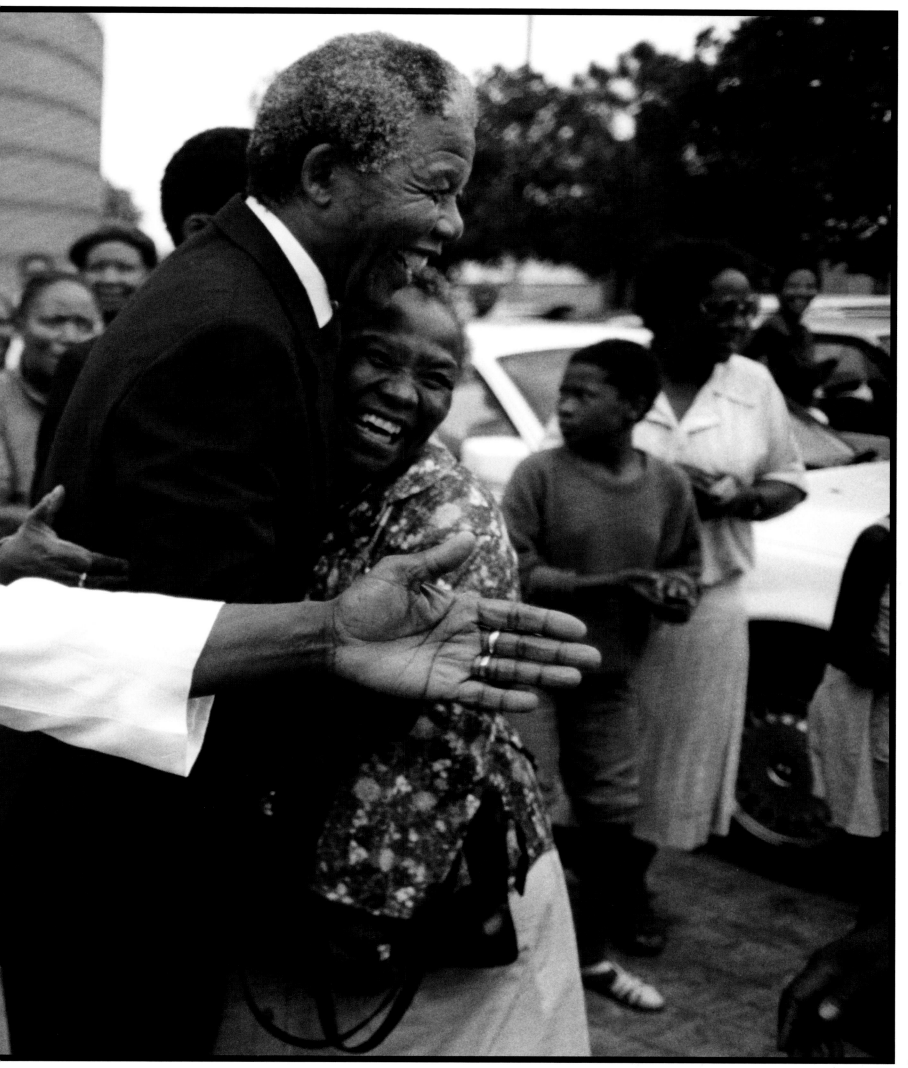

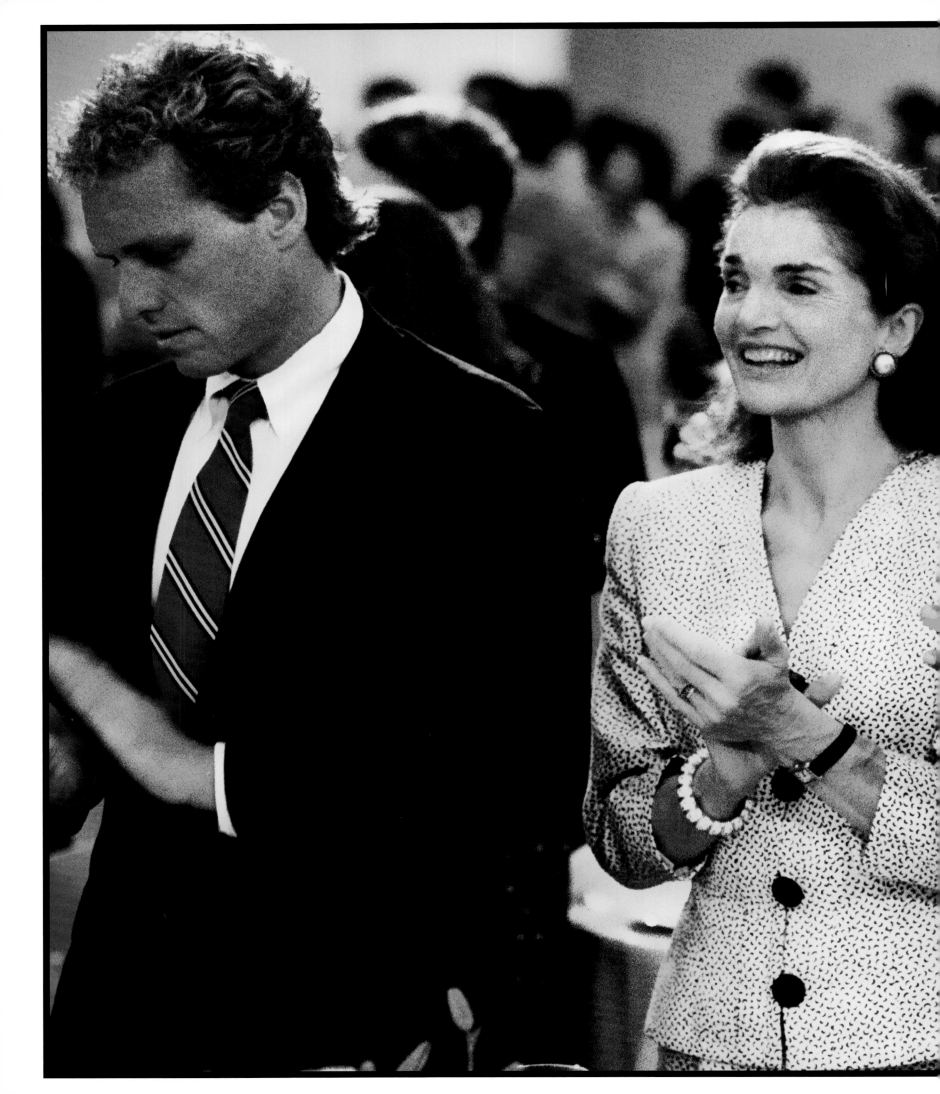

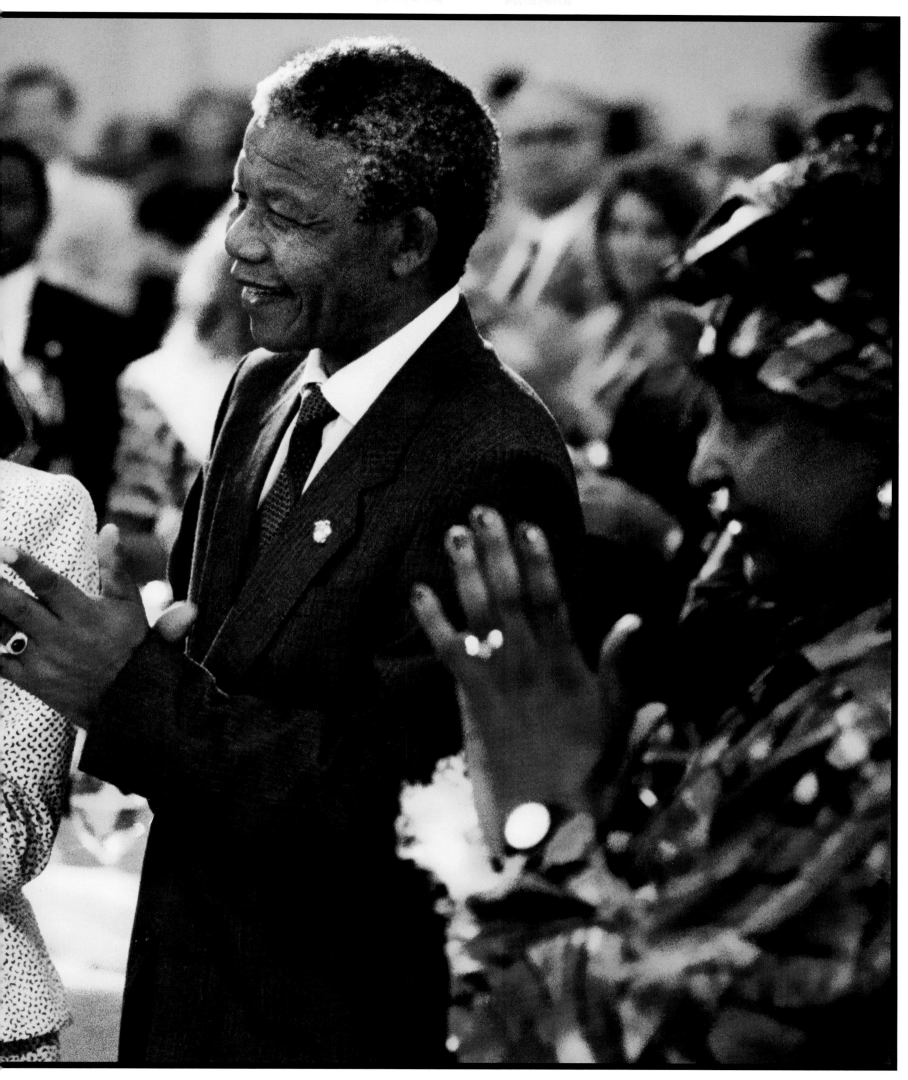

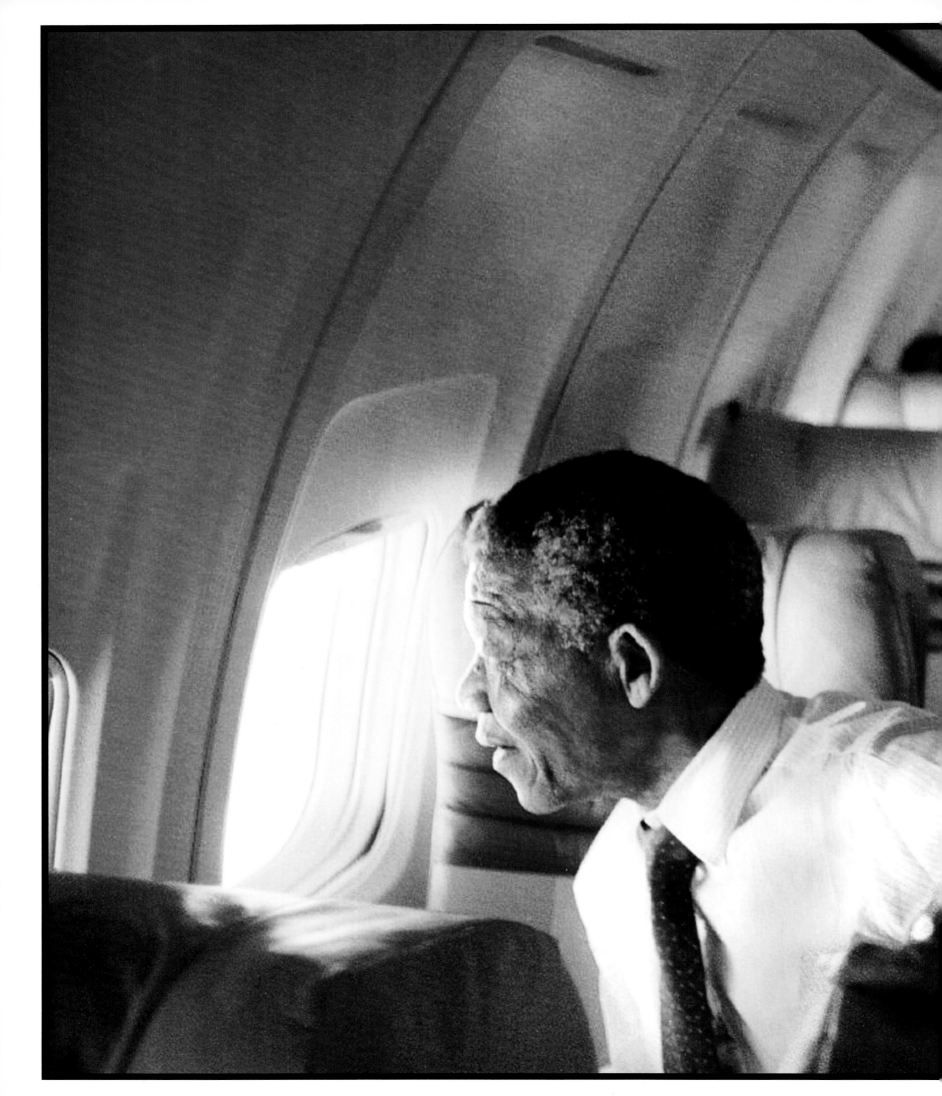

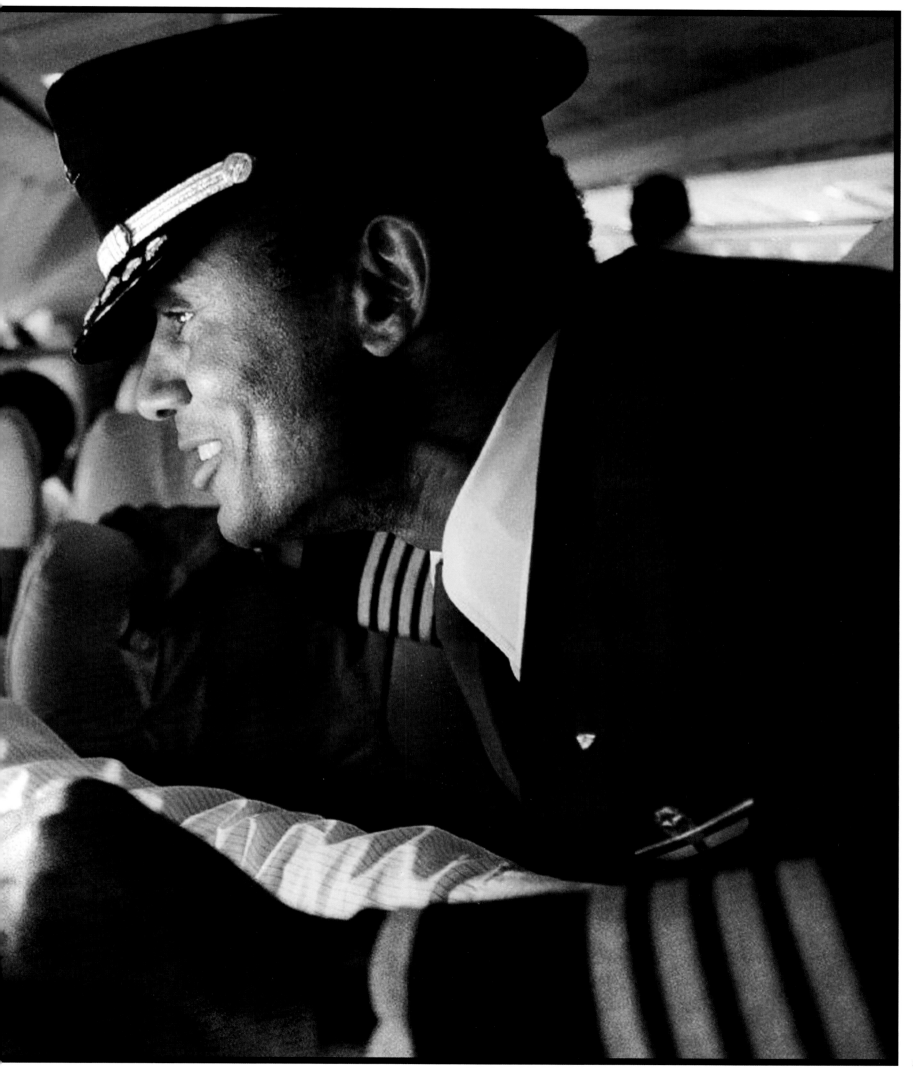

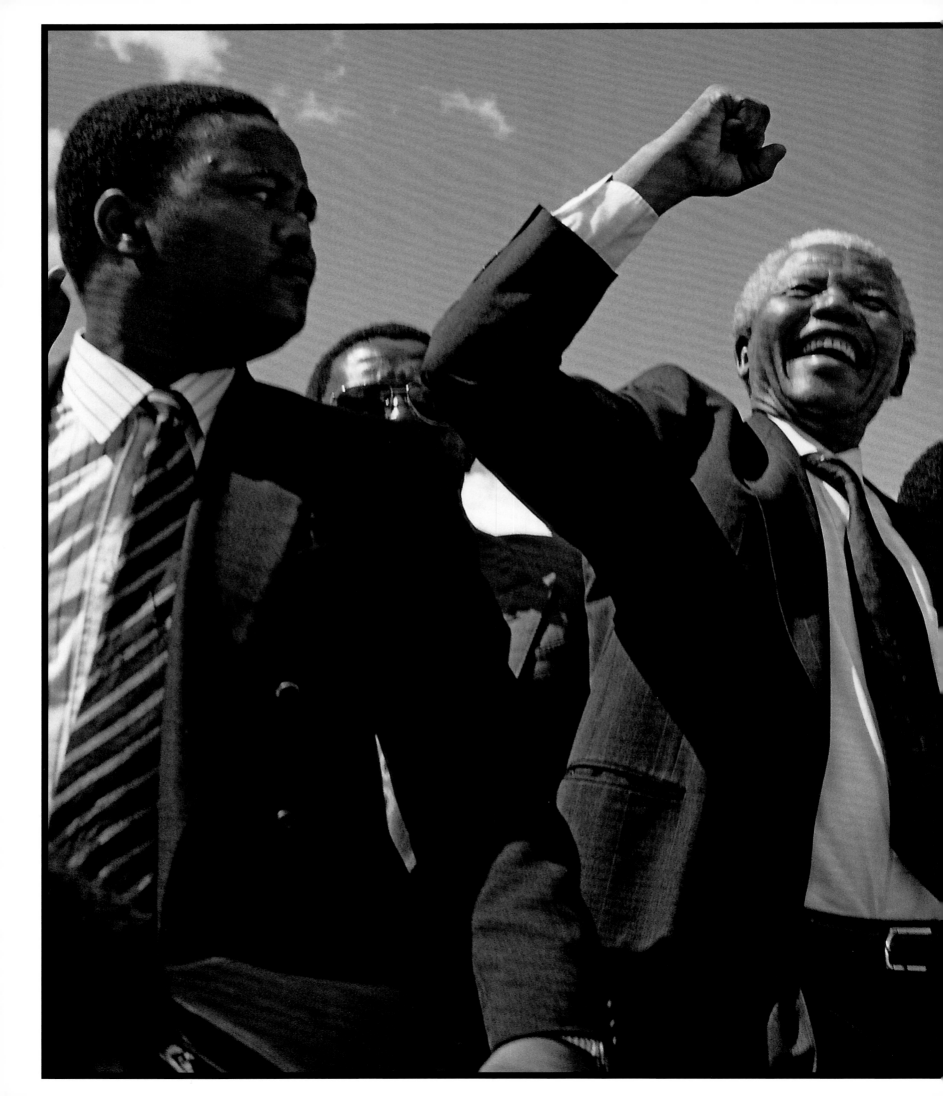

Two days after his release from prison, Mandela sits with his wife Winnie in the backyard of their home in Orlando West.

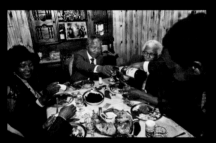

On the first evening of his return to Soweto after twenty-seven years in prison, Mandela enjoys dinner as a free man. Winnie is seated to his right, and Walter Sisulu to his left. Cyril Ramaphosa pours champagne.

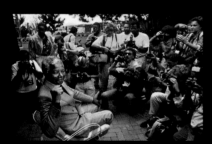

Mandela sits for press photographers in the backyard of his Orlando West home on the day after his release from prison. On seeing the cameras, Mandela joked, "Are these weapons?"

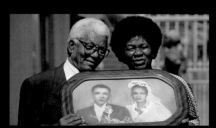

Walter Sisulu and his wife Albertina pose with their wedding portrait. Sisulu spent twenty-six years in prison with Mandela.

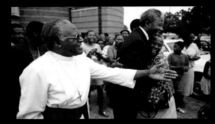

Accompanied by Archbishop Desmond Tutu, Nelson Mandela greets his people in Soweto days after his release from prison.

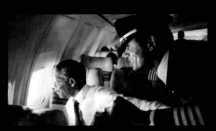

With his wife Winnie, Nelson Mandela meets Jacqueline Kennedy Onassis and Joseph Kennedy at the Kennedy Library on their first visit to the United States in 1990.

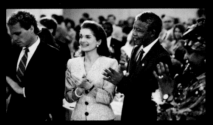

Mandela with the Trump Airlines pilot who flew the plane on Mandela's American tour, 1990.

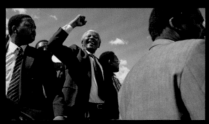

Mandela campaigns for the presidency of South Africa in 1994.

THE ROUGH ROAD TO DEMOCRACY

For more than a hundred years, black South Africans had been trying to sit down and talk with their government, and now the day had finally come. It was inevitable that Mandela, as leader of the ANC, would be central to those talks and that he would stand a good chance of becoming president of South Africa, once an agreement was reached establishing the ANC (and other previously banned organizations) as a legitimate political party—and once the numerous other issues in the transition to a truly democratic process were resolved. From the outset of their negotiations, Mandela and de Klerk had connected and shown a respect and trust in each other's sincerity.

Mandela's task was not easy, however. As party leader, he had to repair deep fissures and rivalries within the ANC. To build a majority party, he would need to unite the various groups struggling for the end of apartheid. And perhaps hardest of all, he had to negotiate with a government that he knew would try to hang on to its power at whatever cost.

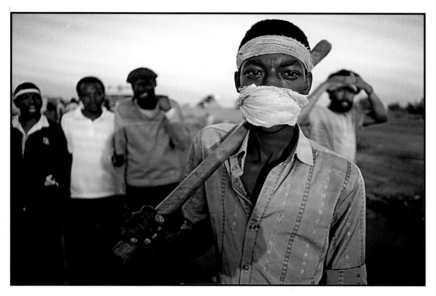

These ANC sympathizers are about to clash with IFP members in East Rand Township just before the elections in 1994.

Ugly and widespread violence, particularly between the ANC and the Zulu Inkatha Freedom Party (IFP), an anti-apartheid organization in the province of Natal, cast a dark cloud over this otherwise hopeful time. Distressed at the surge of violence, Mandela tried unsuccessfully to reach out to IFP leader Zulu chief Mangosuthu Buthelezi. As Inkatha fighters continued to wage fierce street battles with ANC members, Mandela began to hold de Klerk responsible, accusing him of using state security forces to protect "IFP warlords" who were "instigating violence on a mass scale." Mandela and de Klerk evolved into bitter adversaries, and the ANC launched a civil disobedience campaign of strikes and boycotts to demonstrate its widespread support throughout the country.

Mandela's relationship with Winnie also deteriorated as their political paths diverged. More militant and less conciliatory toward the white government than her husband, Winnie was convicted in 1991 of kidnapping, in an incident that had led to the murder of an alleged government informer two years earlier. With sadness and noticeable affection, Mandela announced their separation in April 1992; divorce followed four years later.

When, in April 1993, Chris Hani, the head of the South African Communist Party and one of the country's most popular leaders, was assassinated by a white right-wing fanatic, the country entered a deep crisis, teetering between civil war and democratic politics. Mandela rose to the occasion. The night of Hani's murder, he made a statesmanlike televised appeal to all South Africans, black and white, for calm—and the strongest call yet for political foes to reconcile their differences for the sake of moving forward. Thereafter, the violence began to subside. Despite their conflicts, Mandela and de Klerk were viewed by the wider world as partners in fomenting peaceful change, and the year ended with the award of the Nobel Peace Prize to both men jointly "for their work for the peaceful termination of the apartheid regime, and for laying the foundations for a new democratic South Africa."

When it finally came, South Africa's first democratic election was marked by relatively little violence and confusion. Beginning before sunrise on April 27, 1994, nearly 20 million voters took their places in poll lines across the country. Mandela, in a show of political solidarity with rival third-party Inkatha, cast his vote in Durban, the Zulu stronghold. The election drew a startling 90 percent turnout, and the African National Congress won more than 60 percent of the vote. Mandela became the country's first black head of state. The ANC formed a "Government of National Unity" with the National Party and the IFP, and F. W. de Klerk was named deputy president. On May 10, in a magnificent ceremony put on by the outgoing government, Nelson Mandela was inaugurated as president in front of the Union Building in Pretoria. More than a billion people watched around the world, and some four thousand international guests, from Hillary Clinton and Fidel Castro to Yasser Arafat and Mandela's former Robben Island prison wardens, were in attendance. South African Air Force jets roared overhead in a salute to the new leader.

In his first speech as president, Nelson Mandela promised a future that would not see the tragedies of its history repeated, proclaiming, "Never, never again shall it be that this beautiful land will again experience the oppression of one by another." De Klerk would later appoint the day broader significance, calling South Africa's first democratic transfer of power "the last manifestation of white rule—not only in South Africa—but the whole continent." With Nelson Mandela at the helm, a new South Africa was born.

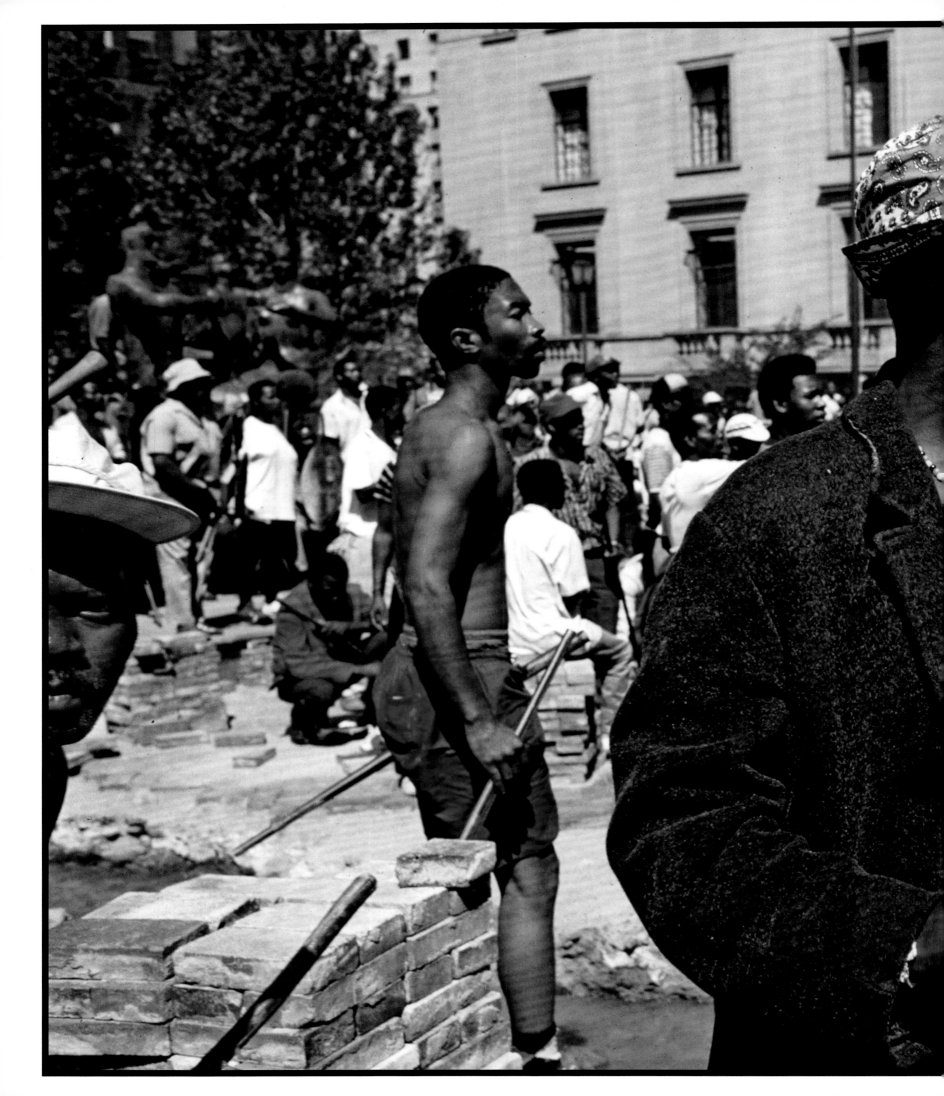

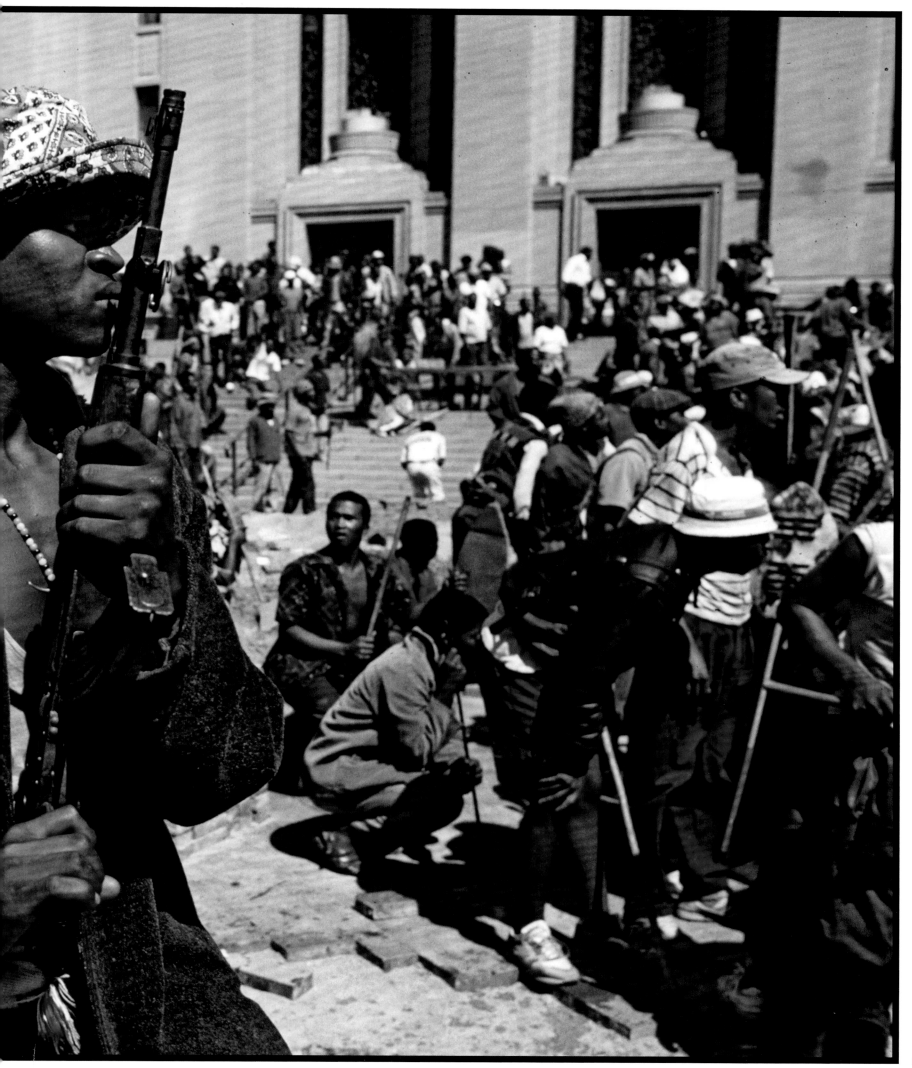

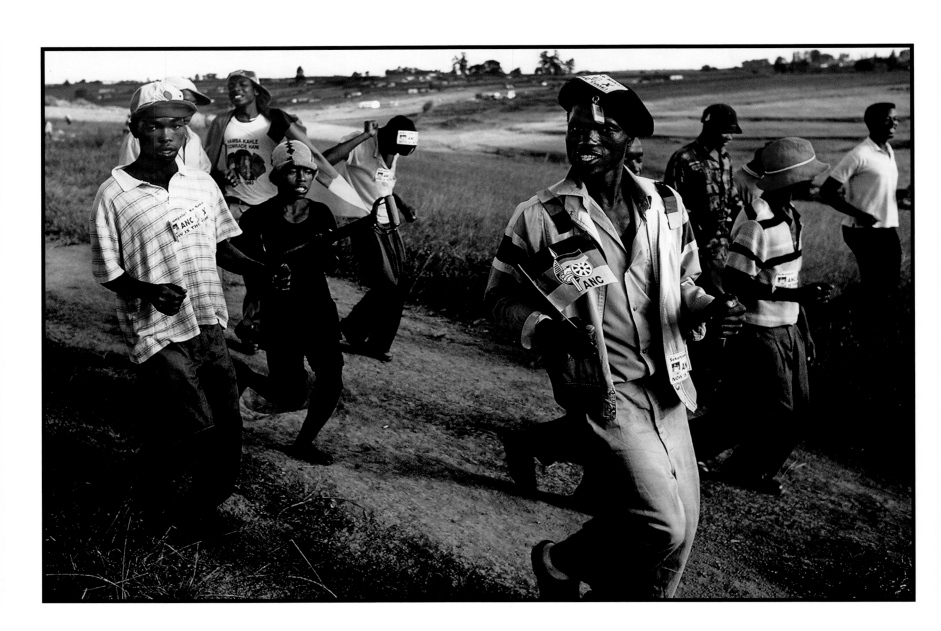

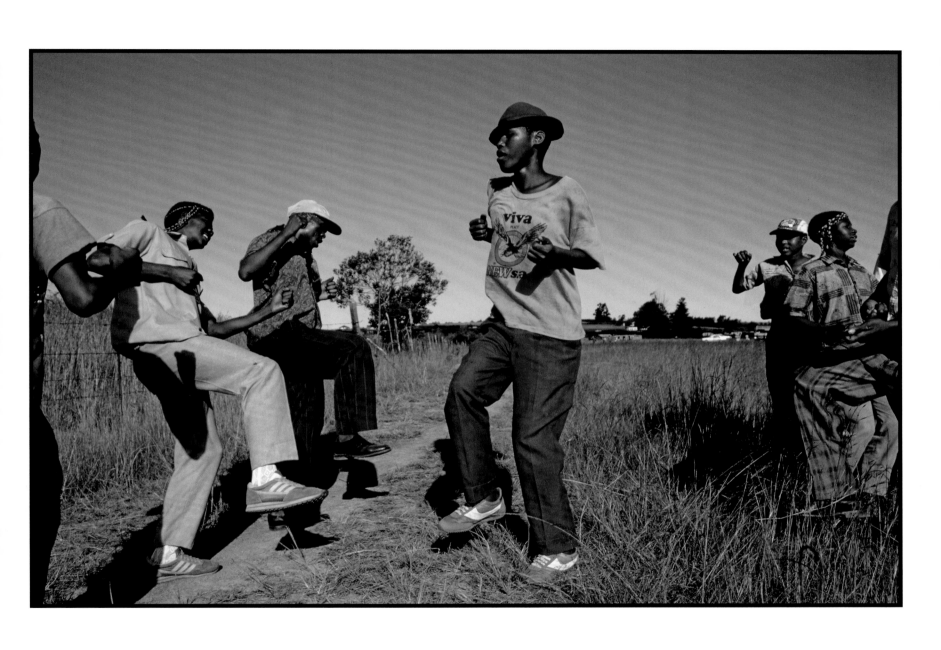

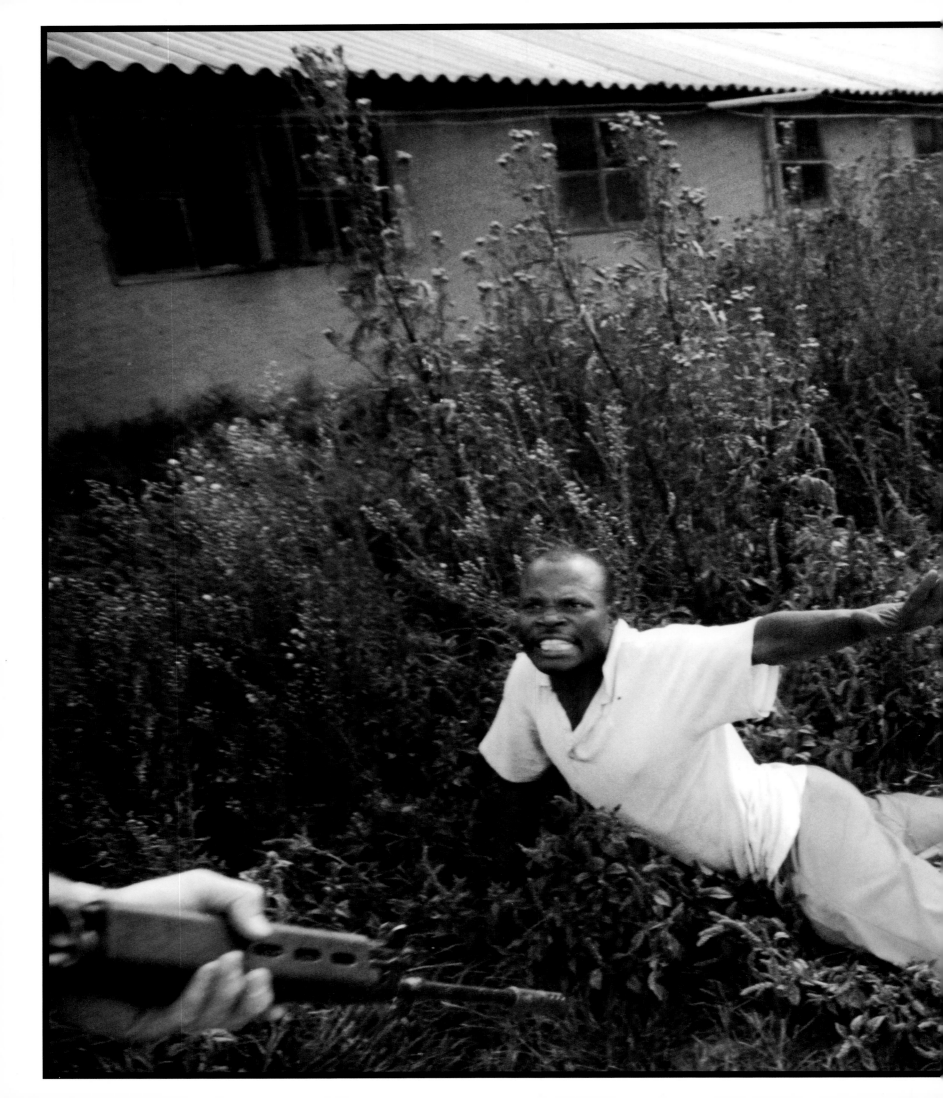

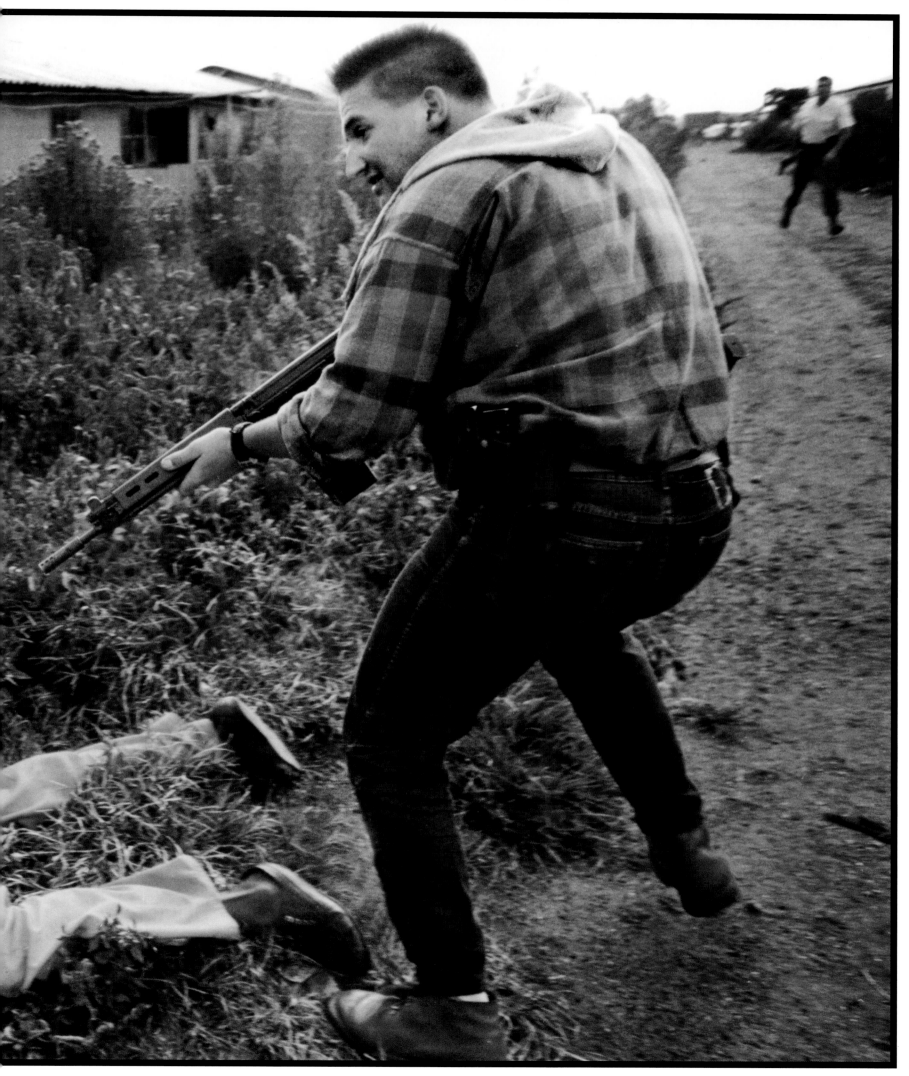

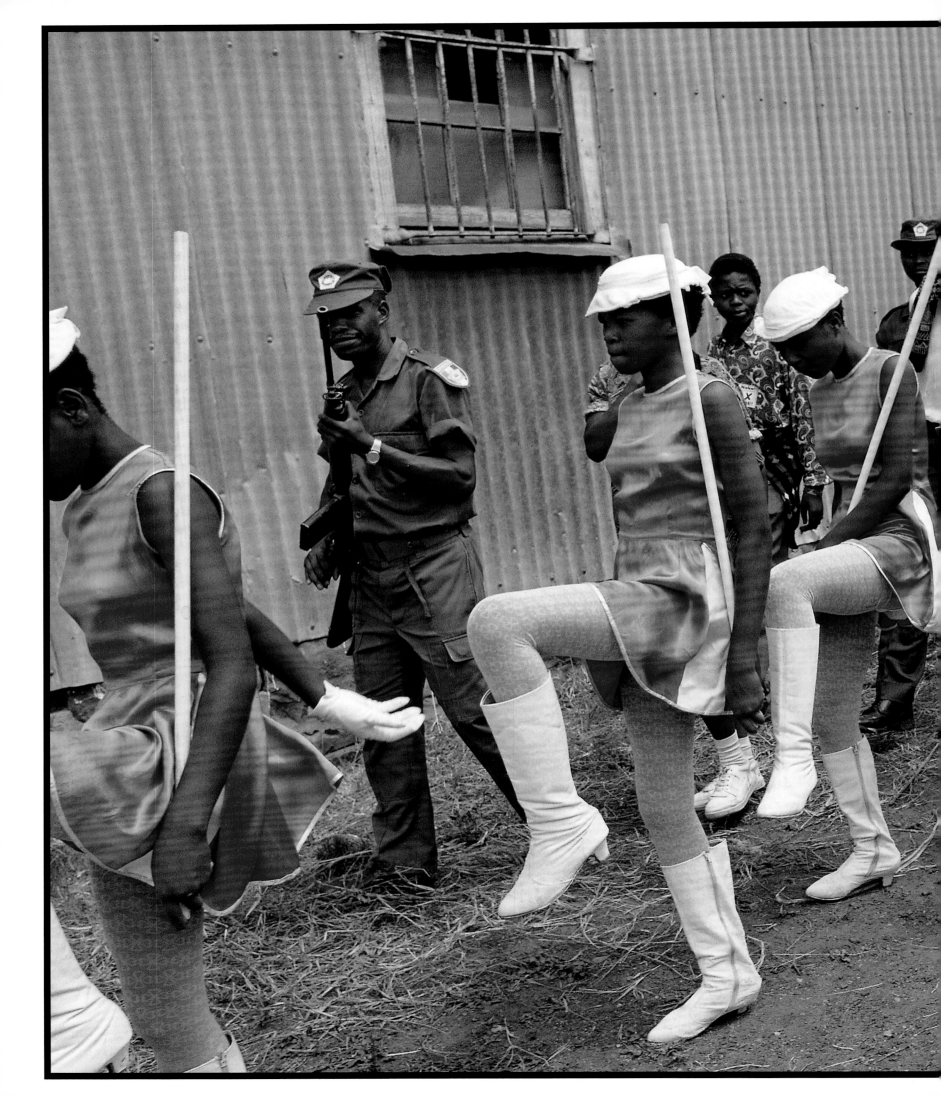

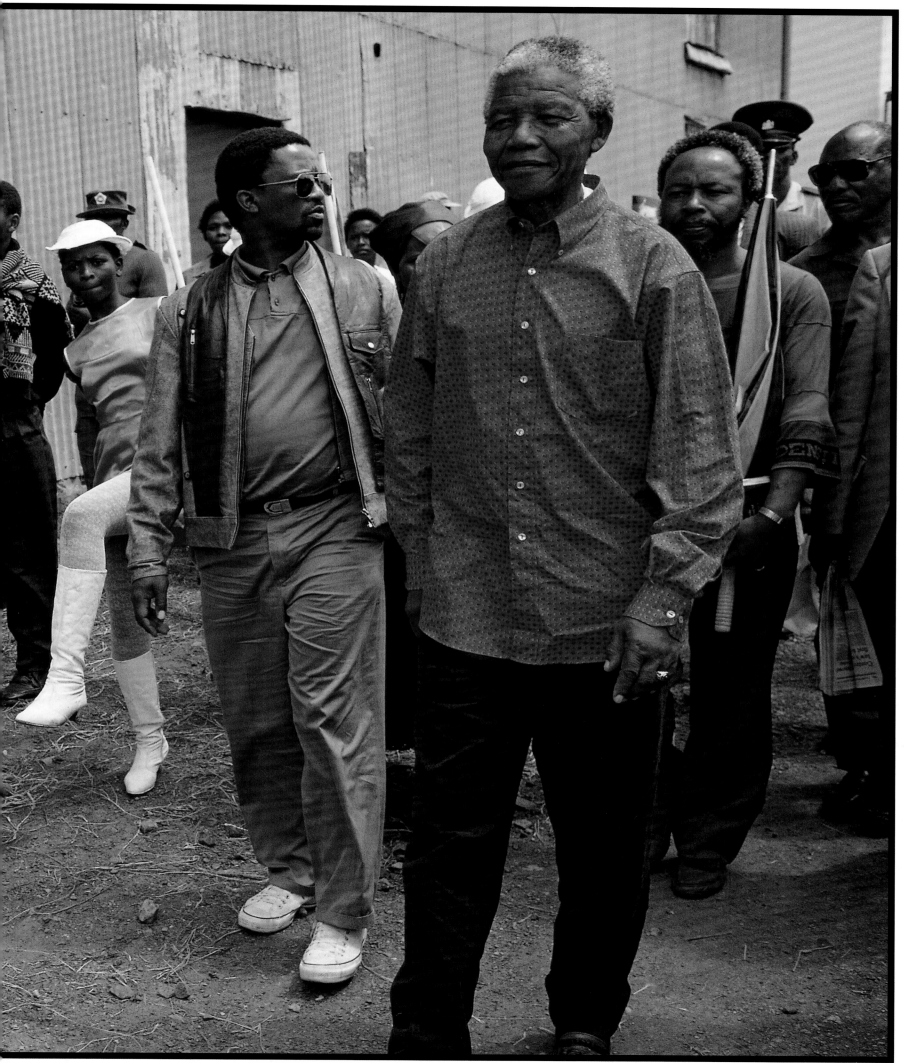

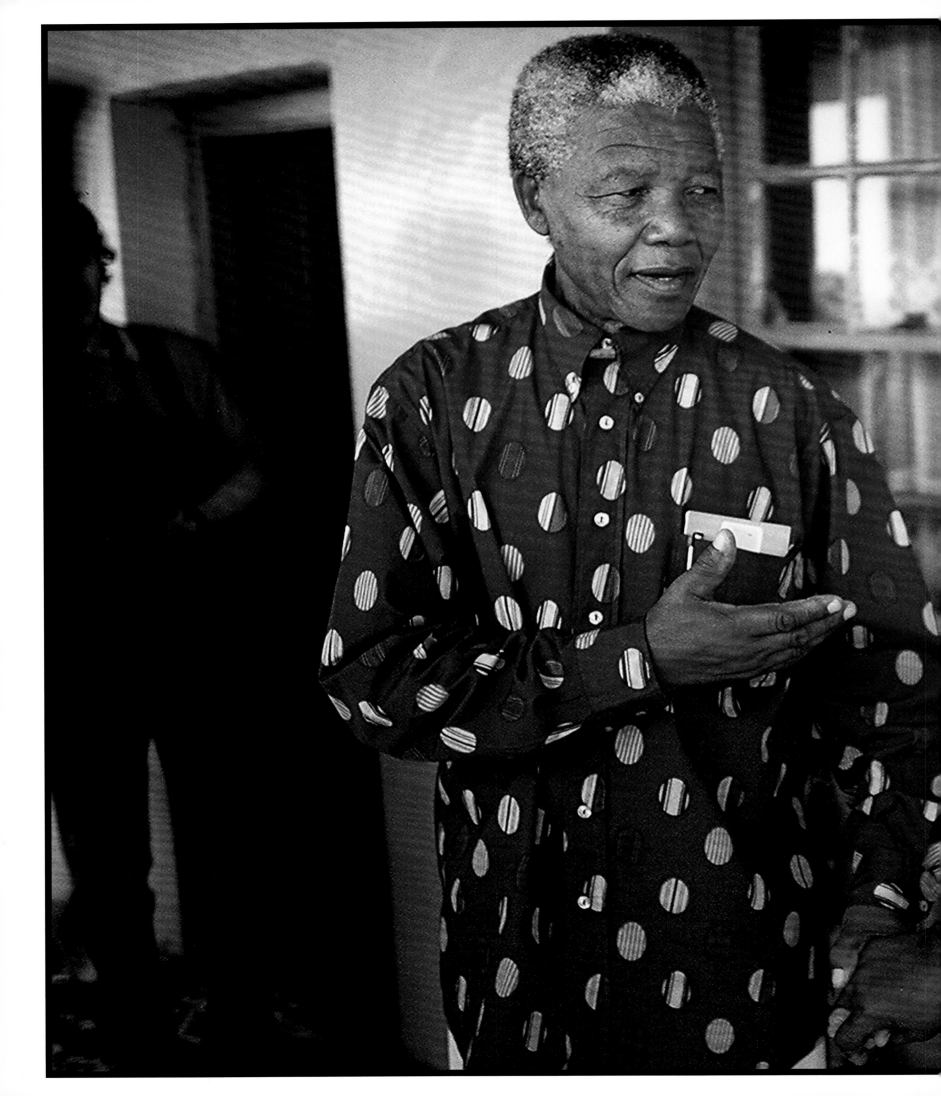

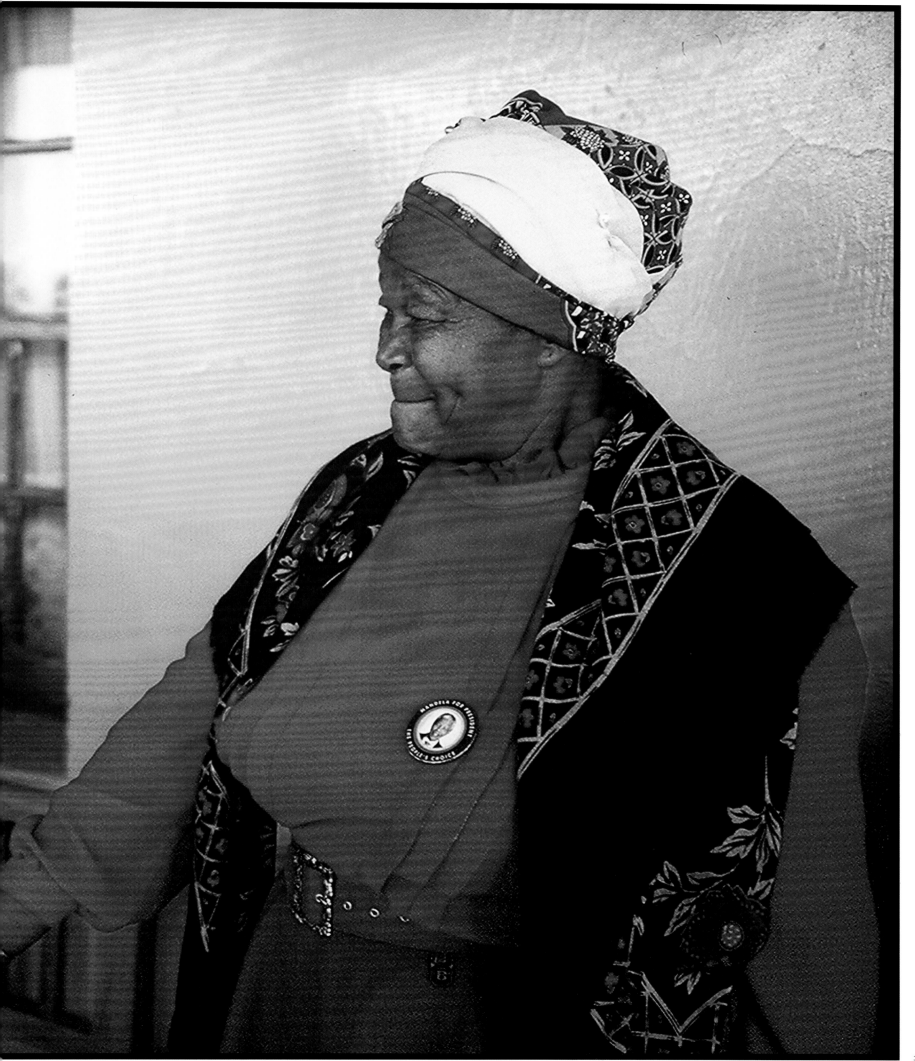

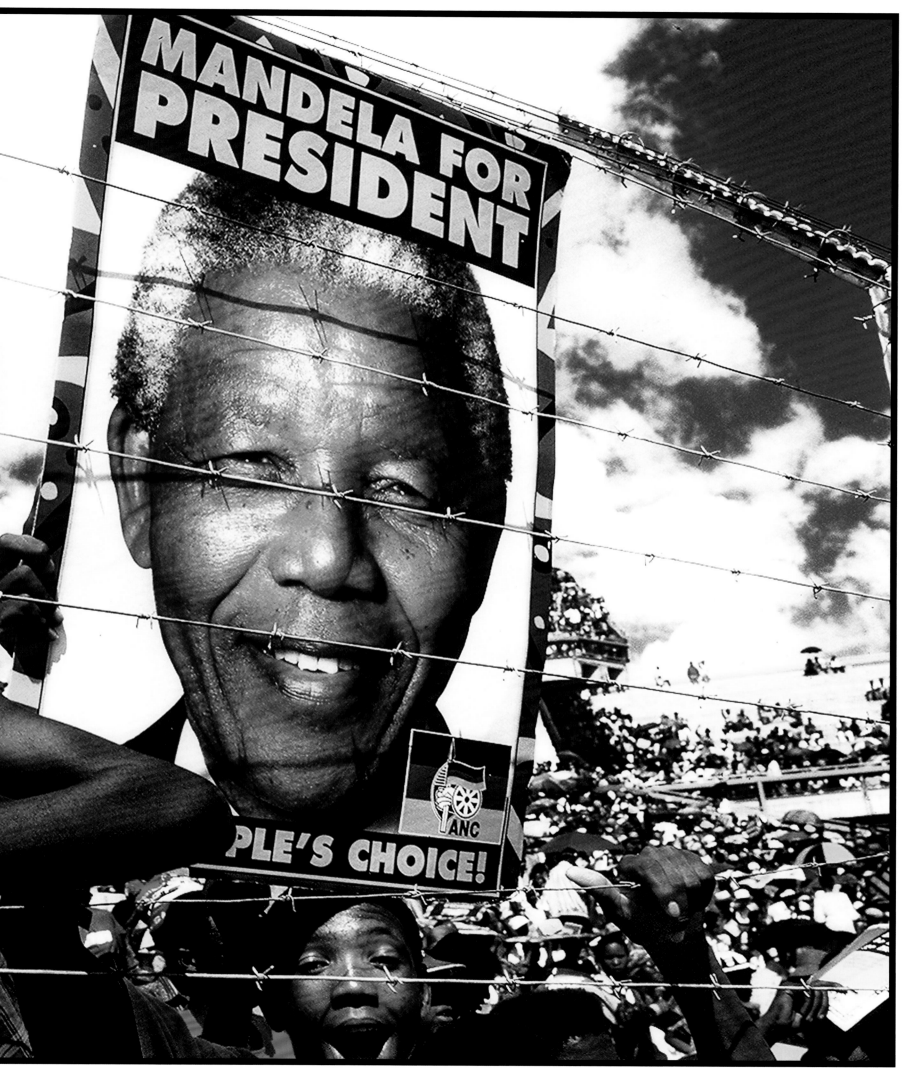

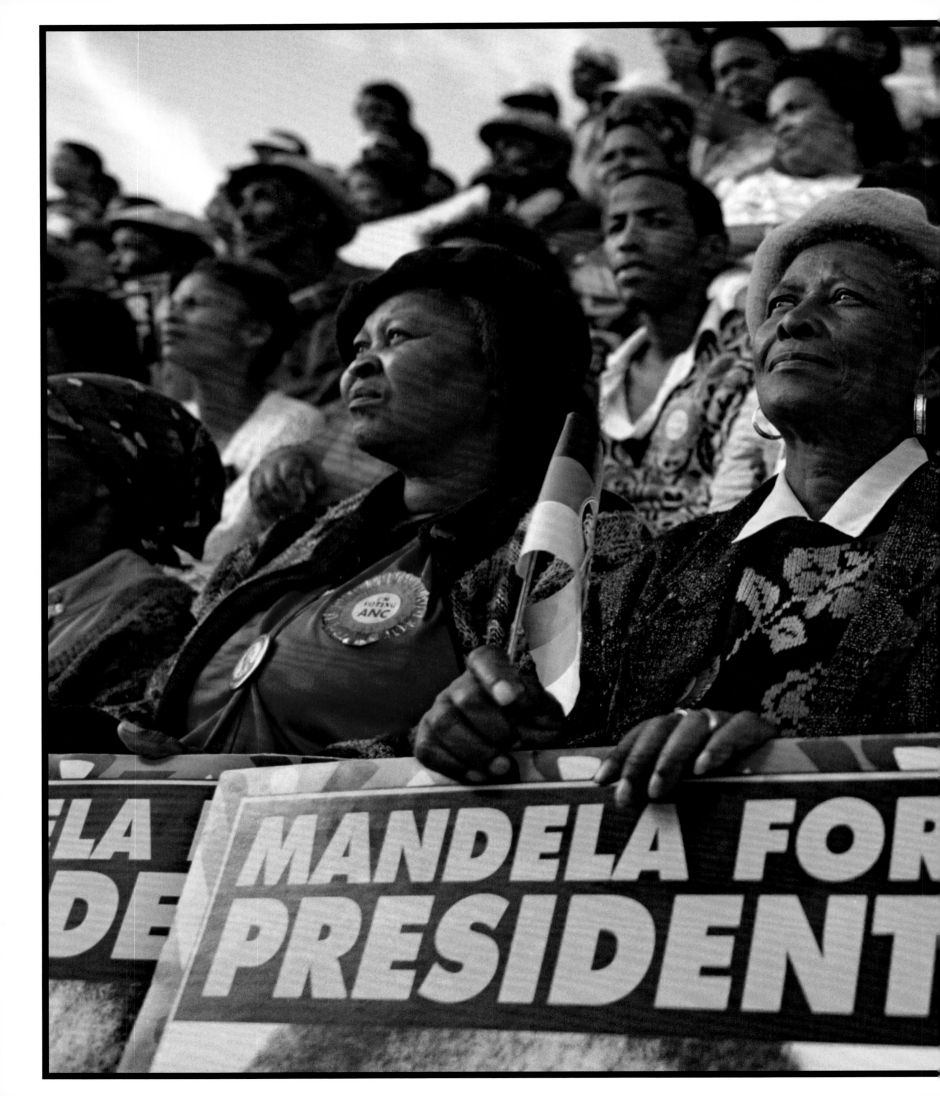

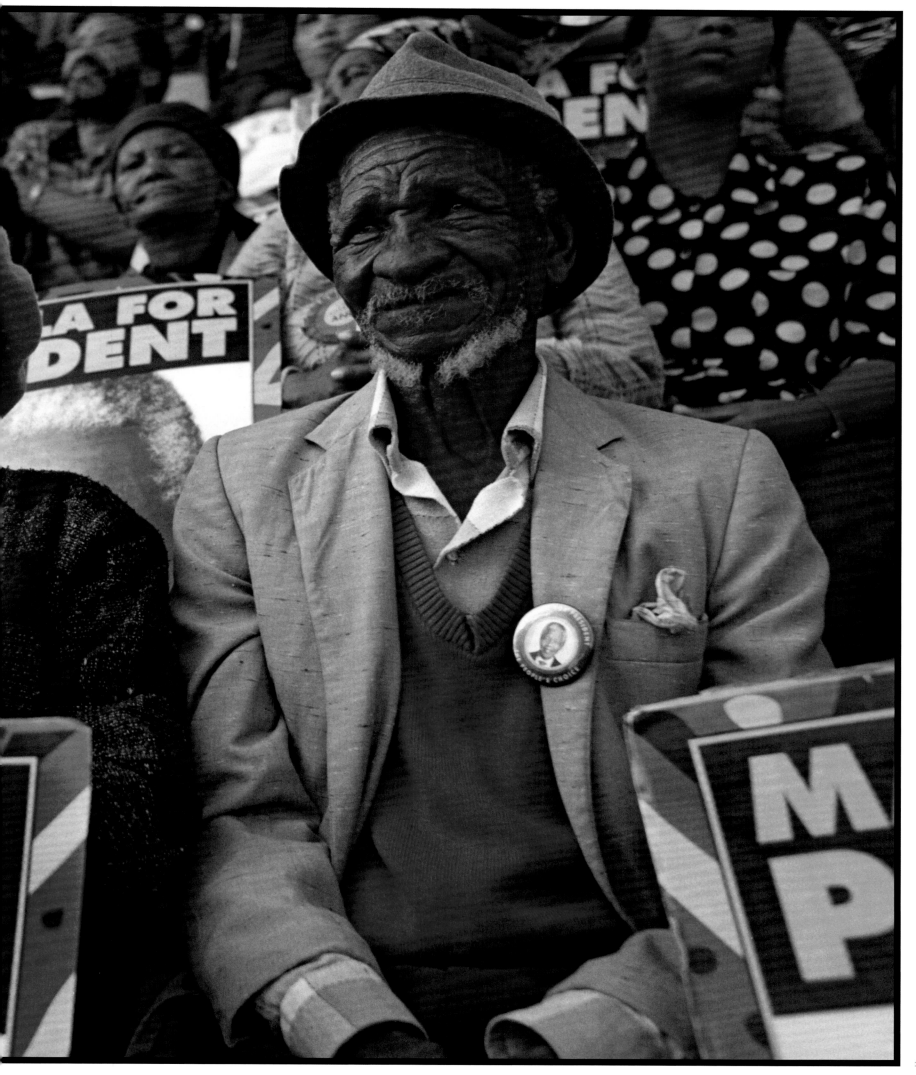

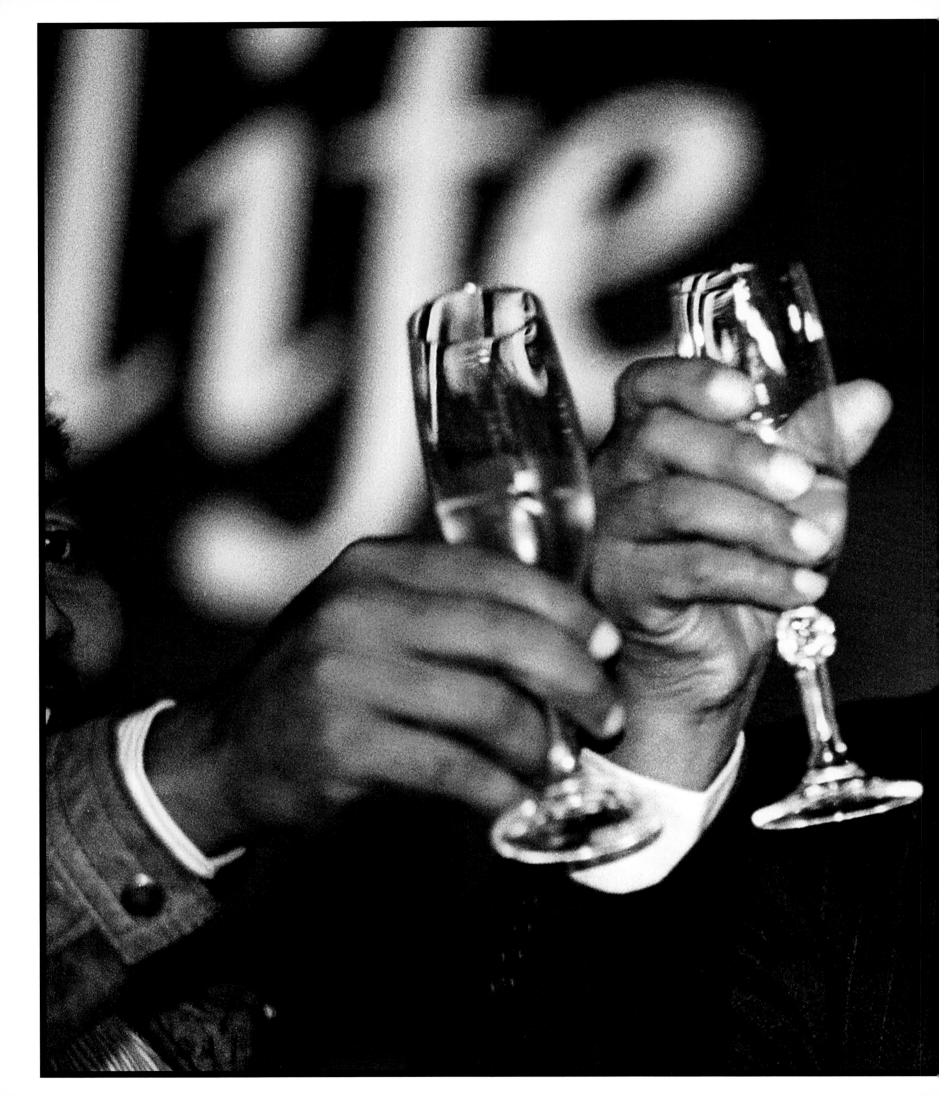

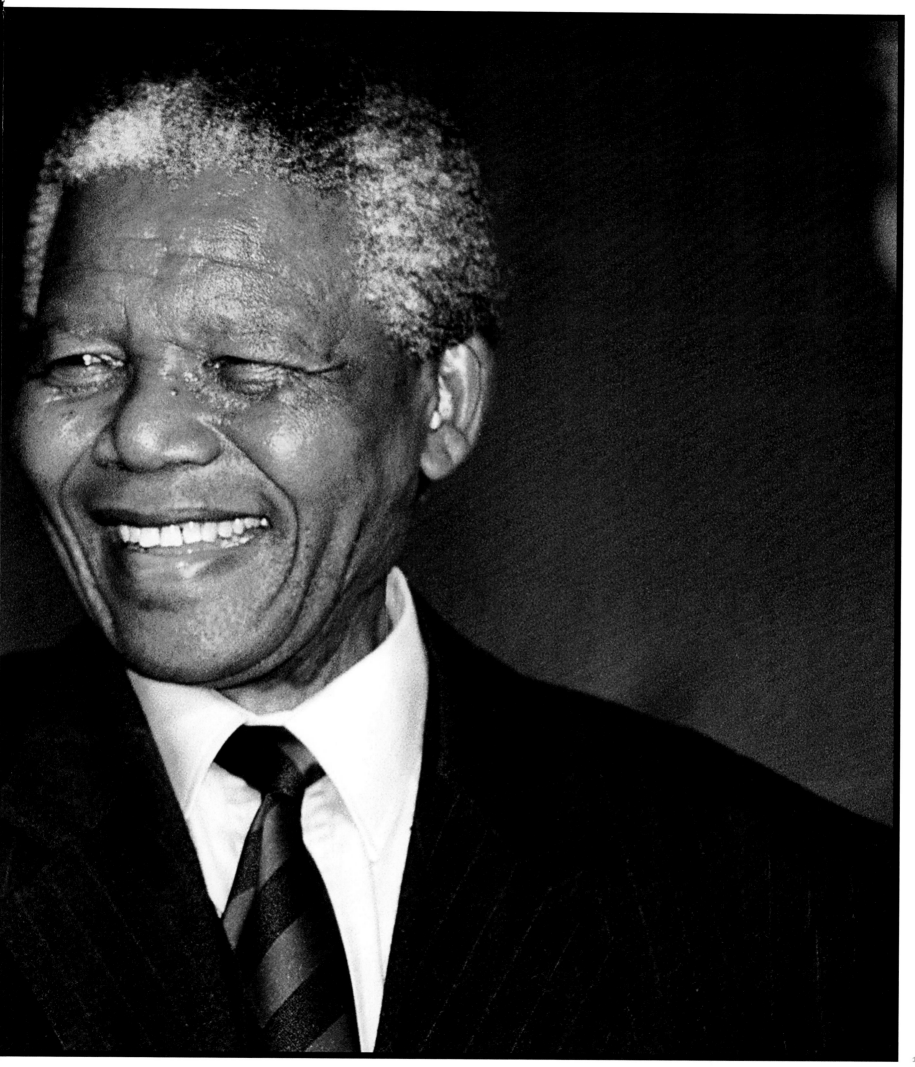

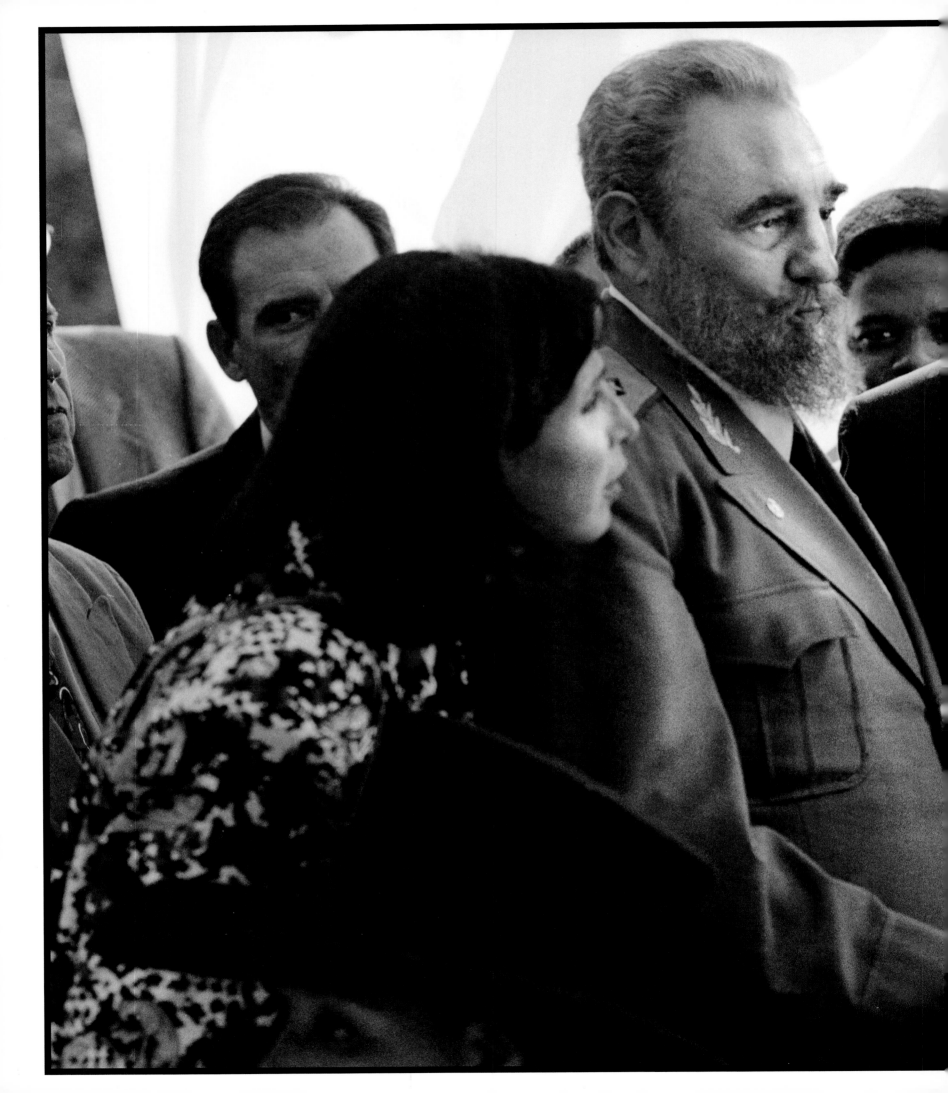

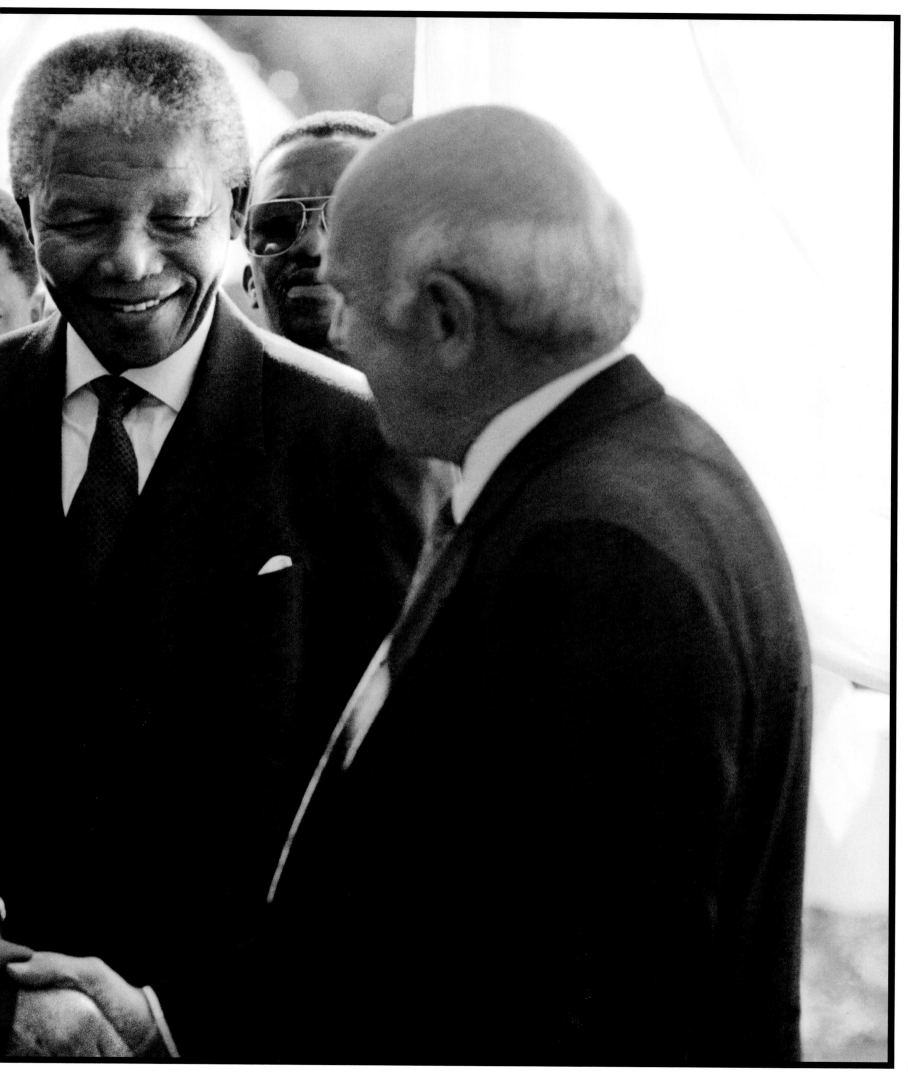

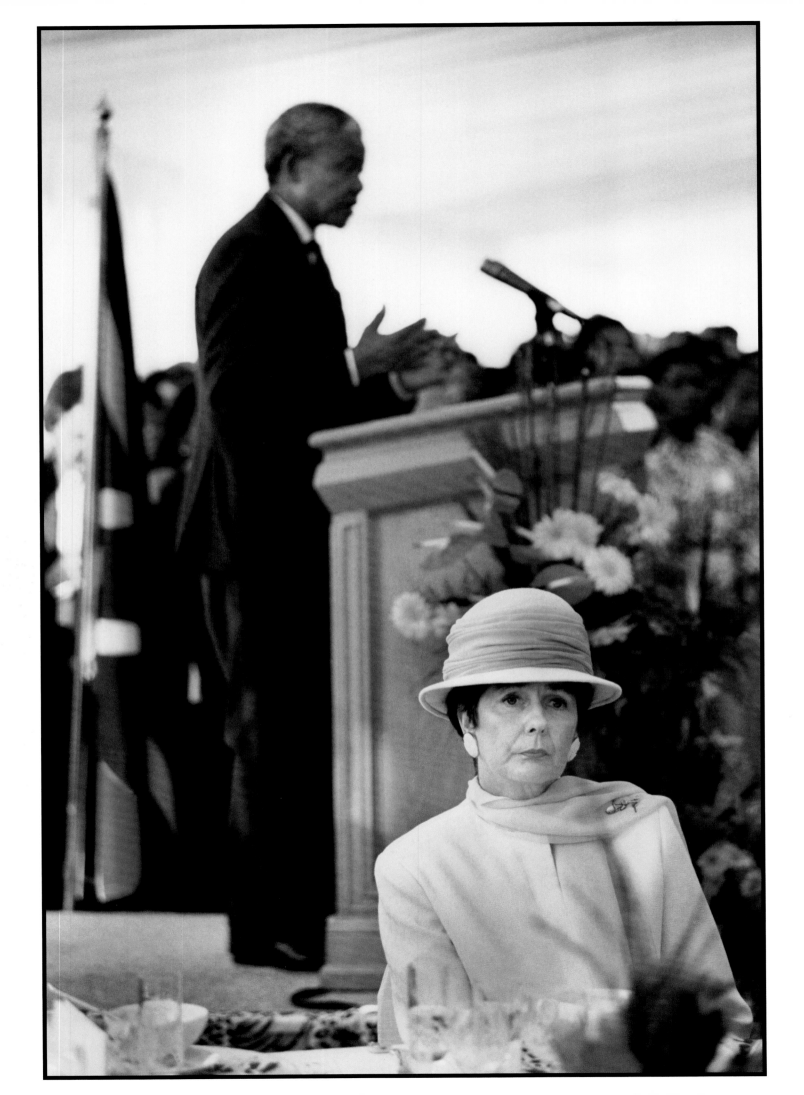

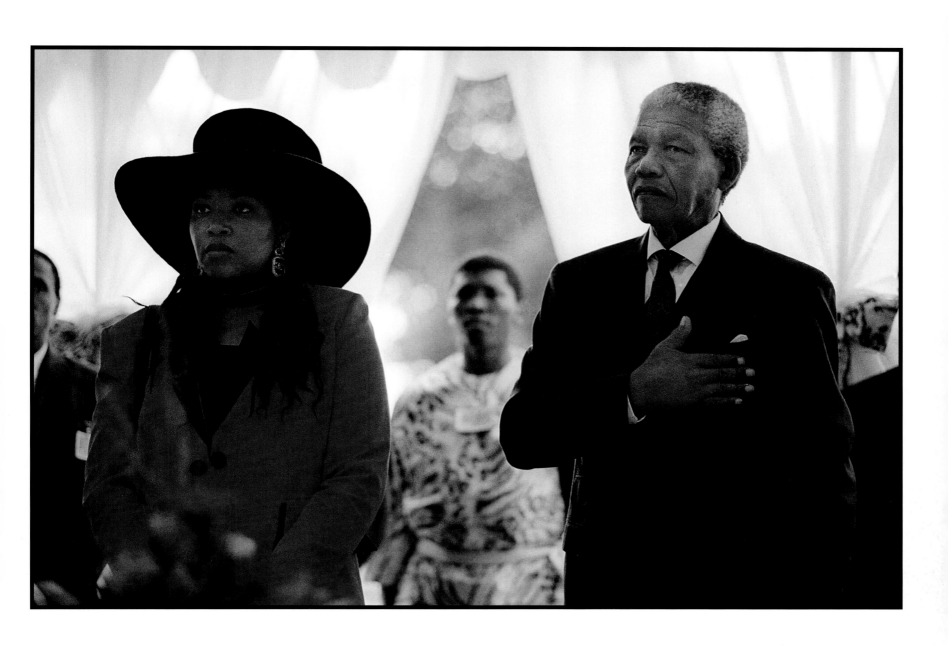

IFP members, predominantly gold miners, march through the streets of Johannesburg in March 1994.

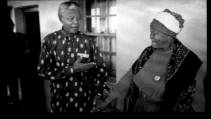

Mandela greets a supporter during a campaign stop for the presidency in the Orange Free State.

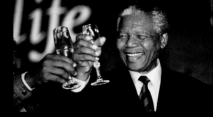

Mandela raises a glass on the eve of his presidential victory.

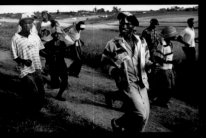

ANC sympathizers *toyi-toyi* through a township in KwaZulu-Natal. The toyi-toyi is a dance in military cadence accompanied by singing.

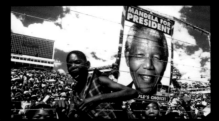

ANC supporters rally in a football stadium in the black homeland of Bophuthatswana in Botswana.

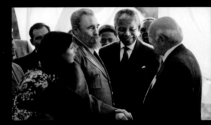

At his inaugural state banquet, President Nelson Mandela introduces Cuban leader Fidel Castro to former South African President F. W. de Klerk.

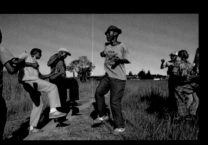

Young ANC members toyi-toyi in a township in KwaZulu-Natal.

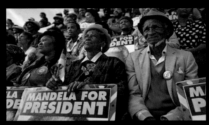

South Africans of all ages supported Nelson Mandela's candidacy for president in 1994.

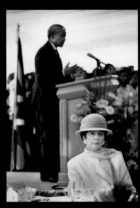

F.W. de Klerk's wife Marike turns away as Nelson Mandela addresses the banqueters.

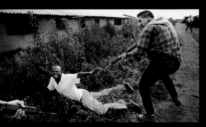

A Zulu miner in Soweto is arrested near his worker's hostel on suspicion of shooting at ANC supporters, 1994.

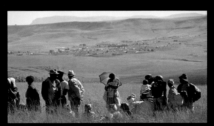

In Qunu, Mandela's boyhood village, South Africans line up to vote for their first time.

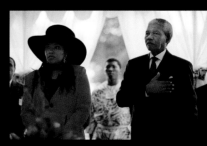

Nelson Mandela and his daughter Zenani stand at attention at his inauguration ceremony, May 10, 1994.

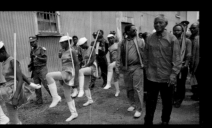

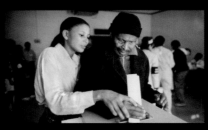

A woman helps an elderly man vote in South Africa's first democratic election, April 1994.

When he assumed the presidency of South Africa in 1994, Nelson Mandela tumbled out of the realm of
legend, in which his every action held a universal significance, and into the more mundane stream of events, where even the most astute leader sometimes falters or finds that he must compromise his ideals to achieve limited ends. Of his administration's two major achievements, one was concrete and the other was more symbolic, but both were essential. In the first instance, his government oversaw the adoption, in 1996, of a new constitution that is universally considered to be an exemplary foundation document for a progressive republic. In the second, Mandela made every effort to use his person and his office to further a spirit of national and racial reconciliation—as in his embrace of the Springbok rugby team—necessary for South Africa to weather its transition to a democratic government.

STATESMAN

On a vital third front, land redistribution and restitution to people who were dispossessed of their property after 1913 "due to racially discriminatory measures," legislation and land courts were put in place, but progress was slow. In 1994, 87 percent of the land in South Africa was in the hands of white farmers and the state, and no less an establishment institution than the World Bank had warned that civil war might result if this imbalance was not addressed. Deep-seated social inequities on this scale are a severe challenge to any democratic government, especially a fragile new one that must appeal to constituencies diametrically opposed to one another.

When Mandela decided not to stand for reelection in 1999, the resolution of this and other pressing problems devolved on his successors. The previous year, his eightieth, he had married Graça Machel, the widow of the former president of Mozambique, and he looked forward to devoting his time to global

Watched over by his wife, Graça Machel, Reverend Jesse Jackson, and John Samuel of the Nelson Mandela Foundation, Nelson Mandela signs copies of his autobiography in his office, 2006.

campaigns on behalf of issues that were close to his heart. Then, in 2004 just before his eighty-sixth birthday, he announced his retirement from public life—the fourteen years of unceasing work since 1990: "One of the things that made me long to be back in prison was that I had so little opportunity for reading, thinking and quiet reflection after my release. . . . I am confident that nobody present here today will accuse me of selfishness if I ask to spend time, while I am still in good health, with my family, my friends—and also with myself." In this, as in all other things, he exhibited a human sense of proportion and priority.

Upon his retirement, Mandela could look back on a uniquely fulfilling life. In a world where violence is the usual means of resolving (or exacerbating) problems arising from the unequal distribution of rights and resources, he led a national revolution that achieved its goals, on the whole and in comparison with almost any other historical example from the past two hundred years, peacefully. He had the satisfaction of drawing strength from ideals that he had forged in his youth in the face of extreme adversity, when the normal fate of the political prisoner is to experience suffering and often death for adherence to principle. As a professional politician—for that too was an apt description of the man—his triumph was total, as he kept his party together and led it from a marginal position in the mainstream political establishment to victory in legitimate elections. In the absorbing autobiography that he published in 1994, he expressed pain over his failings as a husband and father, but anyone who saw him with his children and grandchildren and extended family and old friends after his release from prison could not help but be aware of the deep pleasure he took in their company. All of these qualities taken together—success on a world-historical scale, the realization of youthful dreams of justice, a career in politics pursued with skill and dedication, and a full emotional connection with others—genuinely defined Mandela as a real source of hope and inspiration to millions in South Africa and throughout the world. He exerted his influence not only on the powerless, but also on political leaders with far more power to effect change than Mandela himself.

Of all of the honors and awards that were showered on Mandela after his emergence as a national leader in South Africa, one stands out as a poignant symbol of the arc of his life's story. Having achieved what he set out to do, he assumed the position of councillor to the Thembu court that he had been groomed for as a young man and had turned down in 1942 to become a political activist for the ANC. In Nelson Mandela, the Thembu kings got all they might have wished for, and more.

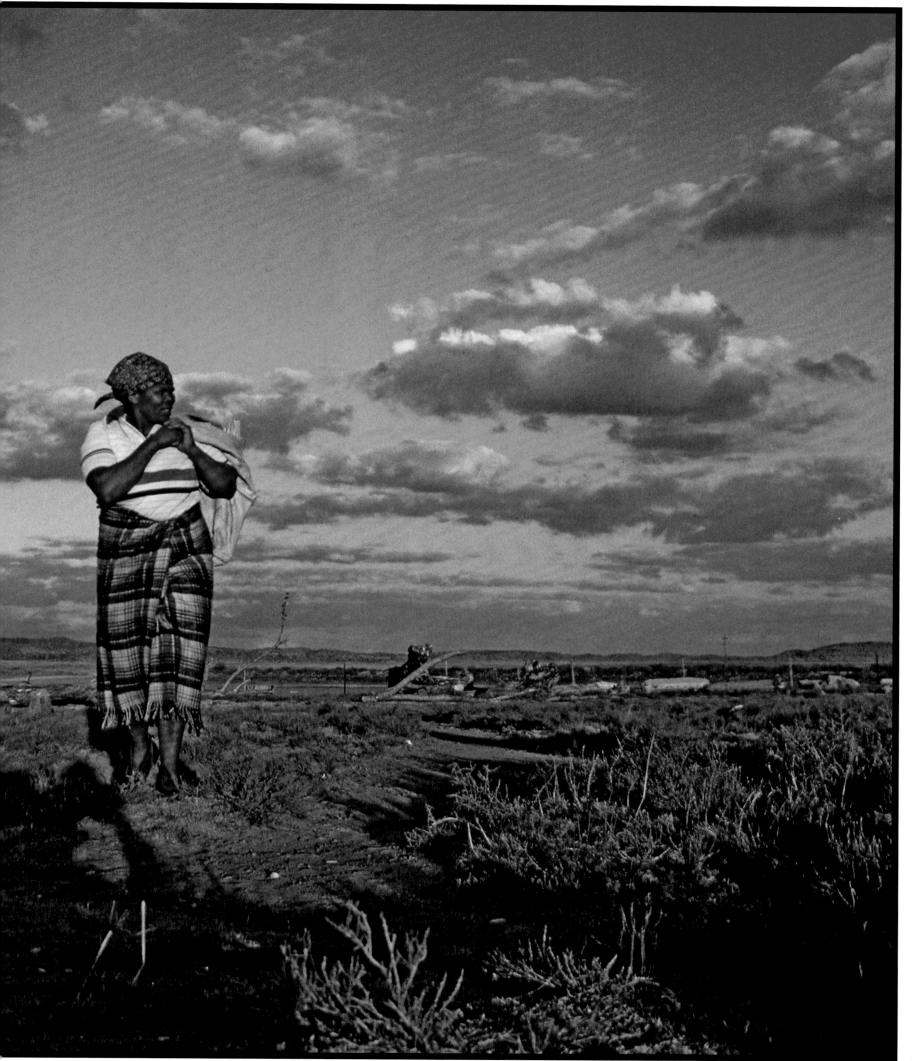

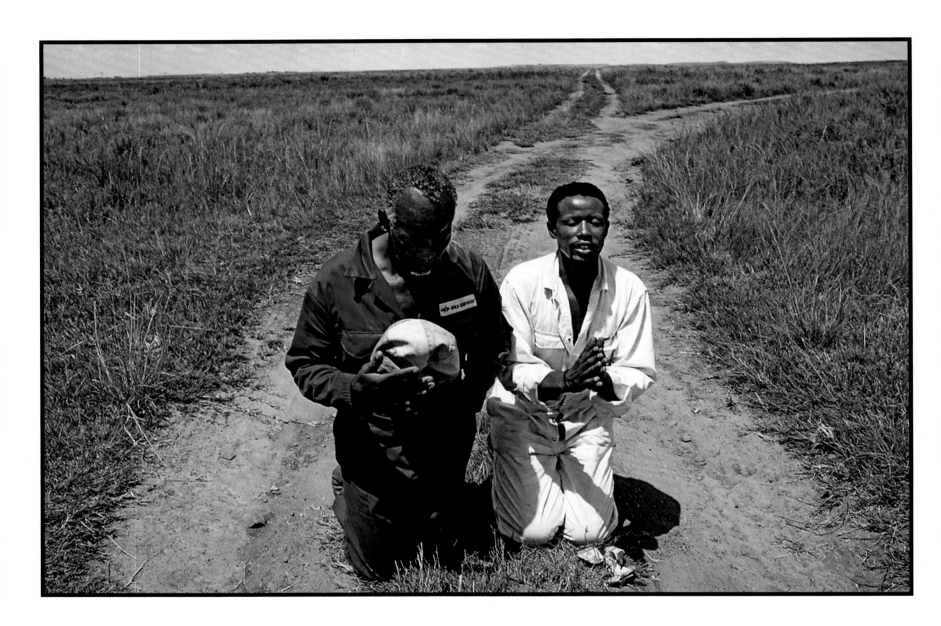

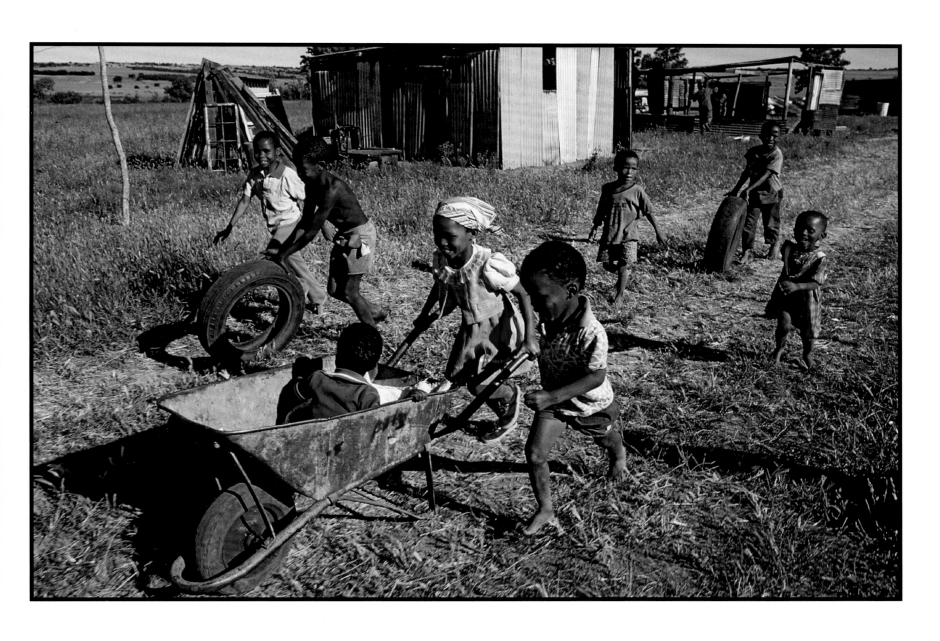

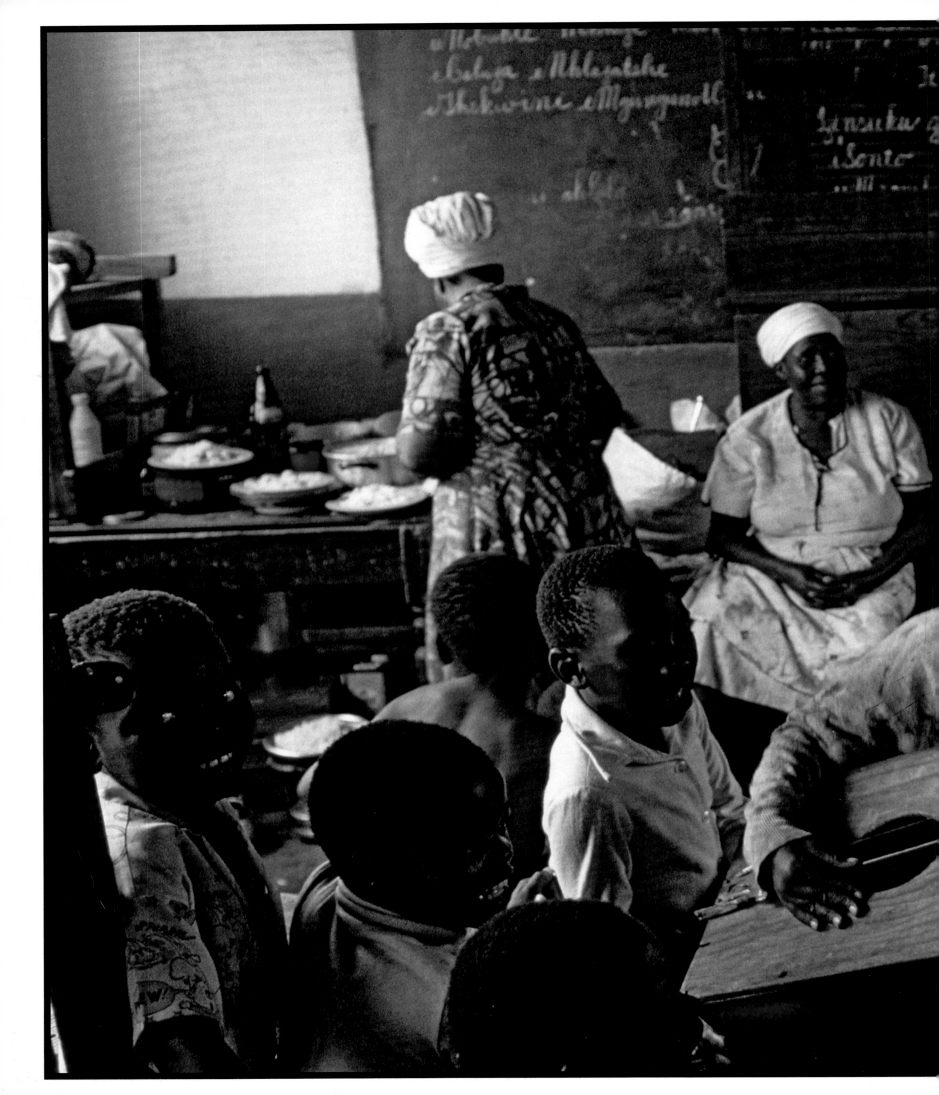

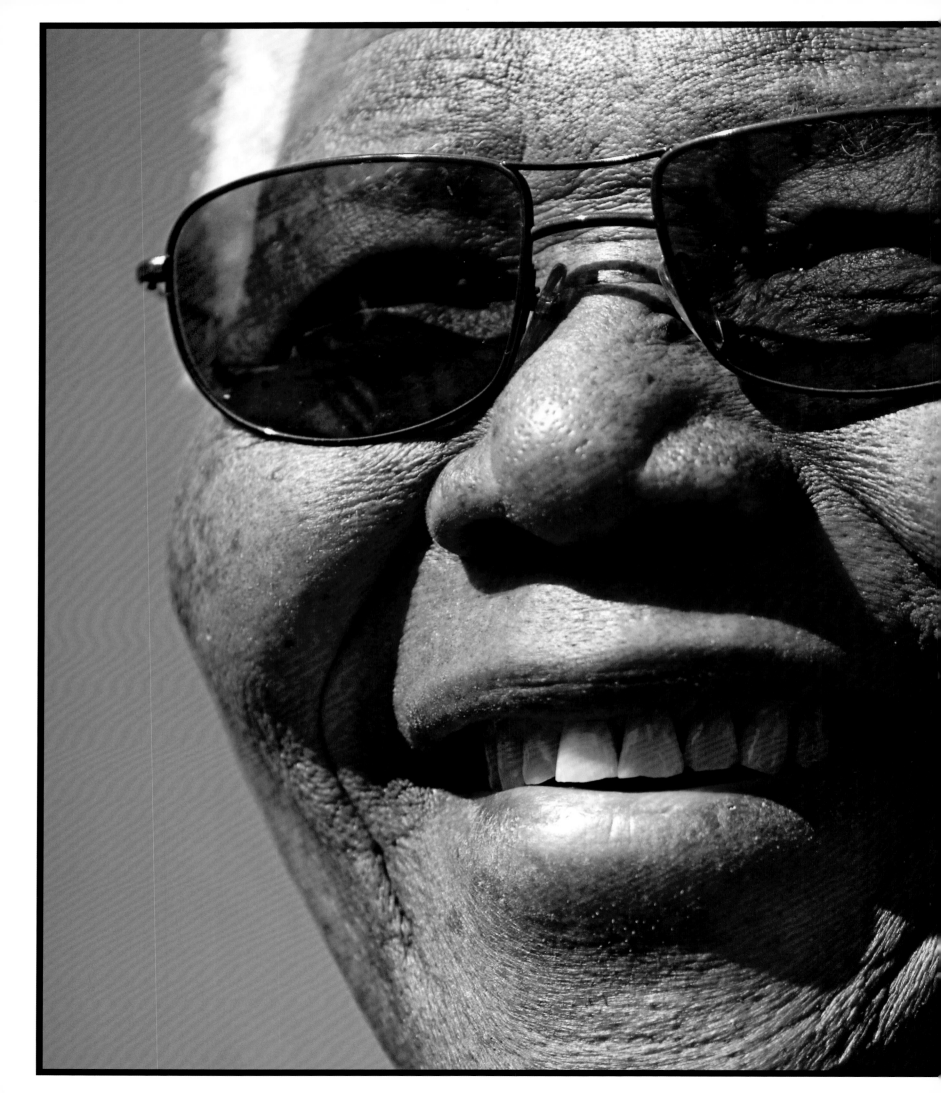

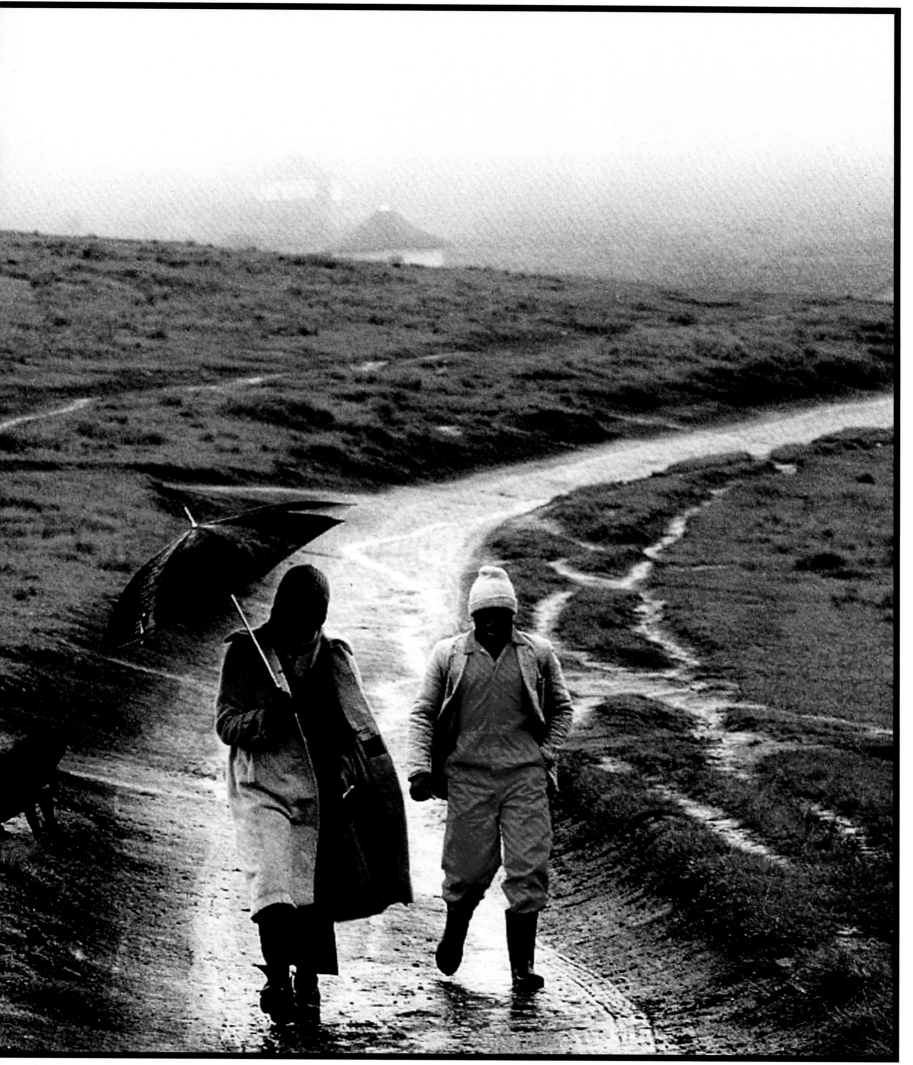

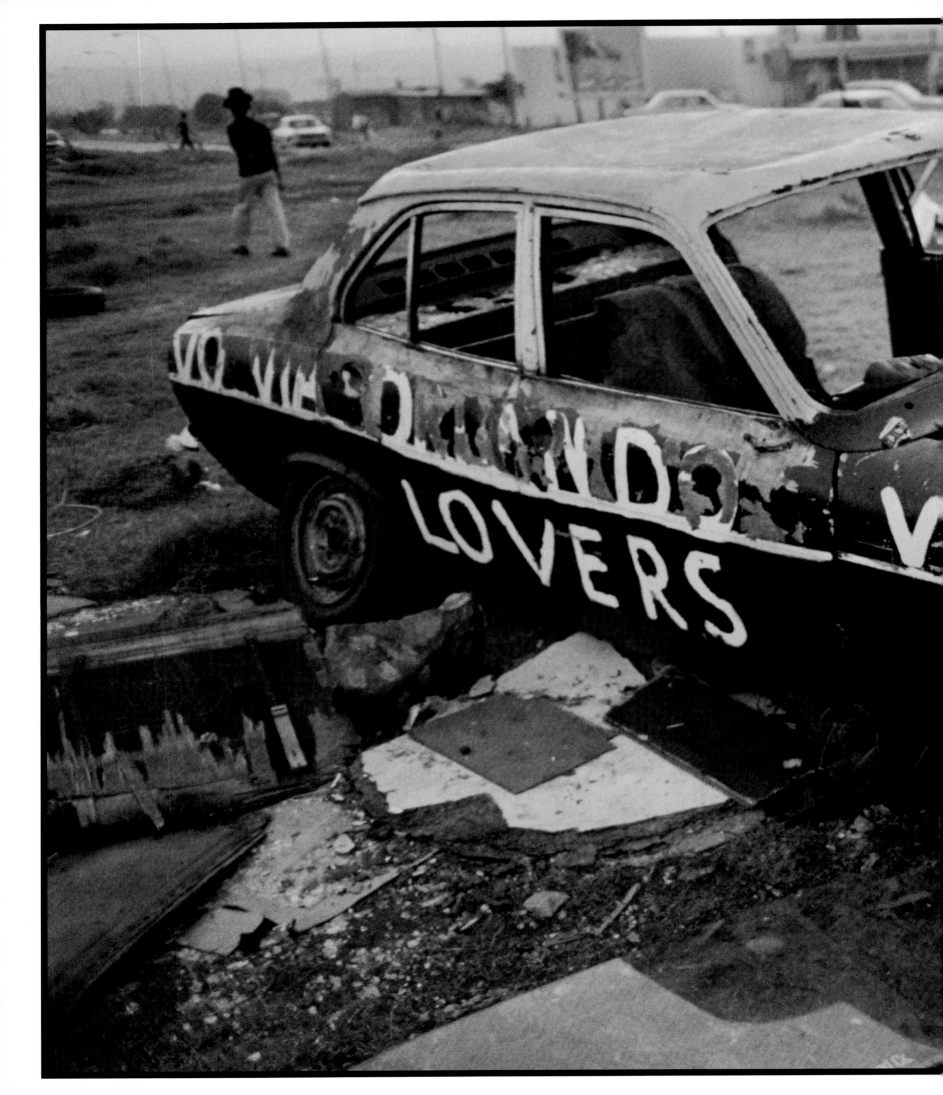

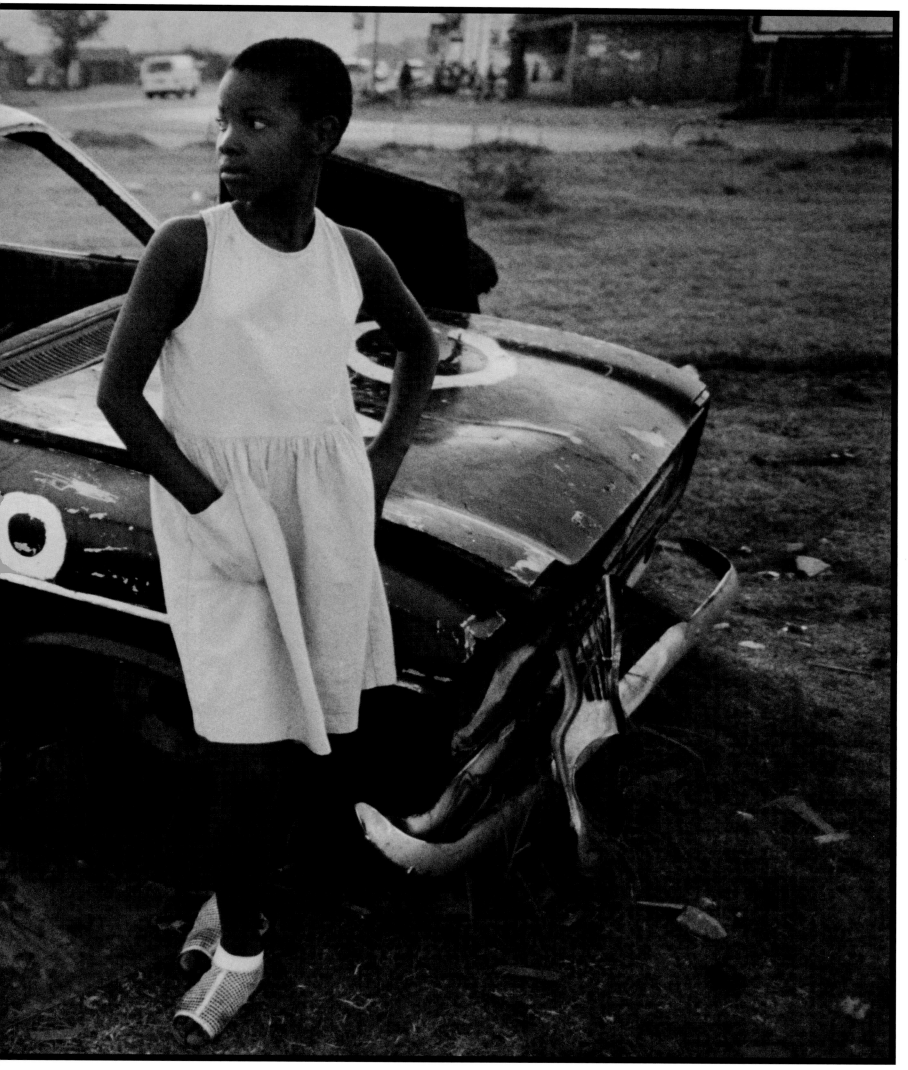

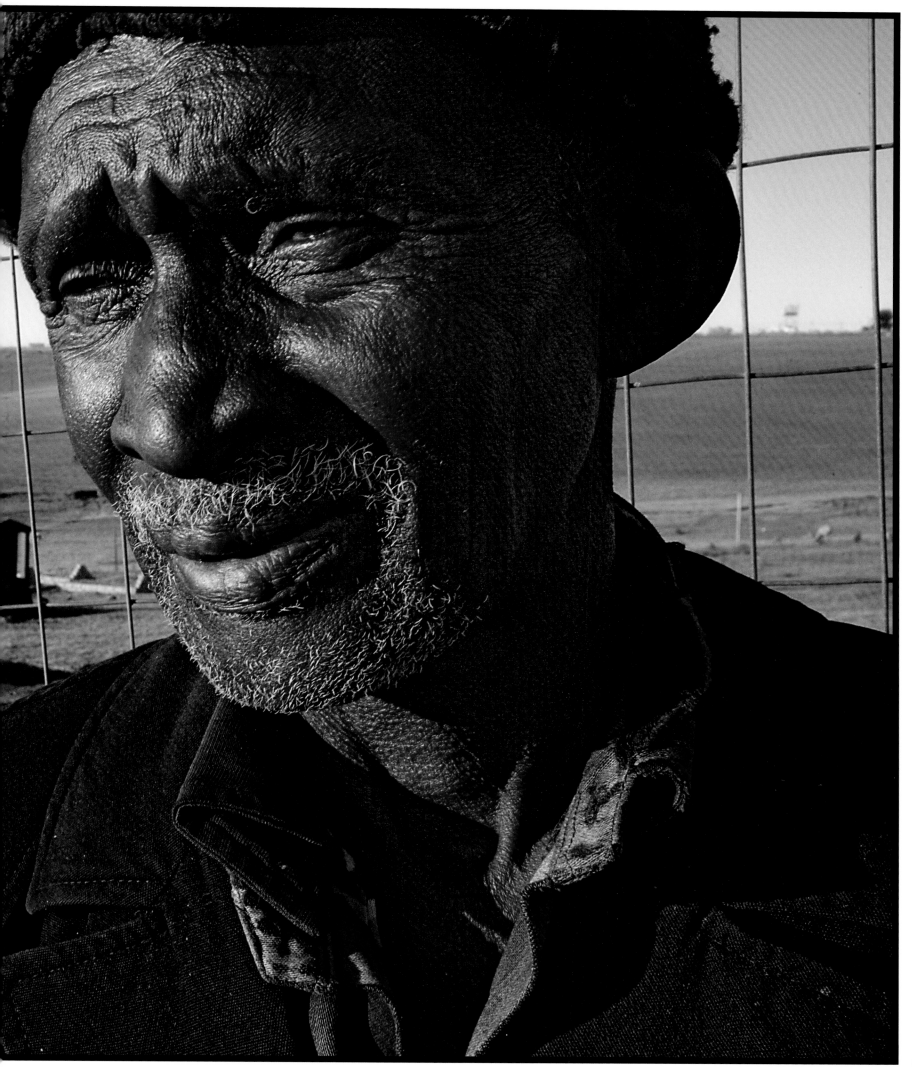

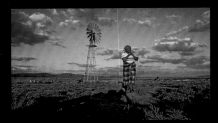

A woman walks from her mud house on an Afrikaner farm in the Orange Free State to work as a domestic for white families.

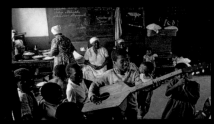

A boy plays a makeshift guitar in a grade school near KwaZulu-Natal.

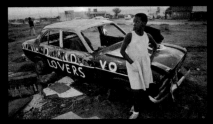

A young girl waits for a friend at sunset in Soweto.

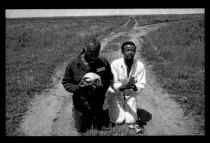

Two men pray as they return in 1994 to land in the Western Rand outside Johannesburg that was confiscated from their family decades earlier. Their ancestors are buried in a makeshift cemetery on the property.

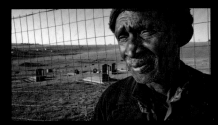

The South African rugby team poses during the filming of a television commercial in Johannesburg, 1994.

A relative stands near the Mandela family cemetery in Qunu, where Madiba will one day be buried.

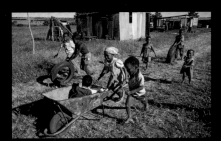

Children play as their parents quickly erect small dwellings on reclaimed land, 1994.

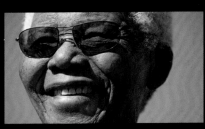

At a rally in his honor in the West Rand outside of Johannesburg, Nelson Mandela greets his people.

Students return from a recess at a private school in Johannesburg.

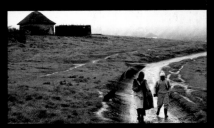

A South African gold miner (right) is greeted by a relative as he returns to his home in the Transkei after eleven months of work.

Nelson Mandela shares an affectionate moment with Graça Machel in their home in the Transkei, 2005.

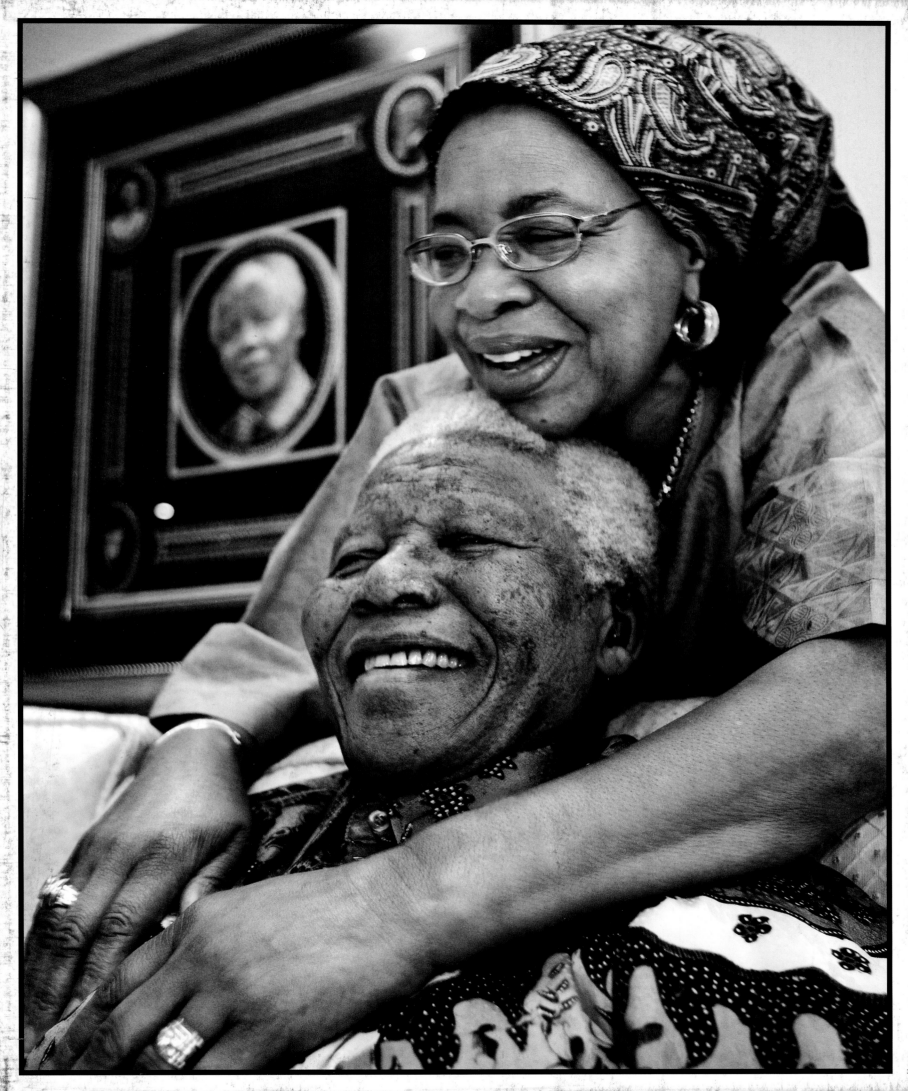

Acknowledgments

Words cannot express the gratitude that I feel toward South Africans for the generosity of spirit, inspiration, courage, humility, and decency which they have revealed to me while I photographed in their beloved country over the last twenty-two years.

At Abrams, I want to thank editor in chief Eric Himmel, who took a personal interest in and made a commitment to this book; Brady McNamara, who designed this book; Anet Sirna-Bruder and Jules Thomson in the production department; and Esther de Hollander.

I want to thank my talented nephew Andrew Turnley Ehrenkranz, who helped me to write my introduction and the biography of Nelson Mandela's life that accompanies my photographs. I am indebted to his extraordinary passion and gift as a storyteller.

Thanks to dear Charles Osawa, who helped me to tone the photographs for reproduction.

The *Detroit Free Press* first sent me to South Africa as a newspaper photographer in 1985 and supported my work there for the better part of three years. At the *Free Press*, I want to thank from the bottom of my heart: David Lawrence Jr., Heath Meriwether, Sandra White, Marcia Prouse, Randy Miller, Mike Smith, Helen McQuerry, Larry Olmstead, Remer Tyson, as well as dear friends on the photographic staff and in the newsroom. The people of Detroit supported our work and believed in our efforts to report on the civil rights struggles of South Africans.

I want to thank the people of the photographic agency Black Star, which represented my work during those early years.

I want to thank Corbis—and especially Steve Davis and Bill Gates—for making my body of work from South Africa available to millions through their Internet-based archive, where so much of my South Africa work resides.

Getty Images has been instrumental in supporting my recent work to tell the story of the life of President Nelson Mandela and his legacy. At Getty, I want to thank Jonathan Klein, a wonderful South African who brought me to that prestigious agency, and his colleagues Nick Evans Lombe, Adrian Murrell, David Laidler, and Aidan Sullivan.

The *National Geographic* provided me with such generous support to make my most recent visits to South Africa to create the work that completes this book. I want to thank especially editor in chief Chris Johns, Susan Smith, David Griffin, and Susan Welchman.

Thank you to the commercial agency Furlined: Diane McArter, Matt Factor, and everyone on the extraordinary staff for support and for friendship.

I have been blessed with the professional and personal friendship of Peter Magubane, who has put his life on the line to photograph so that through his work his fellow South Africans would all have equal rights.

I want to thank my family, especially my wonderful parents Bill and Betty, who raised me, my brothers Bill and Peter, and sister Annie, with the belief that all people deserve to be treated with fairness and dignity.

To my friends, who know who they are, thanks for believing in me and supporting my work.

Winnie Mandela welcomed me into her family starting in 1985. Winnie will always be for me one of the strongest, most eloquent, soulful, dignified women I have had the privilege to know. Her daughters Zenani and Zindzi are dear friends whose grace and hospitality has so touched me.

This book is my testament to President Mandela. Words cannot express the power of his courage, wisdom, and inspiration.

I want to thank Lauren Welles, who has been at my side for the last year and a half, for your support and love.

To the mother of my beloved son Charlie, Karin, and to her wonderful family—I am blessed that you came into my life. In so many ways this book is for and because of you.

And finally, to Charlie, who was born into the new South Africa—I love you so much and want you always to know how proud I am of you. This book is for you.

David Turnley

Editor: Eric Himmel
Designer: Brady McNamara
Production Manager: Anet Sirna-Bruder

Library of Congress Cataloging-in-Publication Data
Turnley, David C.
 Mandela : struggle & triumph / by David Turnley.
 p. cm.
 ISBN 978-0-8109-7092-2
 1. Mandela, Nelson, 1918– 2. Mandela, Nelson, 1918– Pictorial works.
 3. Presidents–South Africa–Biography. 4. Presidents–South Africa–Biography–
 Pictorial works. I. Title.

 DT1949.M35T87 2008
 968.06'5092–dc22
 [B] 2007044457

Printed and bound in China
10 9 8 7 6 5 4 3 2 1

HNA ▌▐▌▐▌
harry n. abrams, inc.
a subsidiary of La Martinière Groupe
115 West 18th Street
New York, NY 10011
www.hnabooks.com